DRYDEN GOODWIN CAST

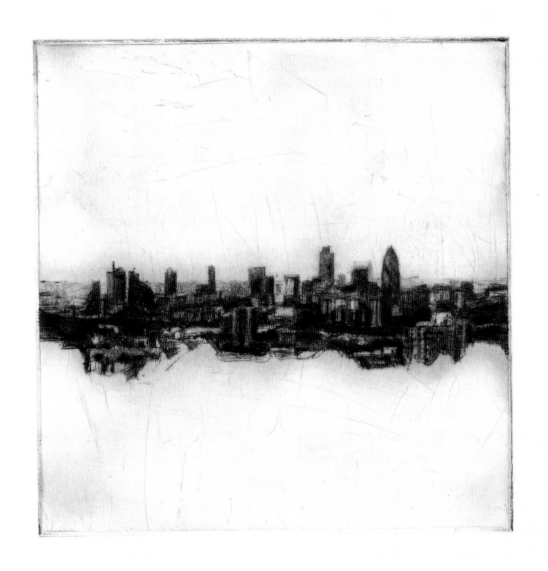

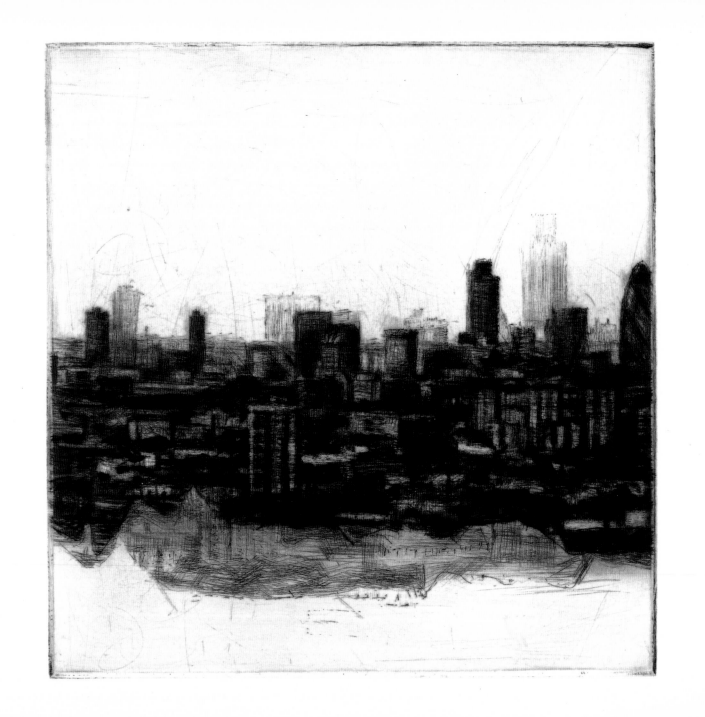

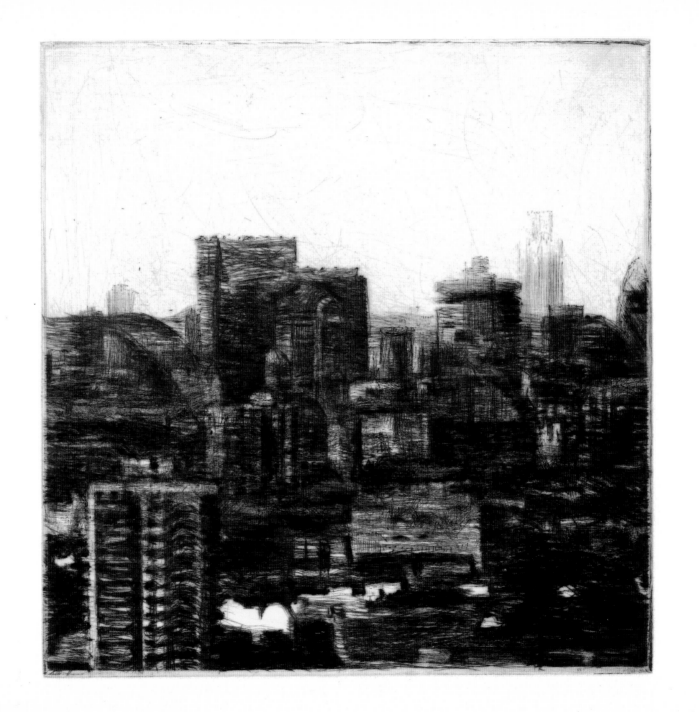

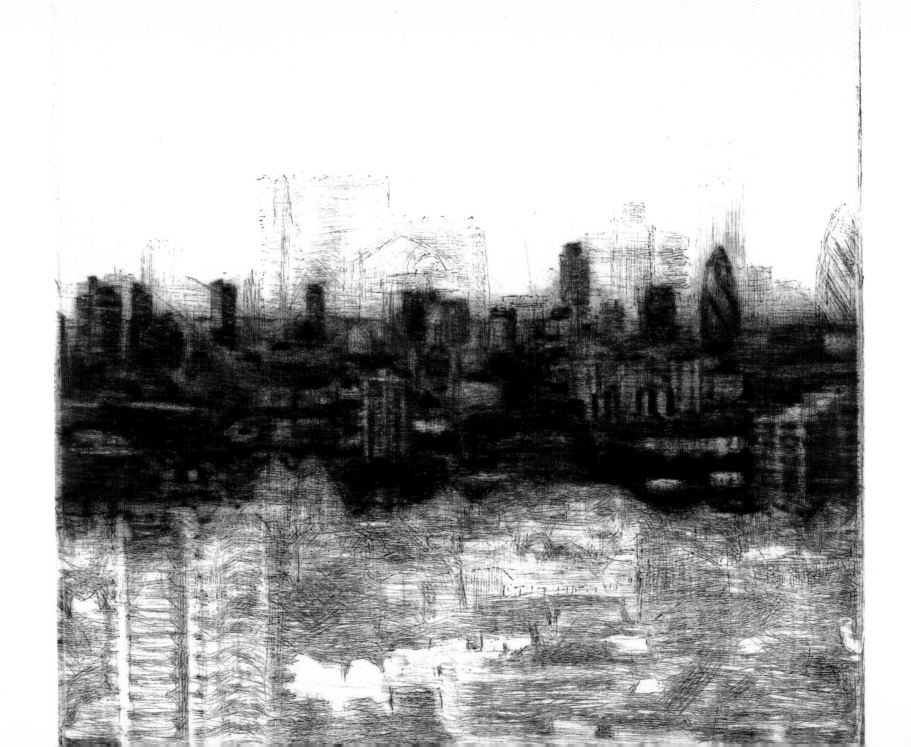

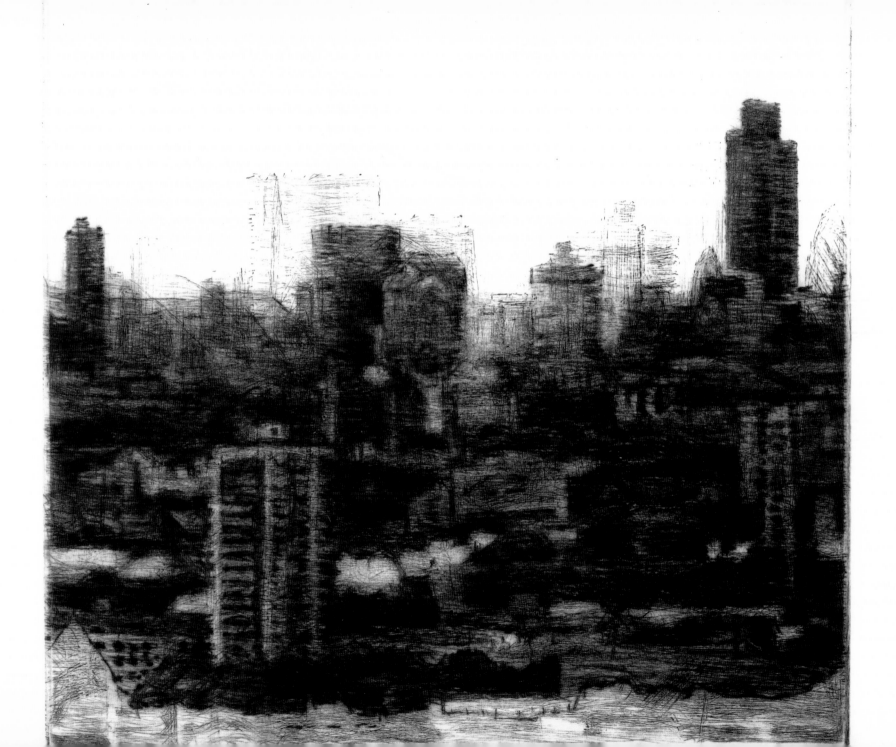

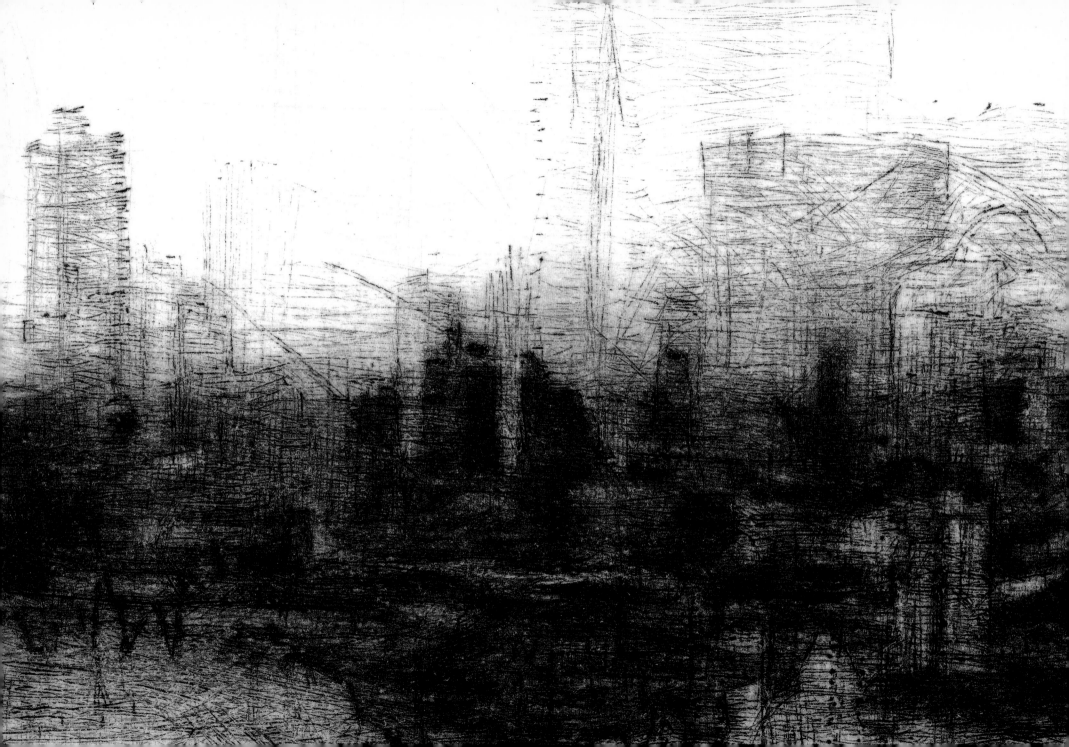

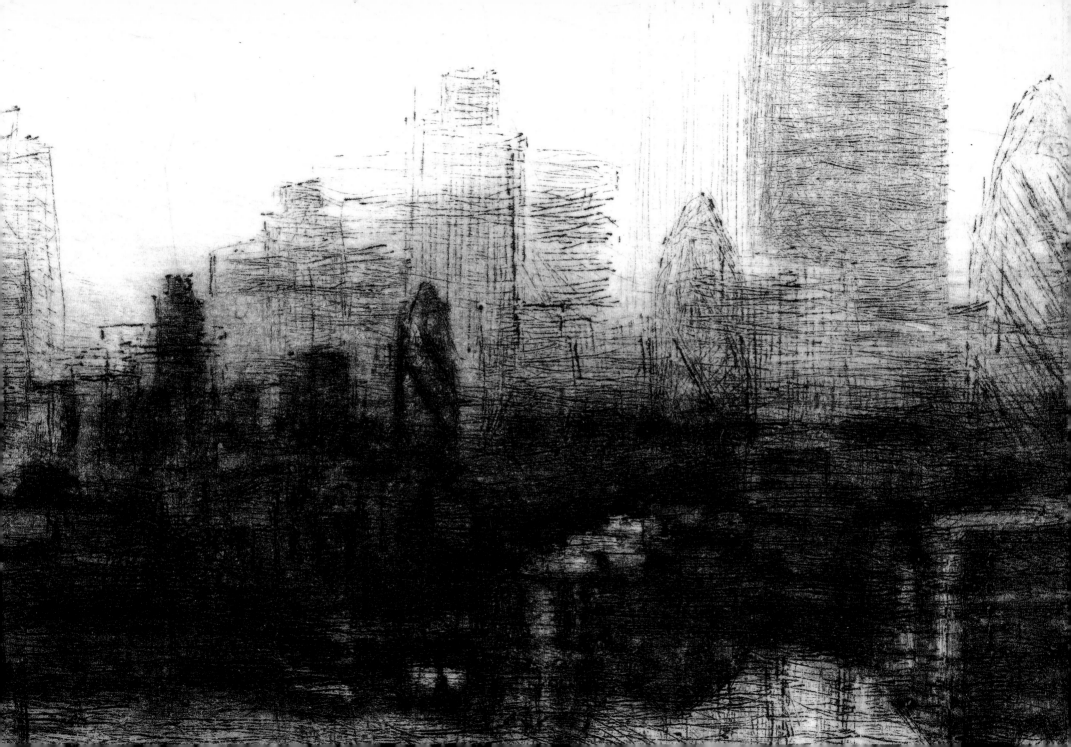

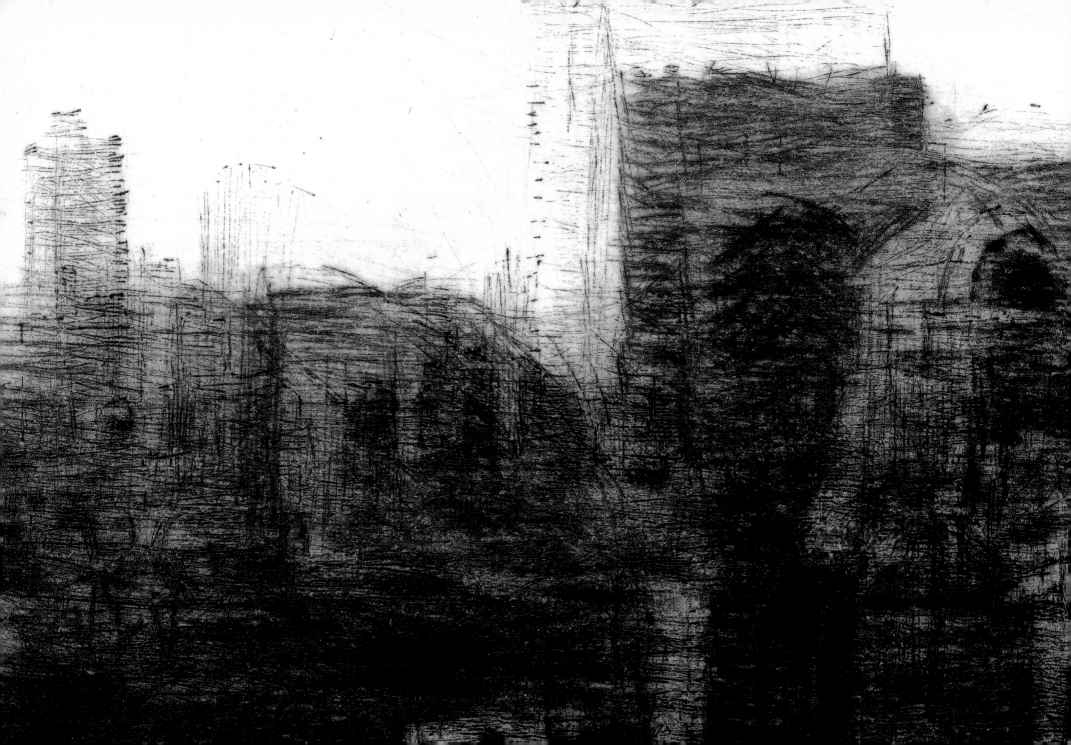

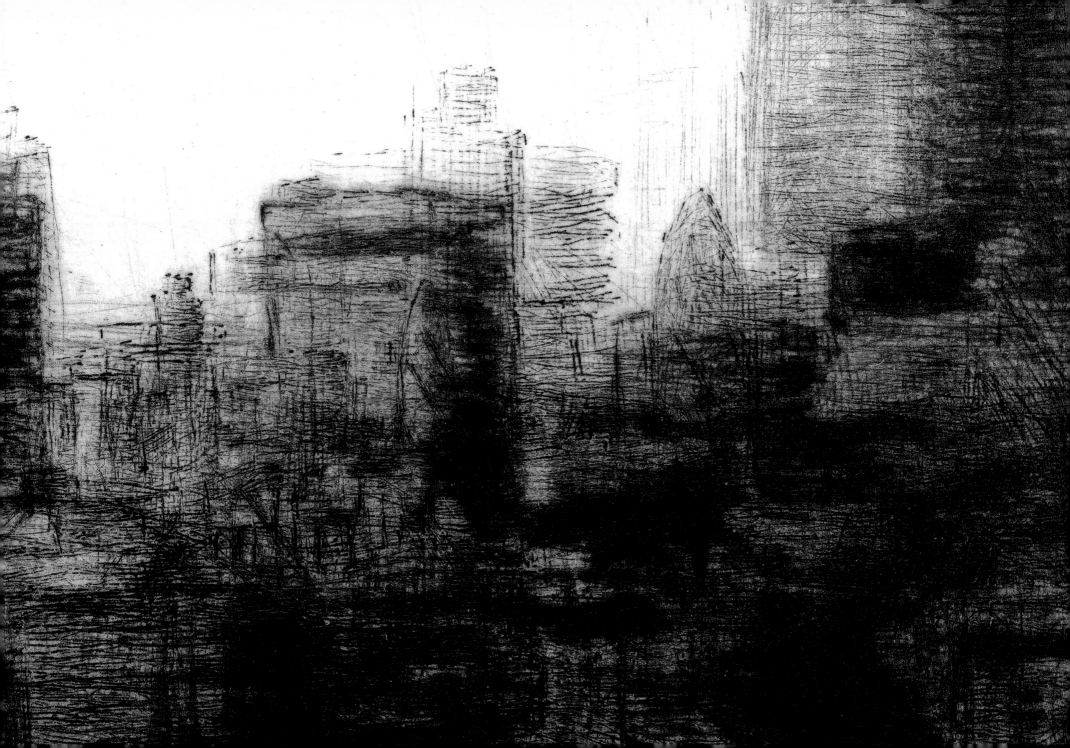

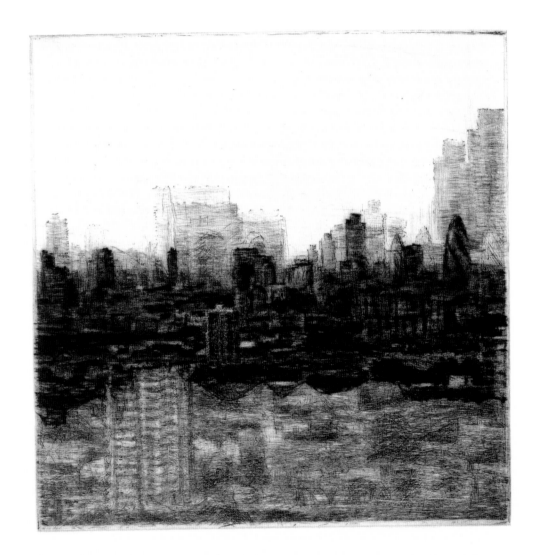

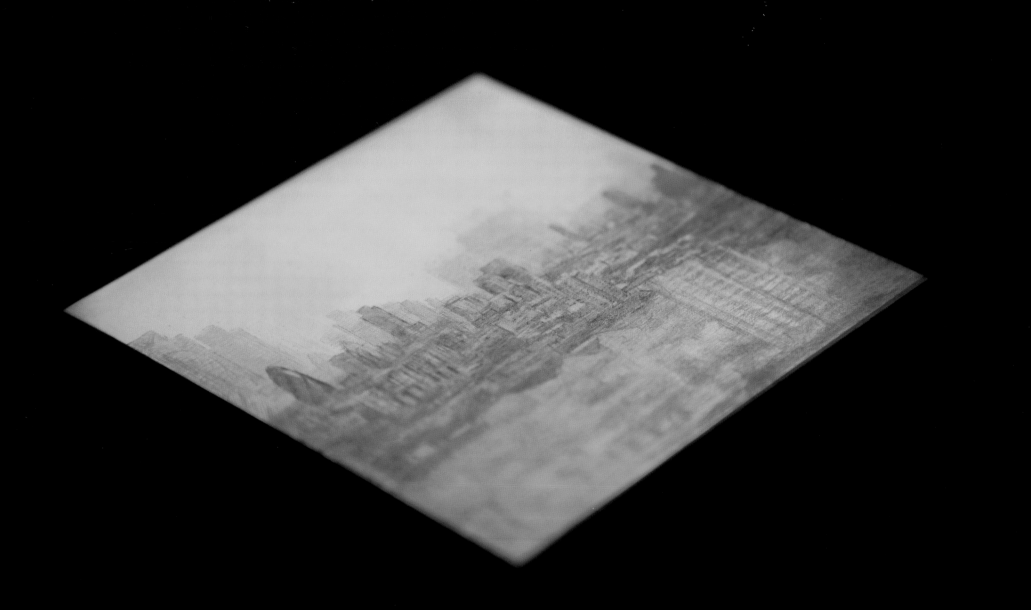

RELIC

The mask was discovered partially buried in the mud of an unusually deep excavation, sunk with surgical precision into the bedrock of one of the busiest streets in London. Disinterred by a local surveyor on a final check of the site, the first small shards were passed on to one of the archaeological team making the most of the limited time that had been made available to sift through this patch of ancient earth before it was covered, once again, by the concrete foundations of a new high-rise building. To the fury of the developers and contractors, the find was considered of such significance that it called a halt to proceedings until a more intensive search was made. While the noise of the city continued to reverberate in every direction, silence descended on the immediate vicinity. People gathered round, and decided to call time, and what remained of the day gradually slowed to a stop. An element of doubt fell like a shadow over future activities.

The next morning, a small plastic bubble tent was erected, in which two senior archaeologists huddled down to begin the delicate work of removing the patina of dirt from the face of the mask. Slowly, gently, and almost tenderly, they returned the object back to the light. First to be exhumed was a part of the cheek, its scuffed copper surface flecked with glints of green and lilac. Then, a fragment from the brow, in which a sliver of flint had become embedded. Then, shortly after, amazingly intact, the pièce de résistance: a central section with the unmistakable lineaments of a face: a rudimentary nose-guard flanked by two tiny apertures, through which a pair of eyes must once have looked.

Even before its pieces had been reassembled, the mask provoked considerable speculation. No bones were found nearby — indeed the extra week's grace yielded absolutely nothing more of interest. Remains from a roughly equivalent period, however, had been found, more than twenty years before, on a dig under an adjoining street, which led people to conclude that the mask may have been a ceremonial artefact, standing watch over a small encampment nestling in the shadow of Ludgate Hill. Others suggested that it could have belonged to a warrior, or a shaman; or a pariah, cast out from the tribe. So little is known about these early inhabitants of London that nothing can be claimed for certain. One thing, perhaps, can be said for sure: that the mask has stayed true to some of its original purpose, namely to hide what was never intended to be revealed.

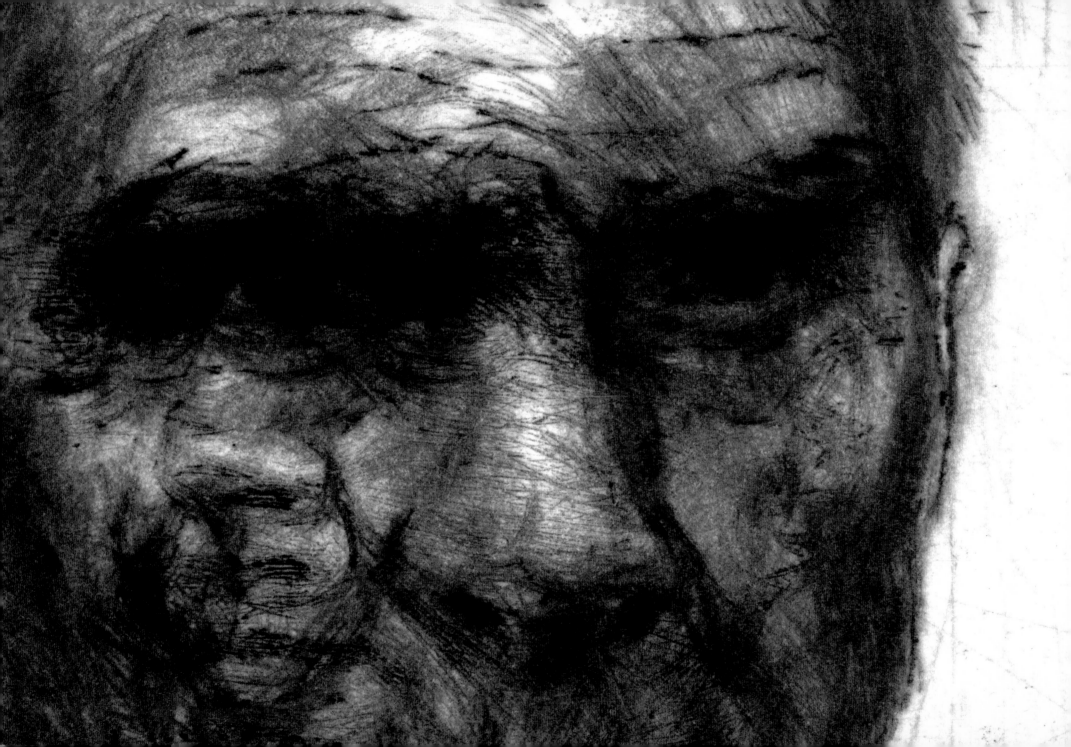

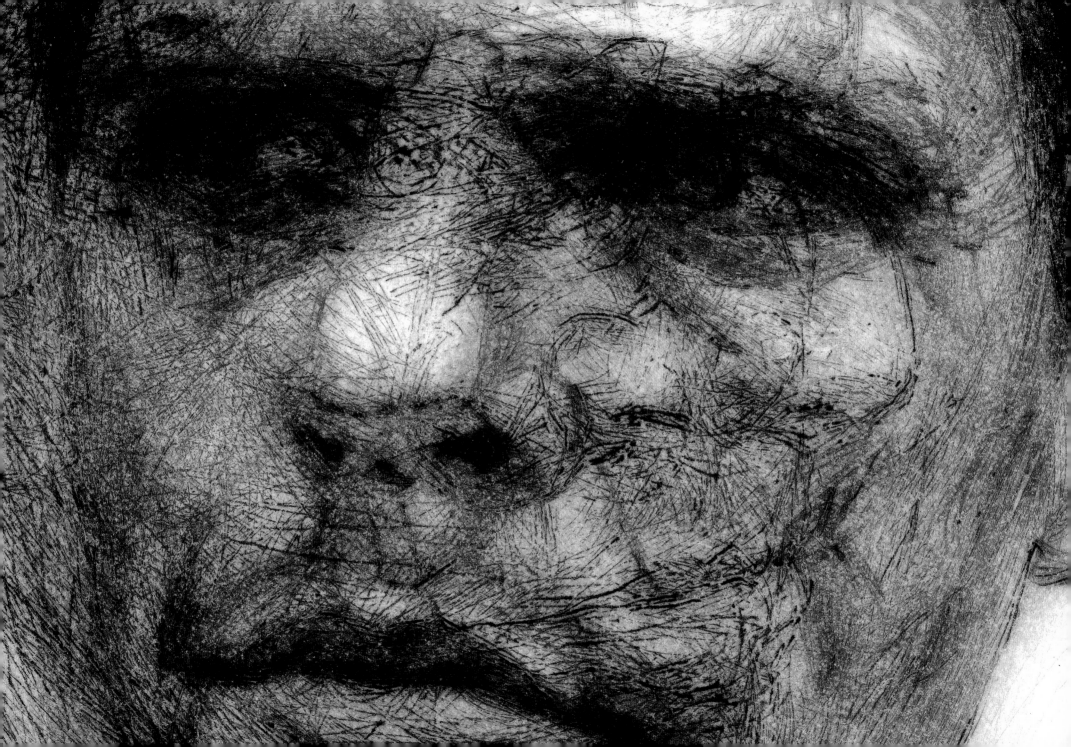

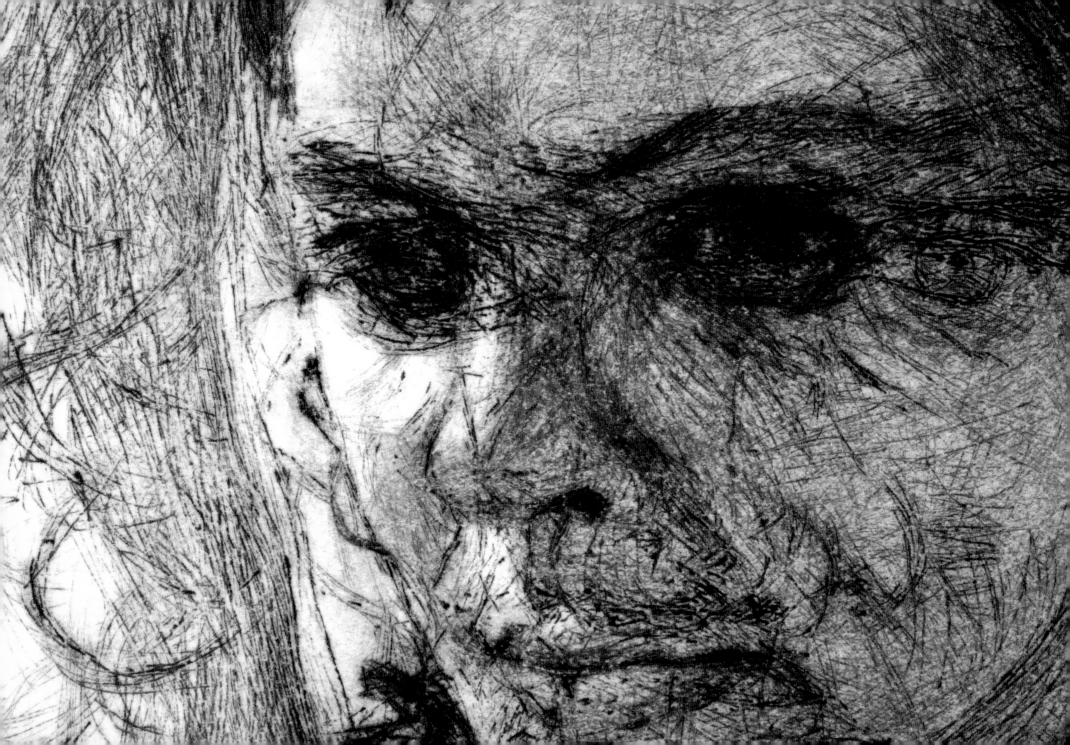

MULTITUDE

The hole in the ground has been
dropped so deep it resembles a lift-shaft.
Its sides are sheer, but stepped and
striated with the accumulated layers of
history; petrified remnants of previous
eras, cast off and superseded like
sloughed-off skins. As the spotlight
makes its ascent through the darkness,
it pauses at each separate level: a ghostly
timeline that resembles a filmstrip, in a
projection that has momentarily ceased
to turn. A brief hiatus in the ongoing
story of the city, the sudden absence of
the illusion of motion forces you to look
more closely at all the different parts
that make up the whole — individual
details, lined up one against the other,
that the eye would not normally be able
to comprehend.

One mile out from London Bridge, that
murky threshold in Eliot's Unreal City,
where the silent throng swarms over the
river (and where the poet cannot believe
that 'death has undone so many'), people
rush by, on their way from work, to
wherever they are going, with whatever
dreams are in their heads.

One mile out from the site of the D---
Coffee-House, where the narrator
of Poe's *The Man of the Crowd* is so
enthralled by the endless parade
of faces that he pursues a mysterious
stranger through the darkening streets,
people swerve to avoid each other,
almost oblivious, their eyes staring
straight ahead.

One mile out from the vantage-point
near the Monument where Wordsworth,
in *The Prelude*, observes the 'endless
stream of men and moving things',
a photographer is out taking pictures,
his face half-hidden behind his lens.

Too many people have been this
way before.

The woman with the tousled hair,
waiting anxiously for the arrival of
a loved one, is standing where the
flower girl once stood.

The man with the haunted expression,
waiting for a taxi to the airport, paces
the very same spot where two lovers
would arrange to meet.

The man with the bleary-eyed look,
waiting for news from the hospital,
has traded places with someone old
enough to be his father.

The city hums with connections: some
of them already happened; some of them
still to be made. I draw the lines in pen
on a map: a cat's cradle of traces and
places and faces.

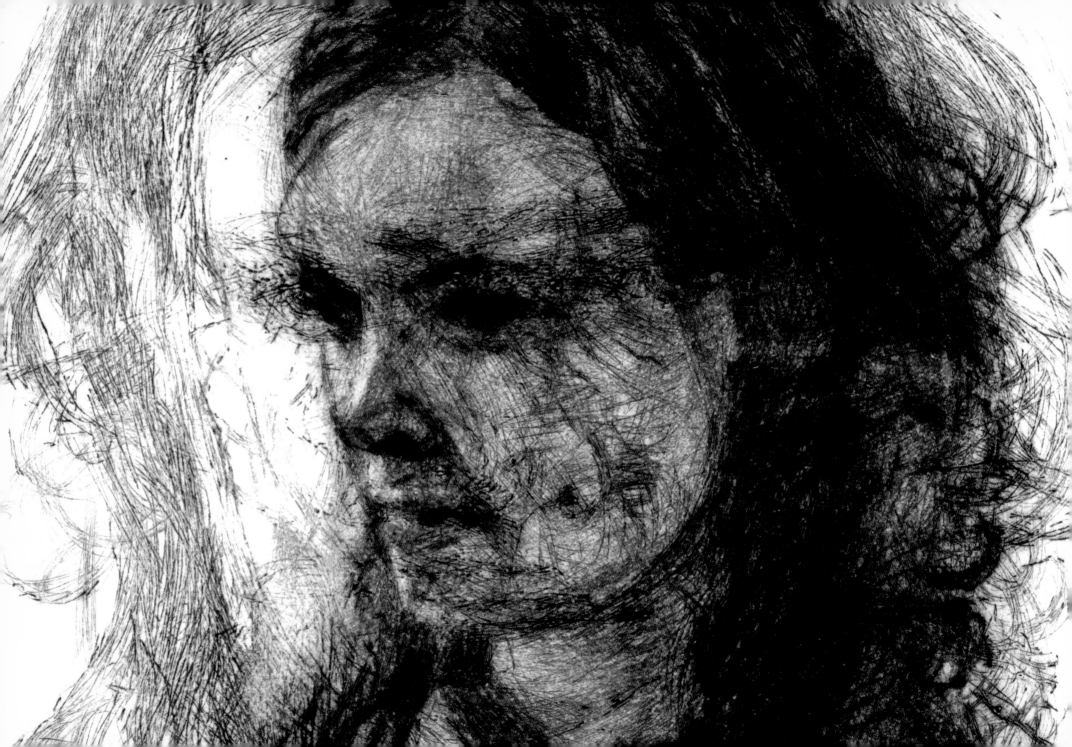

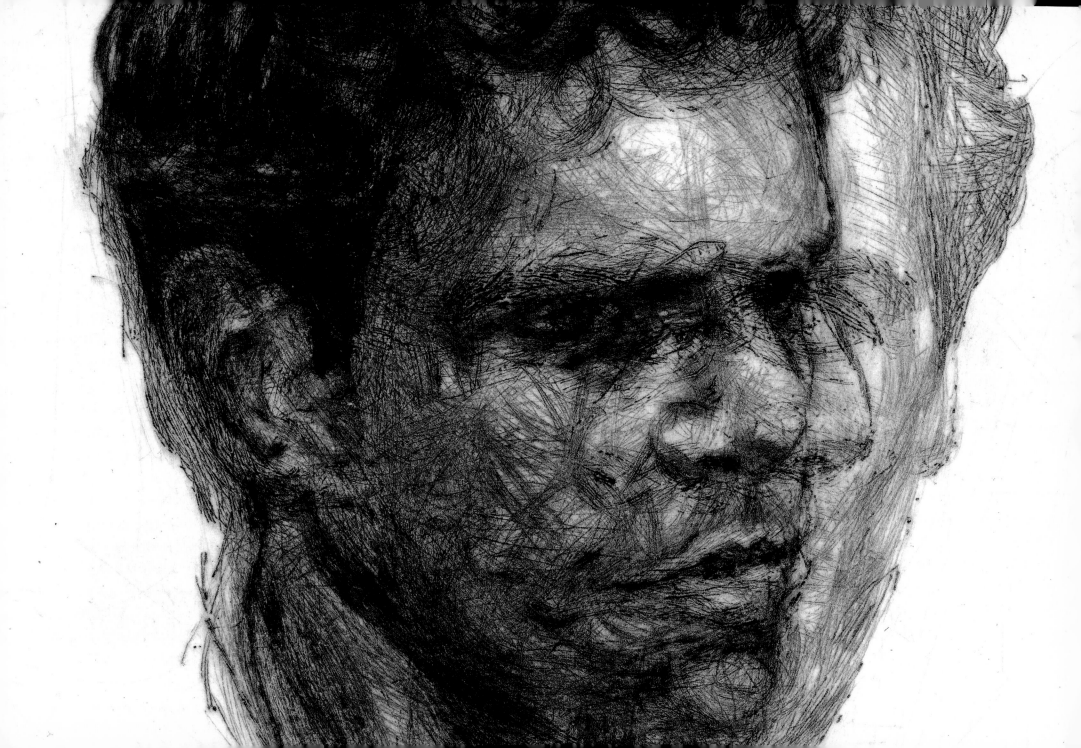

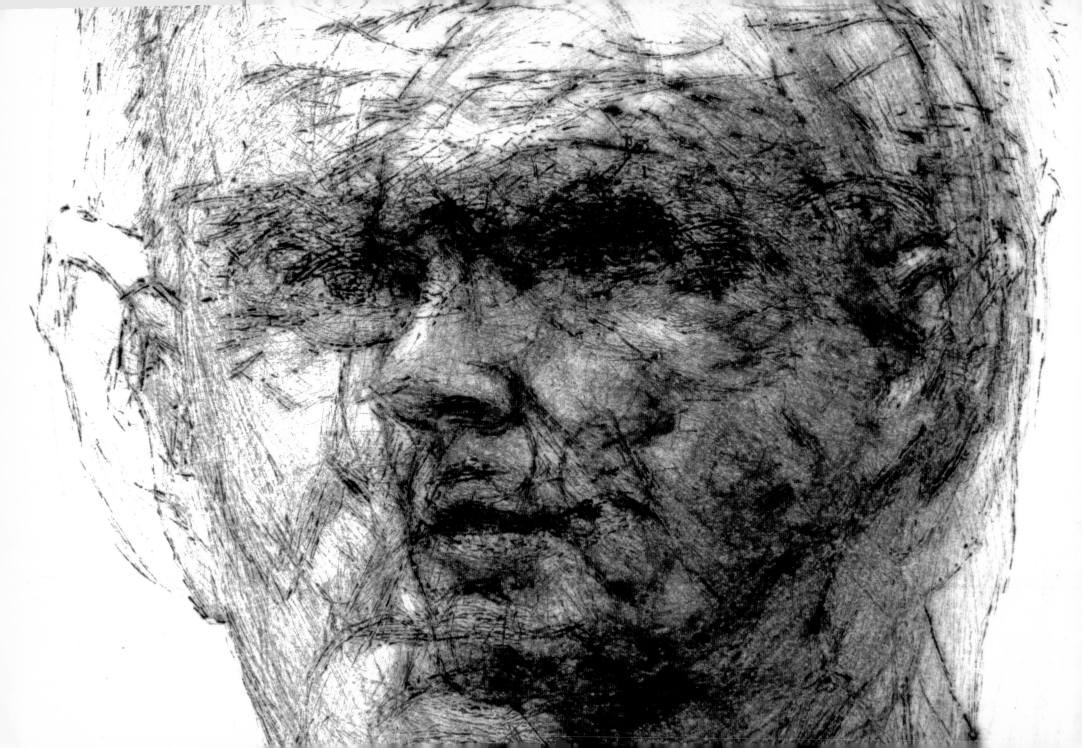

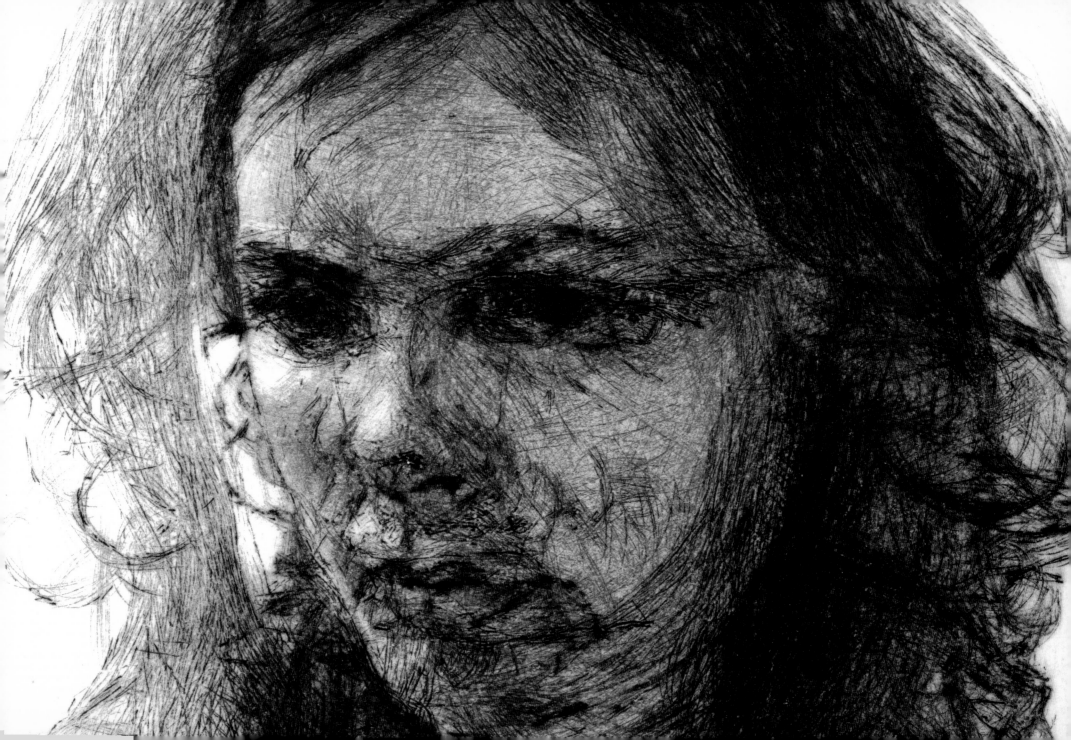

DRYDEN GOODWIN CAST

With essays by STEVEN BODE | CAMILLA BROWN | DAVID CHANDLER

PHOTOWORKS | STEIDL

FOREWORD AND ACKNOWLEDGEMENTS

Over the last ten years Dryden Goodwin's art has been defined by an increasingly rich dialogue between drawing, photography and film. In this work he has consistently focused on the human figure and the portrait form, the resulting work offering a speculative vision that considers the process of looking and representing, both in relation to what is experienced and what is seen. That this speculation is always fluid, that no one act of representation, no one point of description, can ever be finally resolved in time, is also the idea which drives the shifting relationships between different media and the layered nature of Goodwin's work.

Often grounded in an experience of the city, Goodwin wrestles with the continually changing nature of our contact with the people around us, both the well known – family and friends – and the anonymous, the strangers we pass on the street. His work marks an intense curiosity, a desire to know, and yet it is always alive with ambiguities about what the act of making work might reveal or obscure. Similarly, his work suggests the tensions of a society where fear, suspicion and the ever-present technologies of surveillance increasingly infect the atmosphere of public space. And yet Goodwin's work might also be understood as optimistic, aspiring to forms of empathy and connectedness.

This book, *Cast*, extends these enquiries and their various collisions between drawing and photography. It includes new series of works such as *Caul*, *Shapeshifter* and *Casting* along with *Cradle*, developed from earlier works based on strangers photographed on the street at night, and his previous works *State* and *Flight*. The book also takes further Goodwin's practice of drawing and scratching onto the surface of the image, something at once intimate and invasive, a physical intervention that the artist also characterizes as a way of 'thinking into the photograph' and into the stalled nature of photographic time. In doing so the book is a conscious attempt to draw out the importance and specific material qualities of the various processes around which Goodwin's work is so delicately fashioned and through which it gains such sustenance.

This publication has been conceived as an artist's book, an object lovingly crafted like Dryden Goodwin's work itself. And in this, of course, the artist's guiding hand has been paramount. But the book also functions as a monograph, something that summarizes and gets to the heart of Goodwin's hybrid practice, and this breadth has been achieved with the support, advice and committed work of many people and various organizations.

The book has emerged from a project initiated by Photoworks as an artist's commission, which, after a circuitous route, found a home and vital partner at The Photographers' Gallery, London. From this point on the project became a co-commission and it has benefitted immensely from the sensitivity, expert guidance and substantial resources that the Gallery has been able to bring to bear. In particular I am grateful to Brett Rogers, the Gallery's Director, who has shown such confidence in Dryden Goodwin's work over the years and who has been a great champion of the entire project. Camilla Brown, Senior Curator, has led the project at the Gallery and I'm greatly indebted to her for her keen insight and organizational abilities and for her excellent essay in this book. I am also very grateful for Camilla's irrepressible enthusiasm throughout. While Camilla was on maternity leave, Clare Grafik, was also a vital and supportive colleague who helped sustain the project during an important phase in its development. I'd also like to thank all the other members of The Photographers' Gallery team who have helped during the production including: Sam Trenerry, Jo Healy, Sioban Ketelaar, Jason Welling and Tim Mitchell.

Fundamental to the character of the book is Steven Bode's writing. It is particularly pleasing for an editor when a commissioned text not only matches expectations but also exceeds them. Steven's beautiful essay and written fragments have given the book its structure and have helped build its atmosphere, as well as providing such an eloquent commentary on Dryden's work; my sincere thanks to Steven for his invaluable contribution. Thanks also to Dean Pavitt who, once again for Photoworks, has designed this book with such sensitivity and assurance; to Ruth Charity who, in her former role at Artpoint, was an enthusiastic colleague helping the project through its earliest incarnation; to Richard Rowland who played a vital role in the re-photographing of Dryden's works for the book; to David Hubbard of the Stephen Friedman Gallery; and to our funders for this project, the Esmée Fairbairn Foundation and, more generally Arts Council England – South East, for their continued support. My gratitude and thanks go once again to all my colleagues at Steidl, especially Michael Mack and Gerhard Steidl, and to all my colleagues at Photoworks, Laura Thomas, Rebecca Drew, Gordon MacDonald, Jane Noble, Helen Wade, and Ben Burbridge. And lastly I am indebted to Dryden Goodwin, for his attention to detail, persistence, enthusiasm, and for getting his head down and doing the work over two very busy years. He has been an inspiration and a delight to work with. Thank you Dryden for all this and for the many laughs along the way.

David Chandler
Director, Photoworks

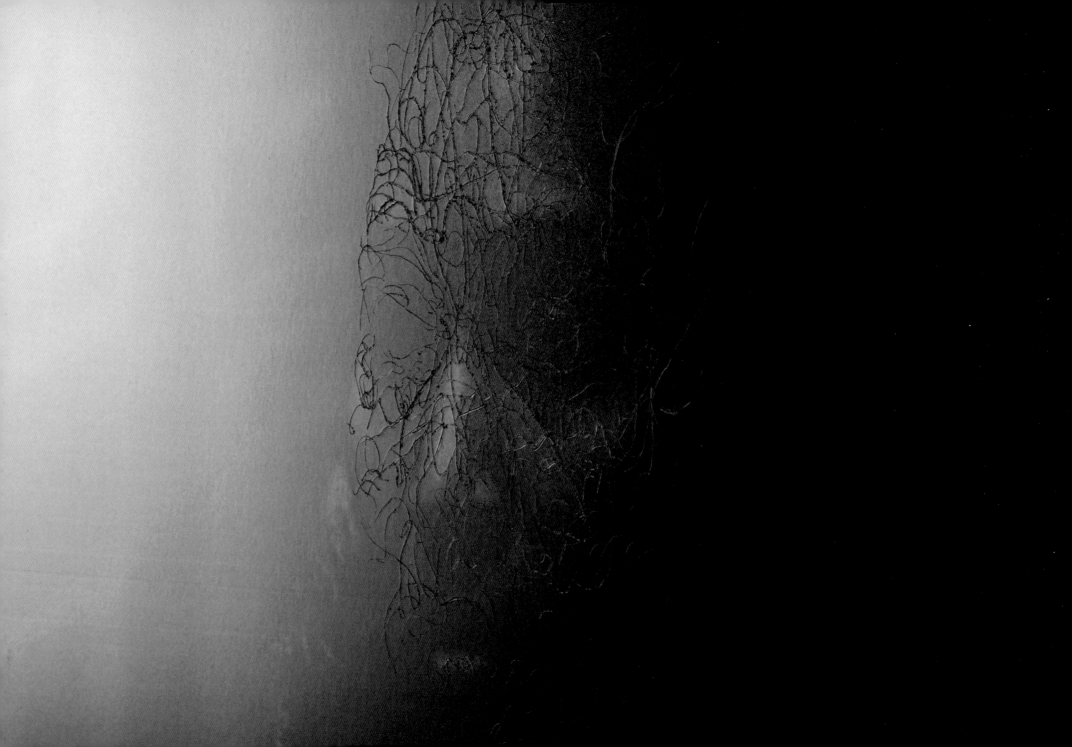

TOUCHING DISTANCE

In the opening pages of *Camera Lucida*, his haunting, valedictory essay on the enduring, sometimes discomfiting power of the photographic image, Roland Barthes makes the intriguing claim that it is not the eye but the finger that is the so-called 'organ of photography'. Barthes never says it directly (falling under the sway of his elliptical style is one of the pleasures of his writing), but the implication is clear: the eye — all-consuming, all-desiring — would, if left to its own devices, never come to rest without the presence of the finger on the shutter to capture the decisive moment. Barthes has already made us sit up and take notice by introducing his famous notion of the 'punctum' a few paragraphs before. The punctum (to paraphrase once again) is the element of the photograph that not only touches but 'wounds' or 'pierces'; a disconcerting 'off-centre detail' that leaps from the image 'like an arrow' and 'pricks' our attention at an instinctive, emotional level. Not all photographs, it goes without saying, have this arresting, highly personal address: one that seems to appeal directly to the unconscious, while equally forcefully invoking the reality of life outside the frame. Whenever an image touches us in this way, however, it moves us all the more deeply as a result.

Barthes' foregrounding of the revelatory flash of the punctum brings an emotional charge and an elegiac gravitas to the study of photography. Written shortly after the death of his mother, the book transfers some of the pain of her loss onto a series of little deaths that lurk behind the face of each and every photograph. Amidst this profusion of painful memories, Barthes' reflection on time and mortality is literally punctuated with a succession of pauses and stops — sensory, and equally sense-making jolts that transcend the exclusively visual realm of what Barthes calls the 'studium', and hit home with a poignant, almost chastening physicality. In its heightened, visceral connection, the punctum is also a powerful assertion of the tactile dimension of photography, at least in its more ethereal, pre-digital form. While many of the images Barthes revisits in *Camera Lucida* are highly personal, others are more obviously, and iconically, historical, including some of the first photographs ever made. Barthes is at his most evocative when he speculates on how strange and unnerving these early images must have been. Ghostly facsimiles of people and places, they seem incredibly distant to us now. But the distance of time should not blind us to just how uncanny they must also have looked at the moment when they first appeared.

This focus on the past sheds light also on photography's early affinities with drawing. Many of the founding fathers of the medium persisted with their tentative, haphazard experiments as an attempt to go beyond what they saw as the inherent frustrations and limitations of hand-drawn illustration. Henry Fox Talbot, in particular, was acutely conscious of the obvious deficiencies of his anatomical sketches and studies of objects, and turned to the optical devices of the camera obscura and the camera lucida, initially at least, in the hope that they would expedite and refine the drawing process. Even after he had hit upon the technique of fixing this play of shadows onto paper via the action of silver nitrate, the slow materialisation of these

evanescent marks within the form of a photographic negative must have struck him not just as an analogue for drawing or etching but as the culmination of an organic, almost alchemical transmutation. (Fox Talbot called his first collection of photographs, or 'photogenic drawings', *The Pencil of Nature*). In the more than a century and a half that has passed, as photography has established itself as a discrete and expansive form, the linkage between these two sets of practice has become blurred. But, if you look more closely, points of kinship continue to exert their influence into the present day.

In the work of the British artist Dryden Goodwin, these different strands of activity are both highlighted and interlaced. As deft with the hand as he is quick with the eye, Goodwin has accumulated a multi-faceted body of work in which both hand-drawn and lens-based pieces appear in a remarkable number of iterations and combinations. Encompassing film, video and digital technology (as well as photography), Goodwin's exceptionally fluent and wide-ranging exploration of new forms of image-making has not displaced drawing from a central position in his artistic repertoire but, rather, seems only to have encouraged new outlets for

its expression. Indeed, these two sides of Goodwin's practice continually inform and infuse each other: the lens-based works disarmingly resonant, almost haptic; the drawings brimming with intimations of movement; edgy, skittery, as if poised to take wing. Although concentrated mostly on wall-based, two-dimensional works, four interconnected pieces — *Caul*, *Cradle*, *Shapeshifter* and *Casting* (2008) — demonstrate this interplay particularly vividly.

As a backdrop to this body of work, two earlier pieces adumbrate the relationship between photography, video and drawing in a way that is especially emblematic. The first of these, appropriately titled *Reveal* (2003), is an extensive showcase for Goodwin's talents as a draughtsman that equally skilfully mobilises the medium of video to better illuminate the act of drawing itself. A single-channel film that is also an expanded installation, *Reveal*, in its larger manifestation, unveils and unravels over six hours of footage that documents the production of thirty or so hand-drawn portraits — material that not only records the various stages of the artistic process, but also Goodwin's initial approach to his eventual sitter, as well as the conversation between them as the drawing is made. Here, video

functions as a kind of accomplice, an additional helping hand. Like a faithful, unwavering amanuensis, the video camera endeavours to catalogue those aspects of a person — voice, movement etc — that even Goodwin's expert pen could not be expected to capture. Not that Goodwin shirks the attempt. From the very first line that he casts in pursuit of his elusive subject, to every subsequent flexing of his pen, he is as assiduous and meticulous as he can be in search of the fullest and most accurate representation. Staged at Lacock Abbey in Wiltshire as part of a series of events in commemoration of Fox Talbot's life and work, *Reveal* explicitly alludes to early optical aids such as the camera lucida, with its trick of overlaying a reflection of the sitter on a sheet of paper. The piece's installation configuration, in which video mirrors drawing mirrors video, offers a similar kind of palimpsest.

If *Reveal* draws its subjects into the light, *Closer* (2002) gravitates towards the darkness. In the same way that the camera obscura relies on a pinhole flicker of illumination to work its transformative magic, *Closer* employs a miniature laser pen to cast its beguiling, ambivalent spell. *Closer* actually opens with this small red point of light flaring,

stigmata-like, in the palm of the artist's hand, before suddenly departing for the nocturnal demi-monde of London. Capriciously, almost drunkenly, as if heated and engorged, it hovers like a slightly sinister firefly above the crowded streets, its movements seamlessly coordinated with the video camera Goodwin carries in his other hand. Here, the pen reflexively follows the desultory passage of the eye, as *it* alights upon the faces of random strangers. On the late-shift at the office, or sitting absent-mindedly at the windows of restaurants and bars, the anonymous night-hawks that Goodwin latches onto with his camera seem utterly unaware of his attentions, or indeed of the presence of the light-beam that restlessly circles around their heads. Both tremulous and playful, the ray of light reaches out towards them: a prosthetic extension of the camera that sentimentally approximates to the human urge to touch; a gesture of fellow feeling that is not only intimate, but strangely innocent in its appeal. The longer it lingers, however, and the closer it gets to its target, the more it appears to overstep an invisible mark; no longer quite so straightforward or well-intentioned, but increasingly voyeuristic and invasive. Goodwin's gaze is never as dark and as troubling as that

of the hero of Michael Powell's *Peeping Tom*, who famously attached a murderous spike to the end of his camera, but the perceptual and psychological tensions he draws to the surface are equally provocative and unsettling.

Of the four new pieces that make up Goodwin's latest body of work, *Caul* is the closest to *Closer*. In many ways, it is a literal follow-up, in that it catches up with a different set of night-birds on their bus journey home. Shot from out of the shadows and up into the light, whose sodium glare stands out all the more starkly against the encroaching stygian darkness, *Caul* condenses the video's gradual slow-burning exposure into a series of taut still frames, compacting *Closer*'s craning forward momentum and ominous crosshair focus into the form of a photographic diptych in which one image is a more extreme close-up of the other. Seen through glass as spotted and smeared as a petri dish, it distils a similar mood of watchful surveillance, and leaves you once again with the vague but profoundly melancholy sensation of being on the outside looking in.

As if emboldened by the experiment of *Closer*, working in the wake of its

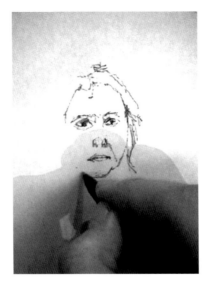
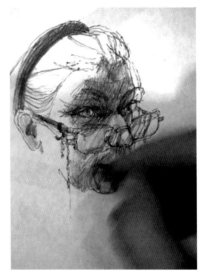
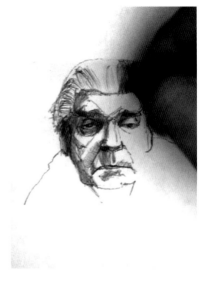
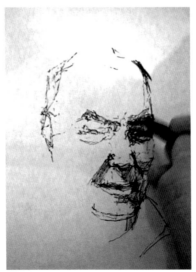
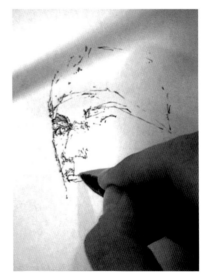
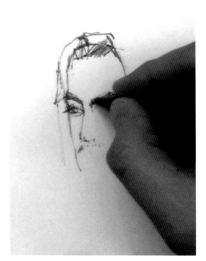

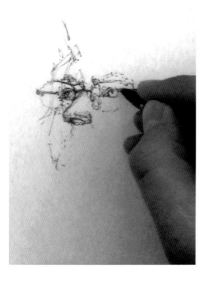

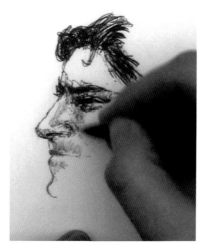

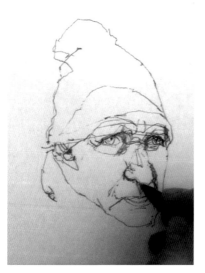

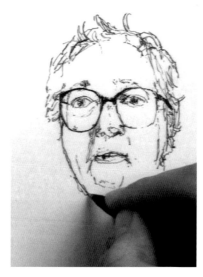

Reveal (installation) 2003
36 drawings with video and soundtrack,
6 hours 32 minutes
DVD, Biro on paper

preliminary pinprick of light, Goodwin makes cat's-claw forays around his drowsy subjects; orbiting, probing, feeling his way across the contours of each face. These are actions, of course, of which the individual is not conscious: the thin red lines that mark the traces of this intimate contact have been superimposed afterwards on a computer. Performed with a digital pen and graphics tablet, the way an anatomist might work on a slab, Goodwin's ministrations take on a mortuary aspect; the colour and shape of each outline alluding not only to the skull beneath the skin, but the blood that courses around it. Although the marks he leaves are always roughly the same, the way they register is ambiguous. At times, it is as if we get to see a glimmer of a person's aura: a ghostly exoskeleton formed out of a glowing circuit of filaments. (The young man in the short-sleeved shirt gripping the top of the seat in front of him in barely-concealed frustration is certainly made to seem even more wired). At others, it is as if we are able to witness (via the extra-sensory medium of a medical imaging scan) a cluster of hitherto unnoticed symptoms — signs of a latent pathology, perhaps, or, more simply, a deep-seated weariness; harbingers of mortality creeping over the face like the spread of broken capillaries.

Drained by another long day at work, and by the grind of slow-moving traffic, people seem shadows of themselves, but also desperately, ineluctably human; veiled behind worry lines, and a surface crackle of nervous tension, that the hand of a lover or a shot of botulinum toxin will never fully erase.

A caul, of course, is the name we give to that piece of red, filmy membrane (actually part of the amniotic sac) that, in very rare instances, covers a baby's head at birth. Tasked with protecting the foetus from the waters of the womb, this aberrant hooding of the infant's face is frequently supposed to mark out the individual in later life. In some cultures, the presence of a caul has demonic associations; usually, though, it is a sign of good luck; that the recipient is safeguarded, even bestowed with special powers. (A superstition still holds that the caul should be preserved by being wrapped in paper to better retain its talismanic properties). Less of a hopeful augury, more of a baleful afterglow, Goodwin's identifying marks, signed across the countenance of each lonely traveller, as red as the livery of the bus that ferries them through their urban limbo, hint at a very different rite of passage. Rather than ushering them into

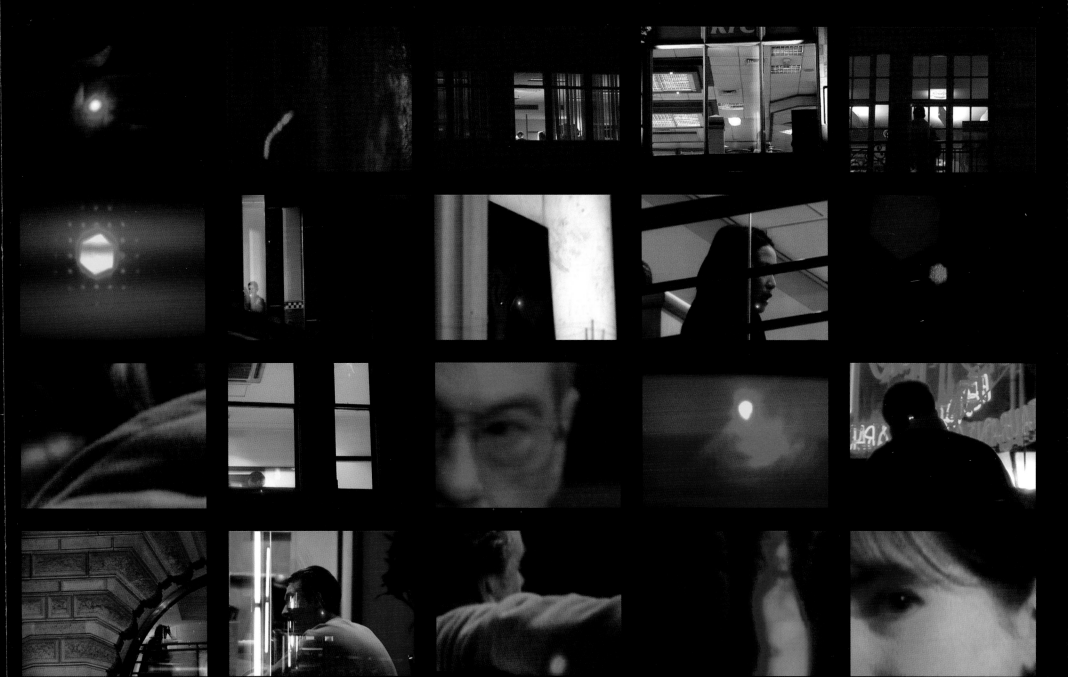

the world, Goodwin's summoning night-time caul seems almost to prefigure their departure: a touch of the hand that assuages their woes and cares; a final benediction that blesses them on their journey, as they cross the river, towards the place where they wait to sleep.

If *Caul* caresses, *Cradle* cocoons. Wrapped up in cotton wool, or the gossamer tracery of something more like cotton candy, the subjects of this ongoing photo-series seem suspended, stickily enmeshed, within the intricate webs that have been embroidered around them. These delicate dandelion threads are so fragile and slender that they appear to float above the surface of the image. On closer inspection, however, you can see that they are, in fact, cut into the emulsion: spidery scratches that insinuate themselves under the skin. As if in the grip of a spell, the people portrayed seem distracted, lost in a dream; their minds somewhere else entirely. A woman walks through a busy arcade in the shadow of Eros with her phone clamped tightly to her ear. A bearded man clutches a packet of cigarettes as he gazes plaintively into the middle-distance. Rendered in velvety black and white, even the familiar London locations (Haymarket, Soho, Regent

Street) seem altered somehow; transfigured into a place of reverie.

The elaborate veils that Goodwin etches around the faces he photographs may have all the makings of a signature motif but their meaning is not so easy to untangle. At first glance, they merely seem to belatedly retrace what the photograph has already effected, in its ability to isolate a moment, and artificially preserve it. Like a picture in a locket, embellished with a few strands of hair, each engraving turns an ephemeral memory into something more like a keepsake. As insidious and affectingly mechanical as a musical refrain, their presence helps to underscore whatever it was that touched him (or pierced him) in the first place, a frisson of connection that needs to cut deeper and deeper to recapture some of that initial sensation. As is true of much of Goodwin's work, that frisson is powerfully double-edged. Repetitive and strangely compulsive, the lines act as a nagging reminder that, within even the most tender and unconditional embrace, we all possess the worrying potential, even the unconscious temptation, to hurt the thing we love.

In *Casting*, Goodwin digs a little deeper. Shot no more than a stone's throw away

from where he sidled up to the people in *Cradle*, this series of photographs paired with drawings revolves around a number of wide-angled street-scenes. It is perhaps their proximity to the bright lights of cinema or theatre-land that gives them the look of location photos, or the pictures that a street-caster or talent scout might take, in the hope that the unknown face of a future star would suddenly step forward from the shadows. From each crowd of people, Goodwin homes in on one individual in particular: someone who is, for him, the unsung fulcrum of the scene. Usually, whoever is chosen looks quite ordinary, which makes the sudden attention seem even more out-of-the-ordinary. In contrast to *Cradle* or *Caul*, a face is never highlighted inside the frame — you only identify the person it belongs to from the multiple drawings Goodwin makes of them: notebook sketches whose routine banality and clockwork regularity turn the subject into something closer to a suspect.

If the photograph assumes the status of a crime scene, drawing becomes a kind of dusting for evidence. Forensic, procedural and slightly creepy in their obsessiveness, Goodwin's thumbnail sketches stack up like fingerprint swatches; proofs to be tested, one after the other,

in an effort to make something stick. The line of enquiry is always the same: persistent, monomaniacal, almost Kafkaesque in its build-up of material. Kafkaesque, also, in the way the author's protagonists are not only the focus of an unending investigation but often the agents of their own personal *excavation*, burrowing further into themselves, plumbing the depths of their own troubled psyche. The cross-infection of surveillance into an equally destructive spasm of self-examination (frequently pursued beyond the edge of madness) is memorably treated in cinema, most notably in Francis Ford Coppola's *The Conversation*, and, more recently, in Michael Haneke's *Hidden*, where a barrage of videos (and drawings) from an anonymous stalker precipitates a similarly violent existential implosion. Cinema, too, brings an extra nuance to the title of Goodwin's work itself, which could perhaps be imaginatively recast in the form of a nightmare screen test, in which an actor is forced to repeat a single take over and over, never quite knowing whether their efforts are increasingly convincing, or whether they will end up discarded on the cutting-room floor.

As if to escape this airless atmosphere, *Shapeshifter* sends Goodwin back out into

Previous page:
Closer 2002
Three screen video installation
with soundtrack
11 minutes 20 seconds
DVD

the open. Detouring away from the well-known haunts of tourist London, where graphic artists make their pitches in Leicester Square or Piccadilly Circus, Goodwin travels across the city by overground train, surreptitiously sketching people with whom he briefly shares a compartment. As they come and go from station to station, jostling for available space, forgoing the occasional vacant seat because of the shortness of their journey, Goodwin draws the faces of passengers he notices, until such point as they exit the carriage or he, too, comes to his stop. Compared to the studied observance and solicitous exchanges of *Reveal*, *Shapeshifter* seems hit-and-run, even hit-and-miss. Taking his cue from the stop-start rhythm of the train, he draws like he might take snapshots: rapidly, automatically. Both furtive and fugitive, part voyeur, part *flâneur*, Goodwin immerses himself in each temporary encounter, until a new face arises to catch his eye. Scrawled on little squares of paper the size of a ticket slip, the drawings seem equally throwaway: speculative thoughts, or passing fancies; casually entertained, and just as abruptly abandoned.

On their way to who knows where, only barely emerging from the crush of the crowd, Goodwin's agitated subjects leave fleeting, glancing impressions, like moths on flypaper. Hurriedly conjured but cruelly, pathetically unformed, these tiny drawings, when laid out in a row, have a doleful, accusatory quality, like the faraway faces of the unborn. The feeling is doubled in an accompanying animation which splices the drawings together in eerie procession. Like specimens in a bell jar, they float before your eye: after-images of people who briefly captured your attention but never quite stayed in the mind. Scraped from the retina, recovered from the cache of memory, they have come back to haunt you, with a force they could never quite muster before.

CAUL

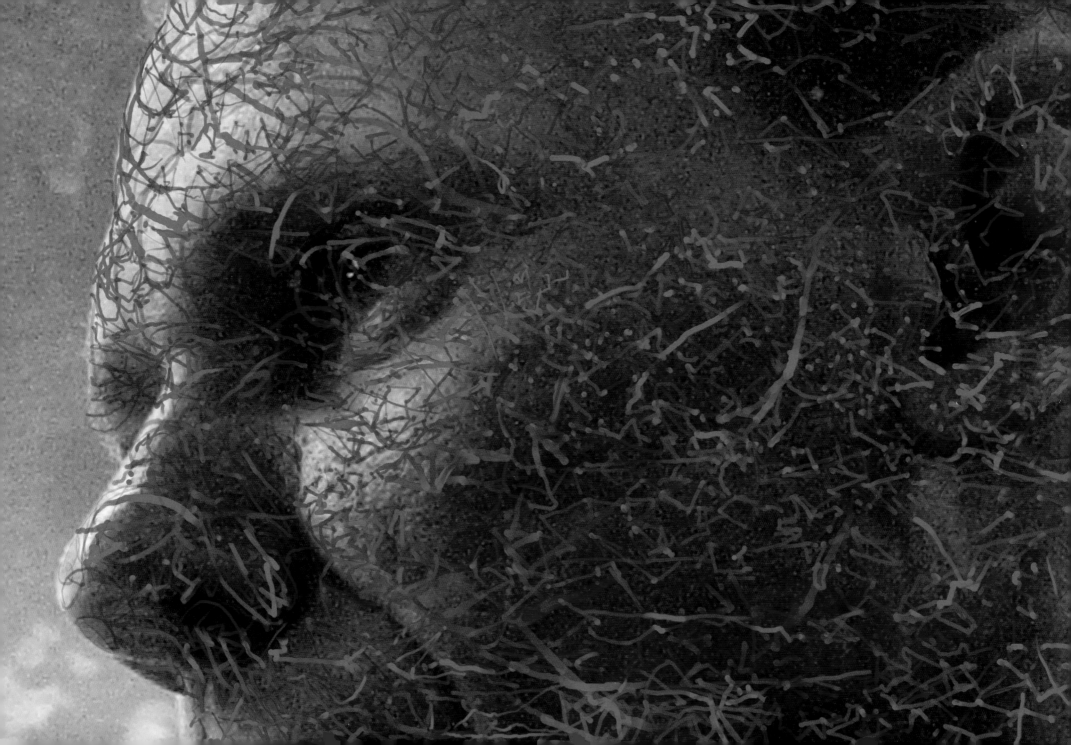

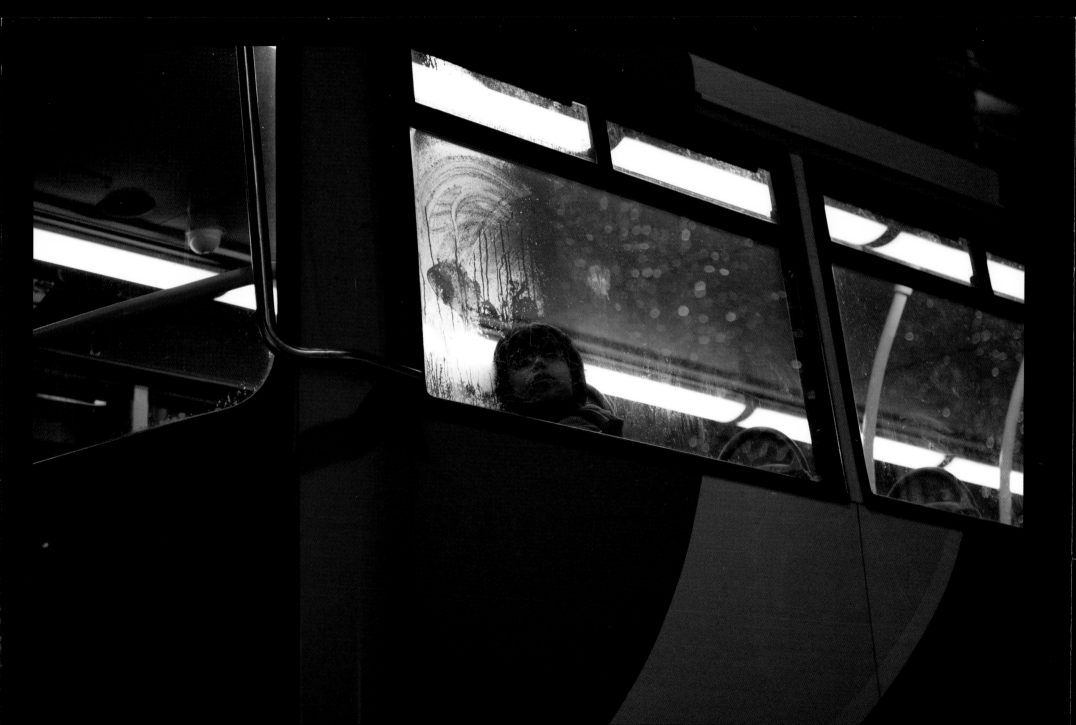

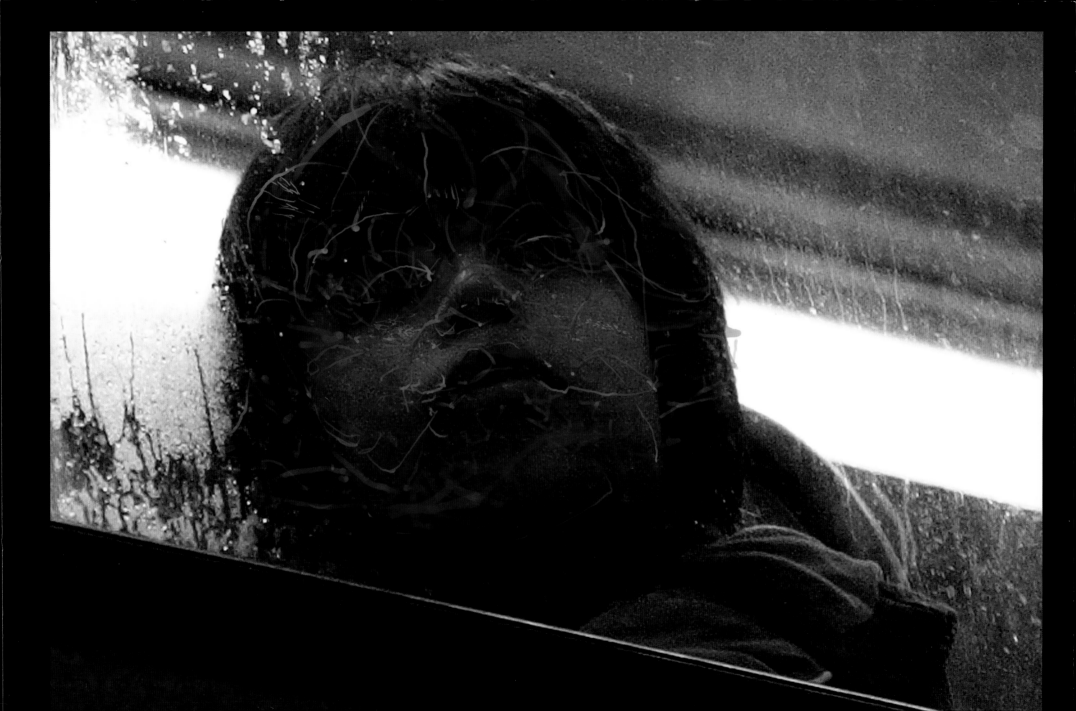

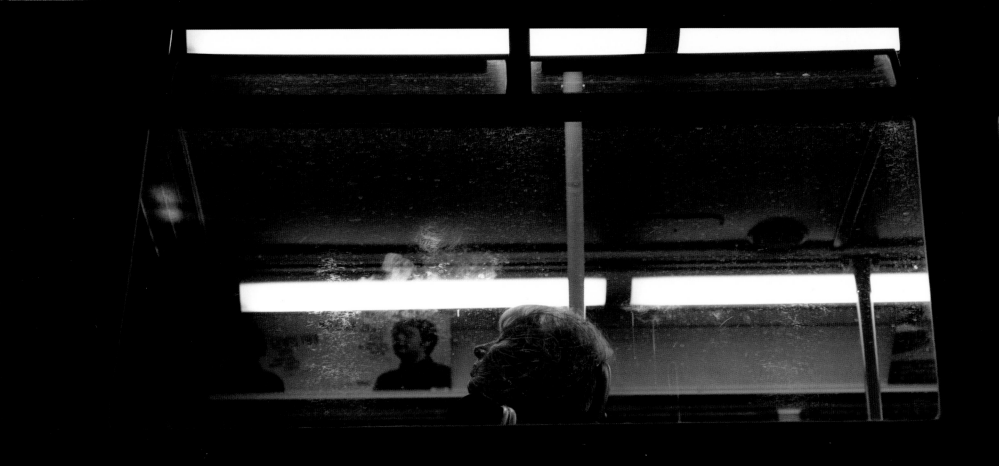

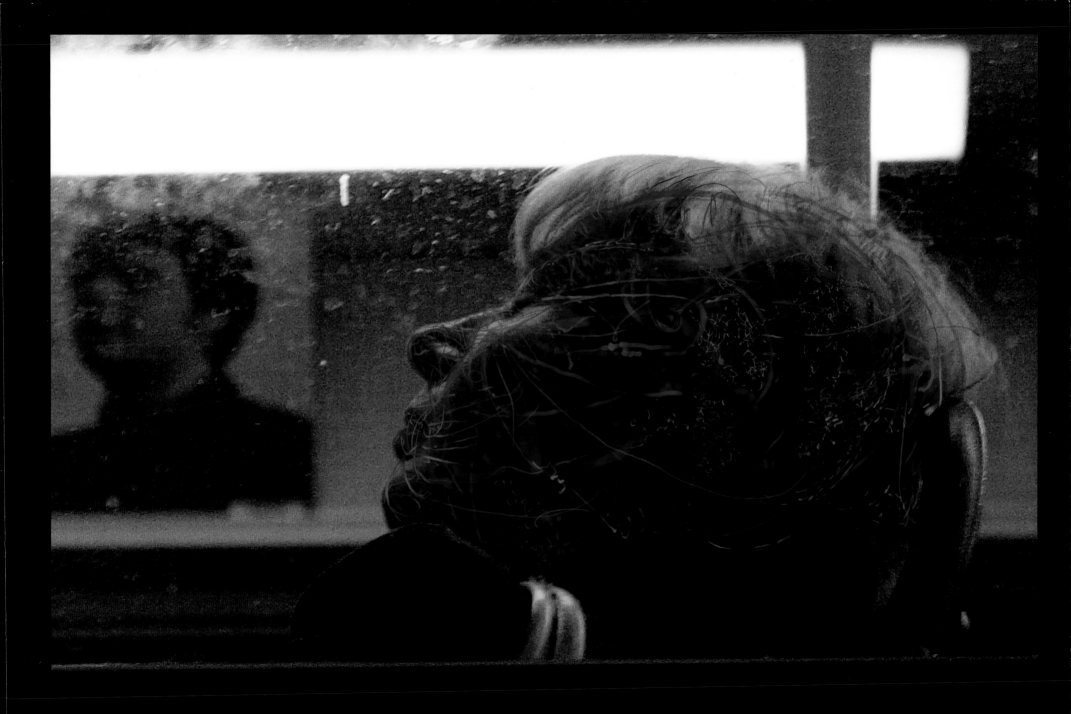

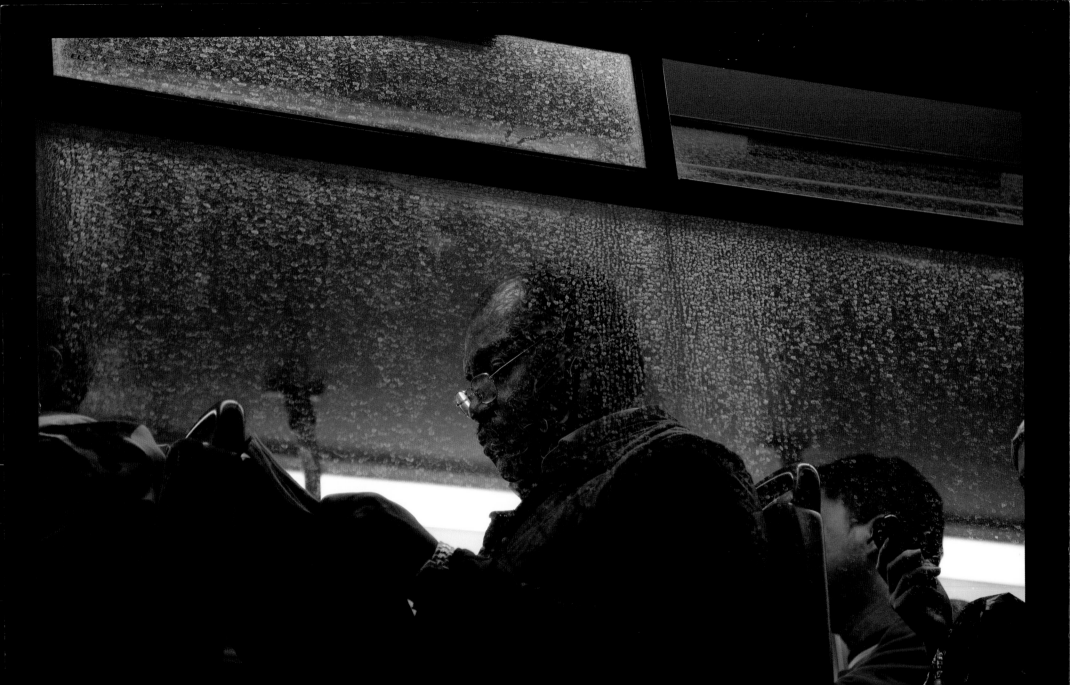

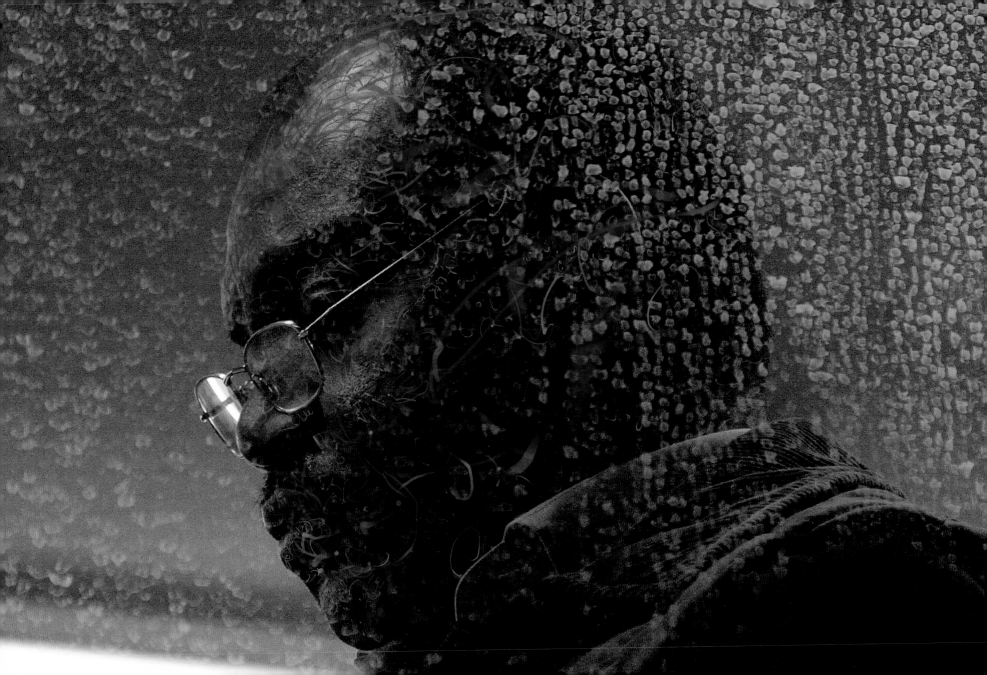

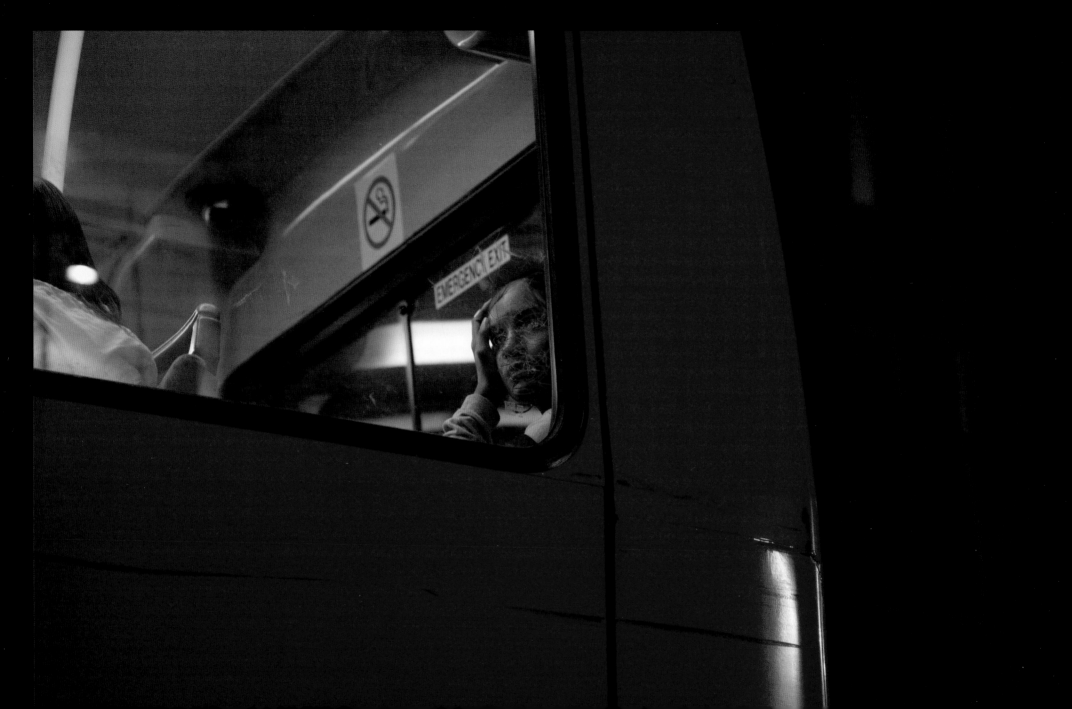

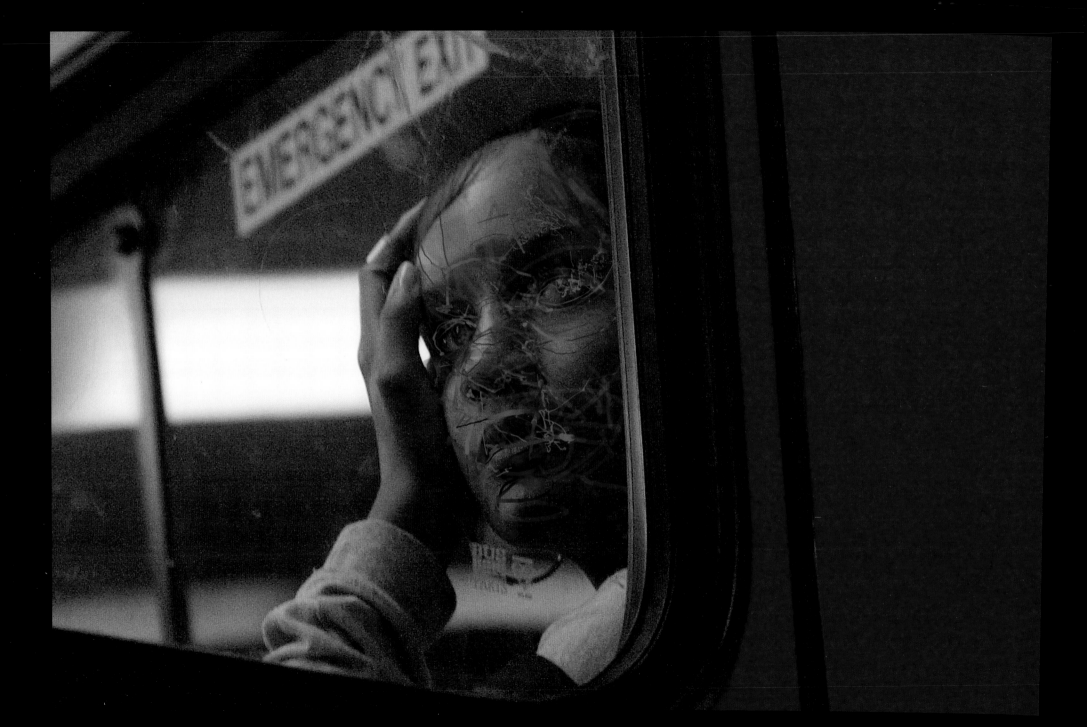

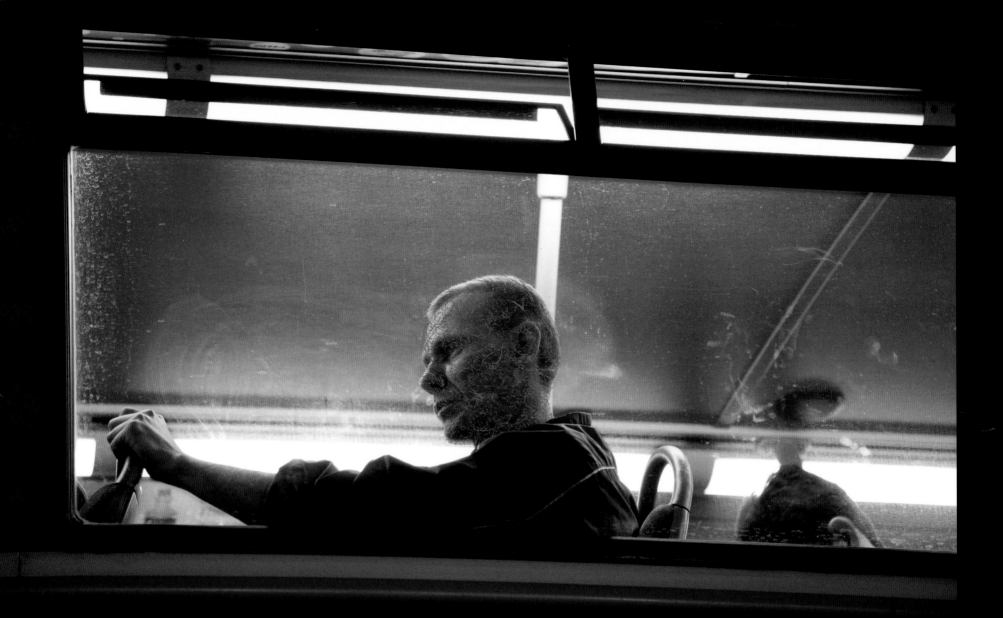

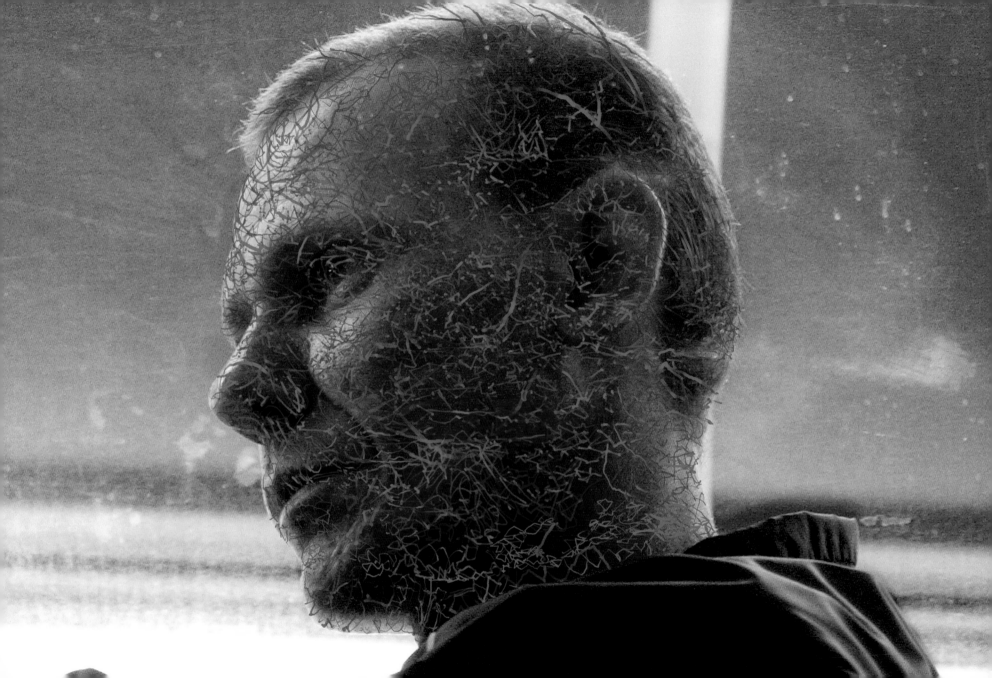

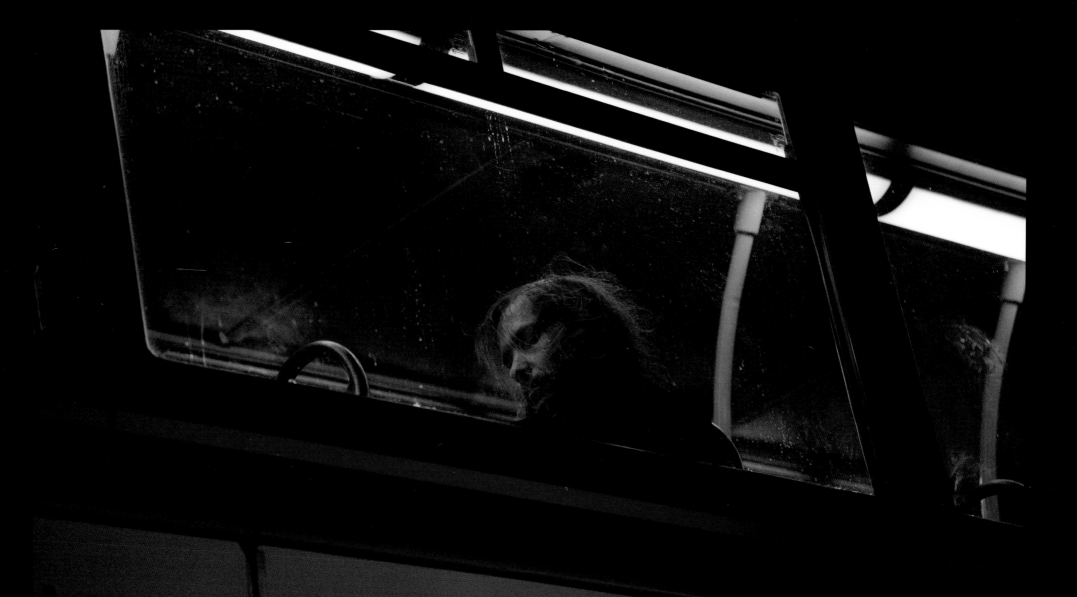

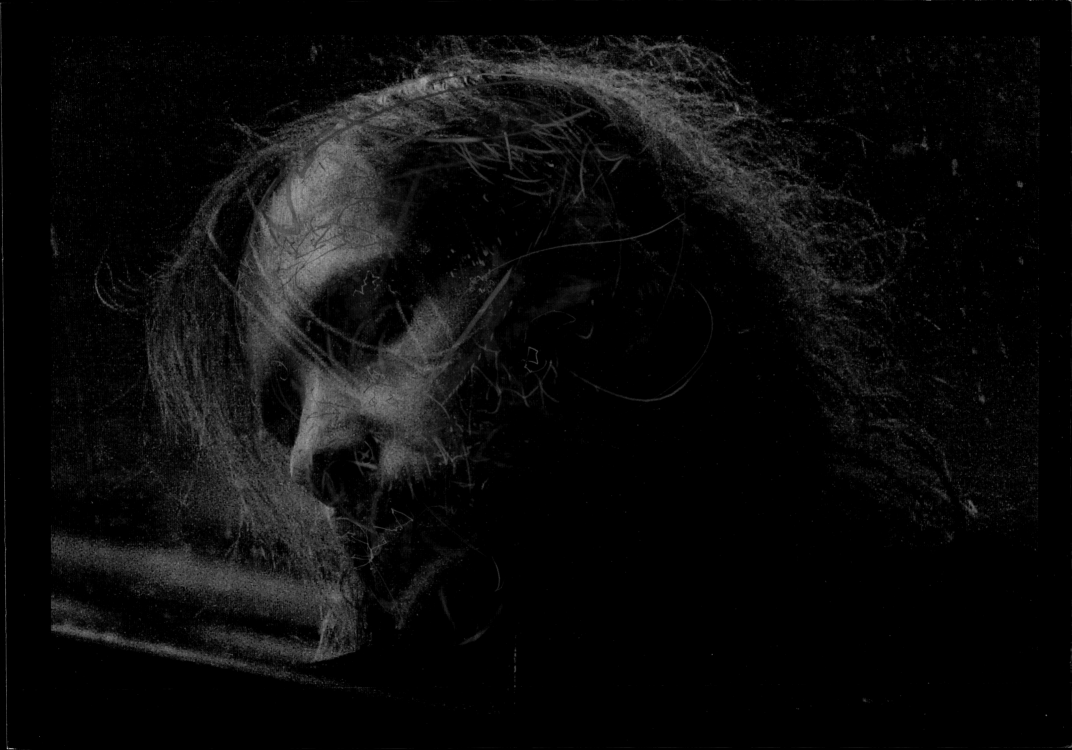

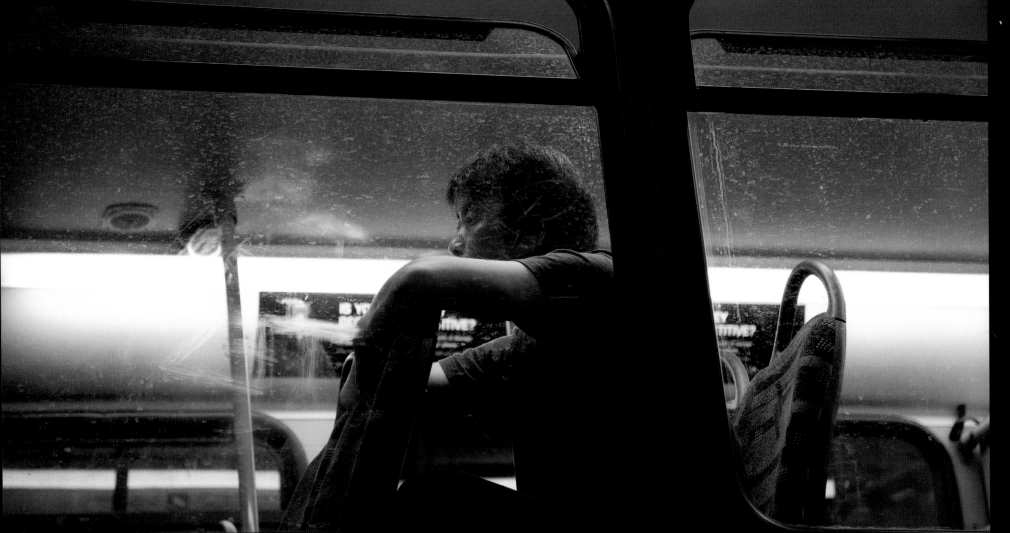

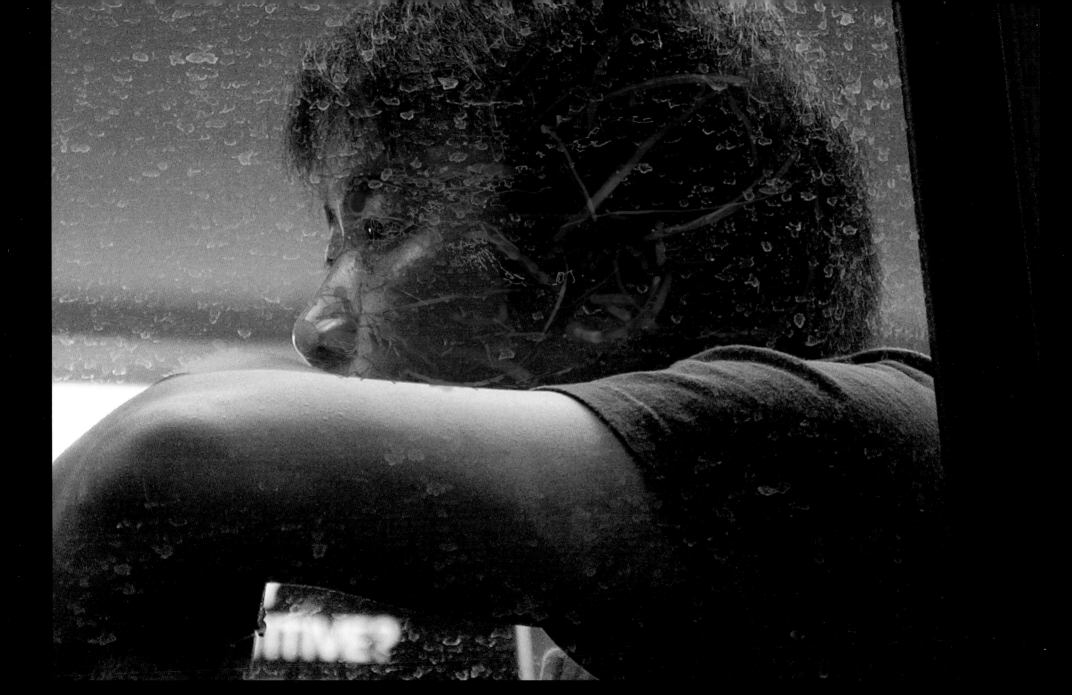

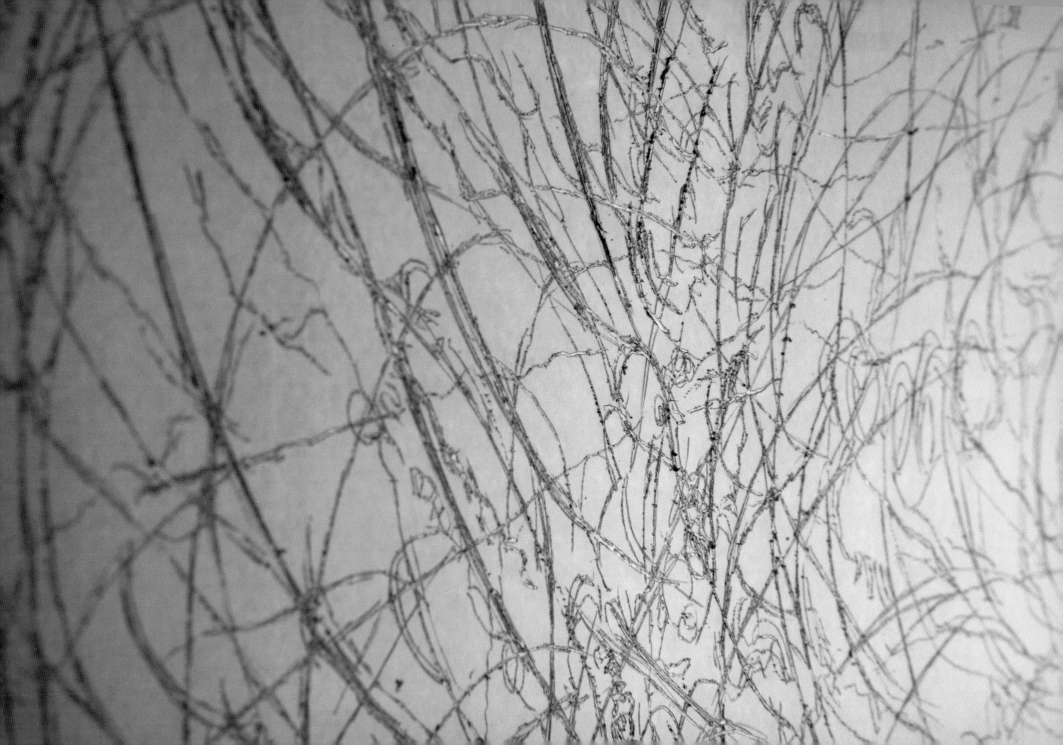

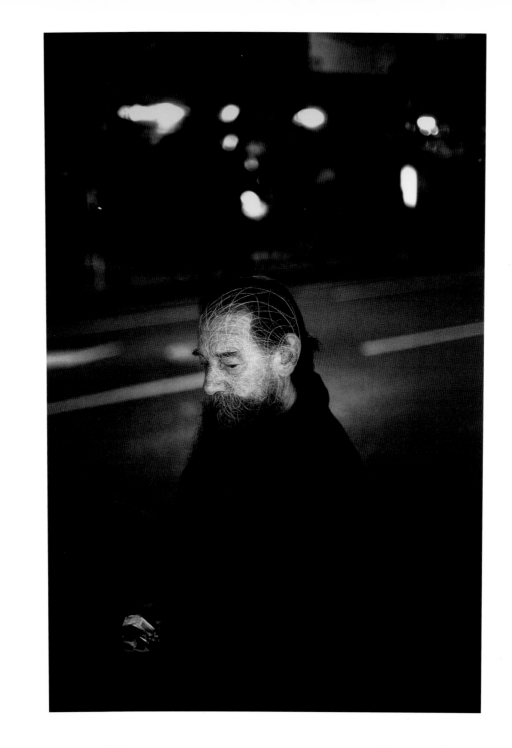

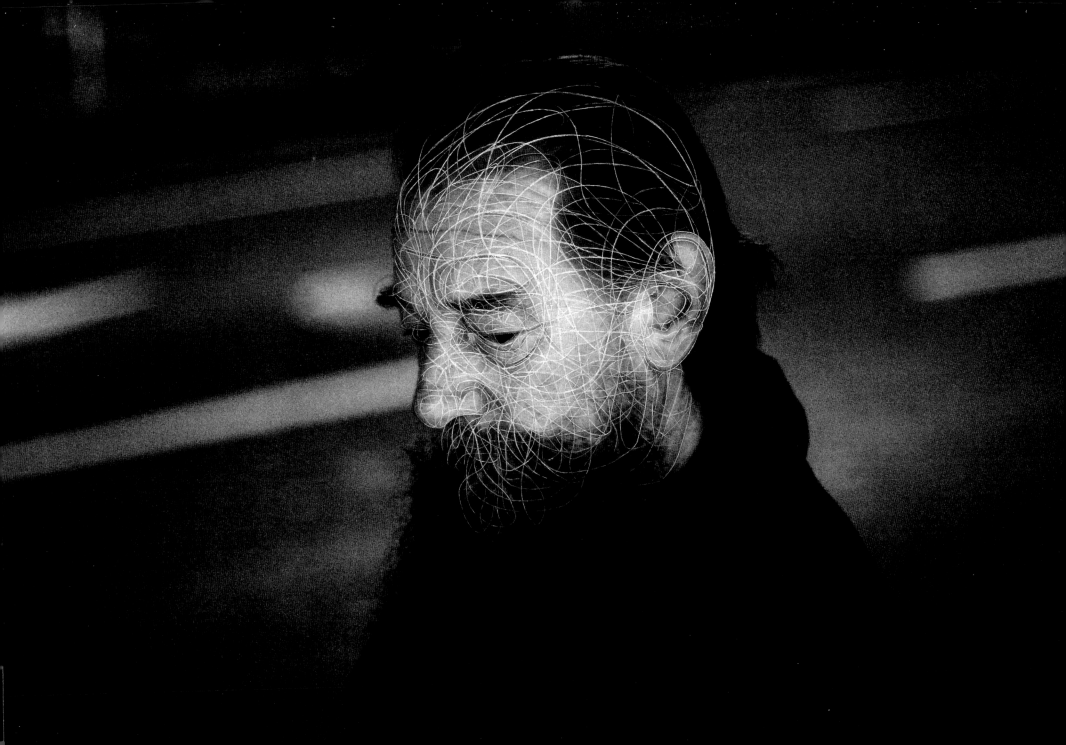

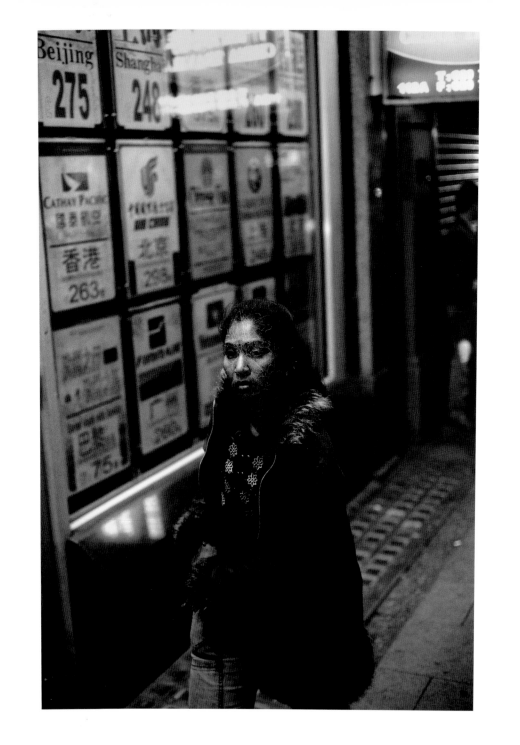

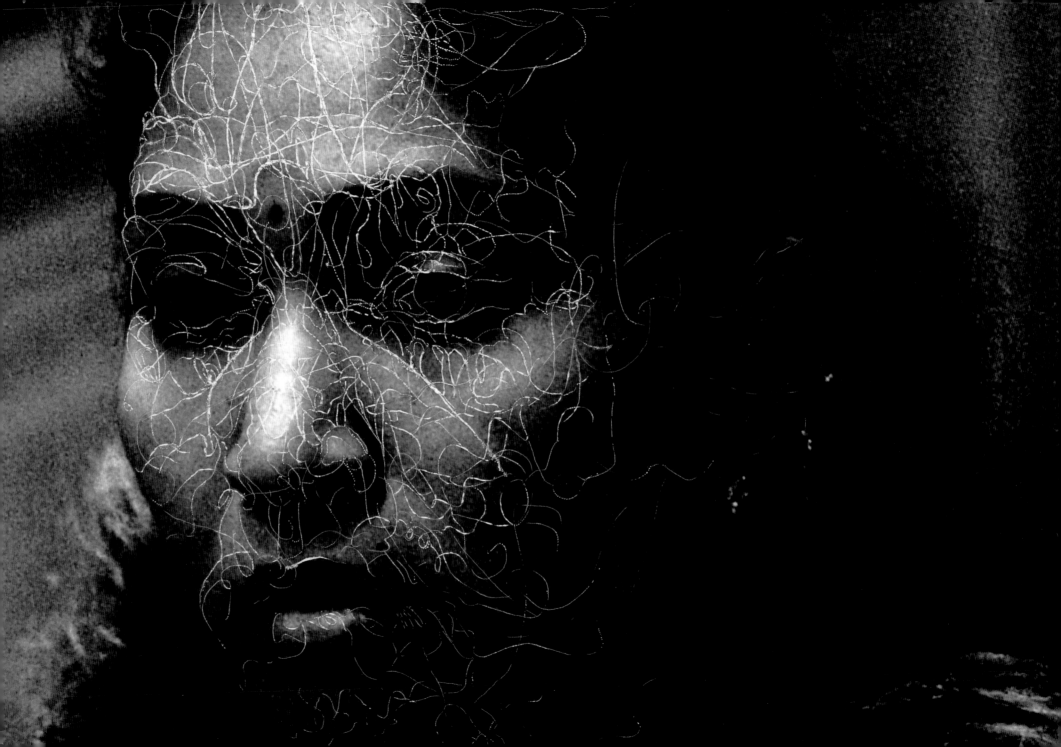

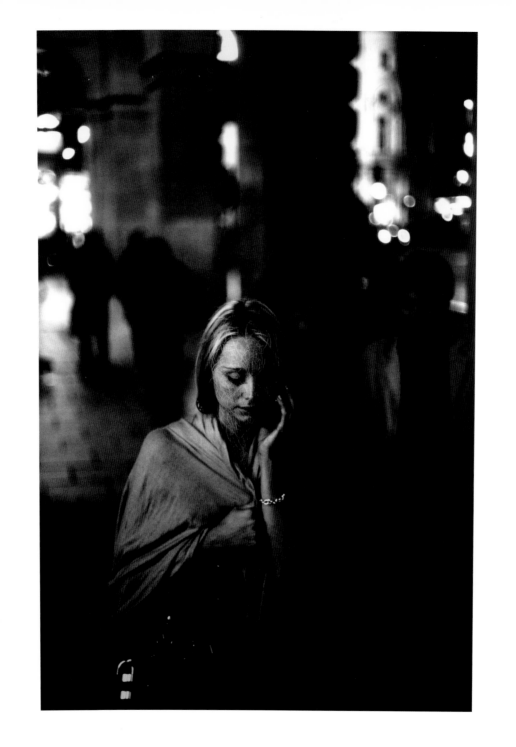

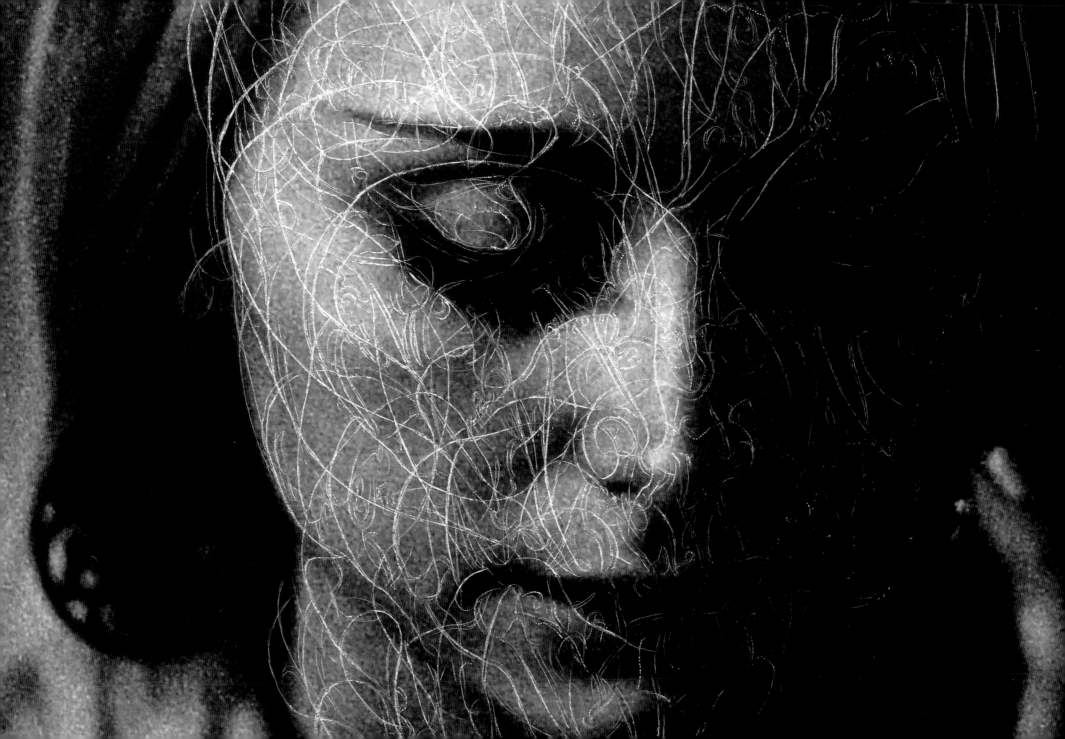

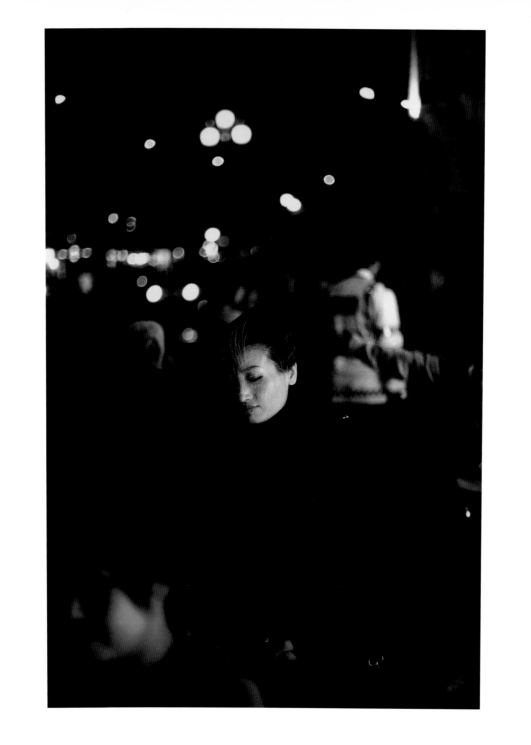

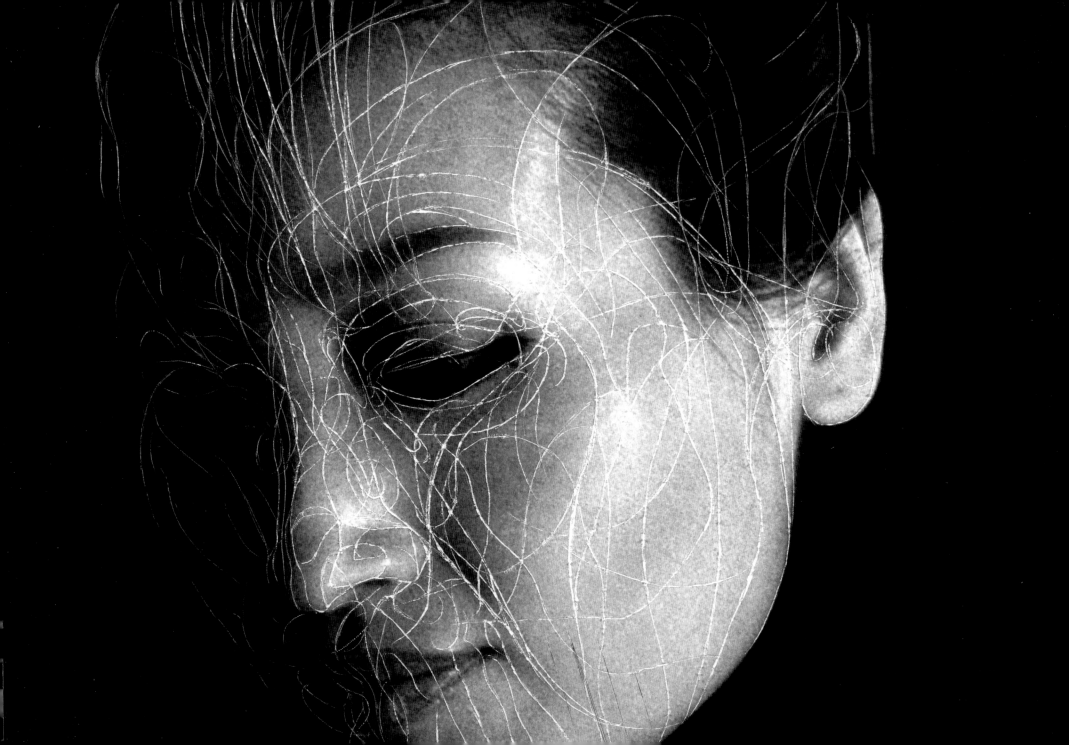

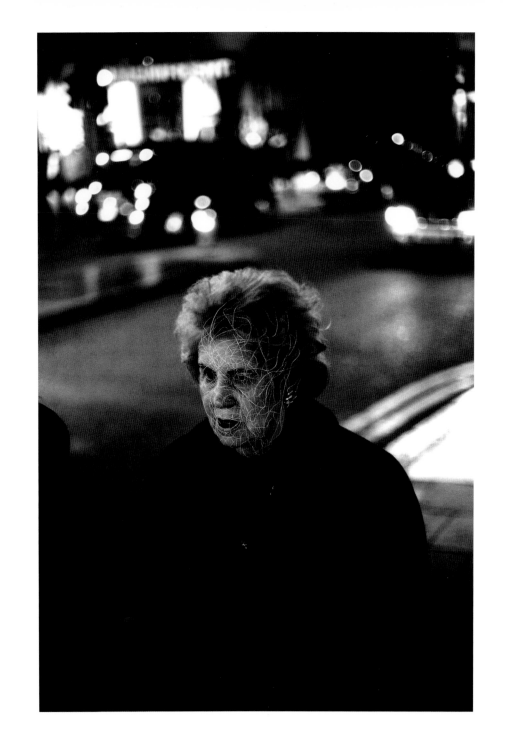

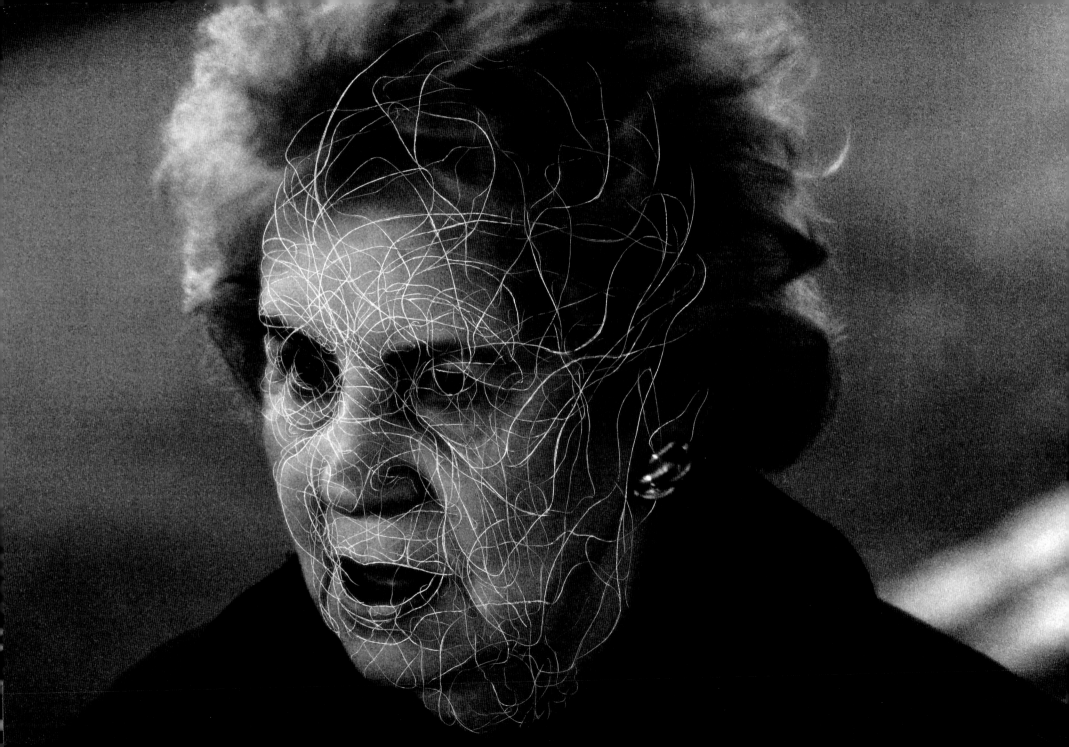

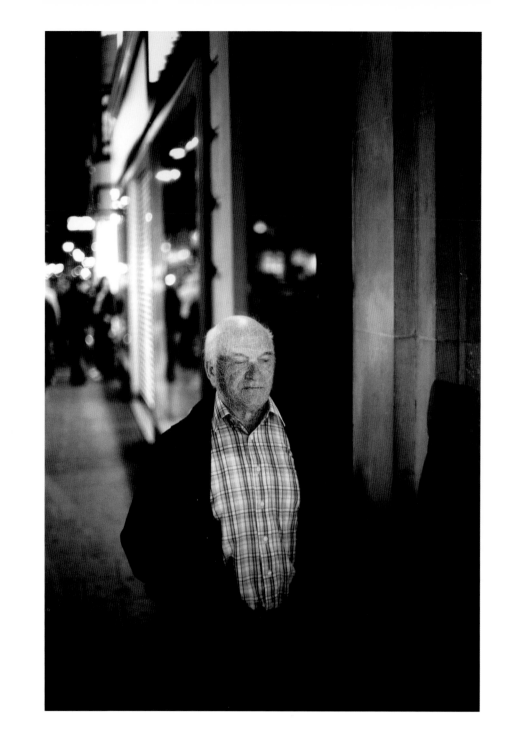

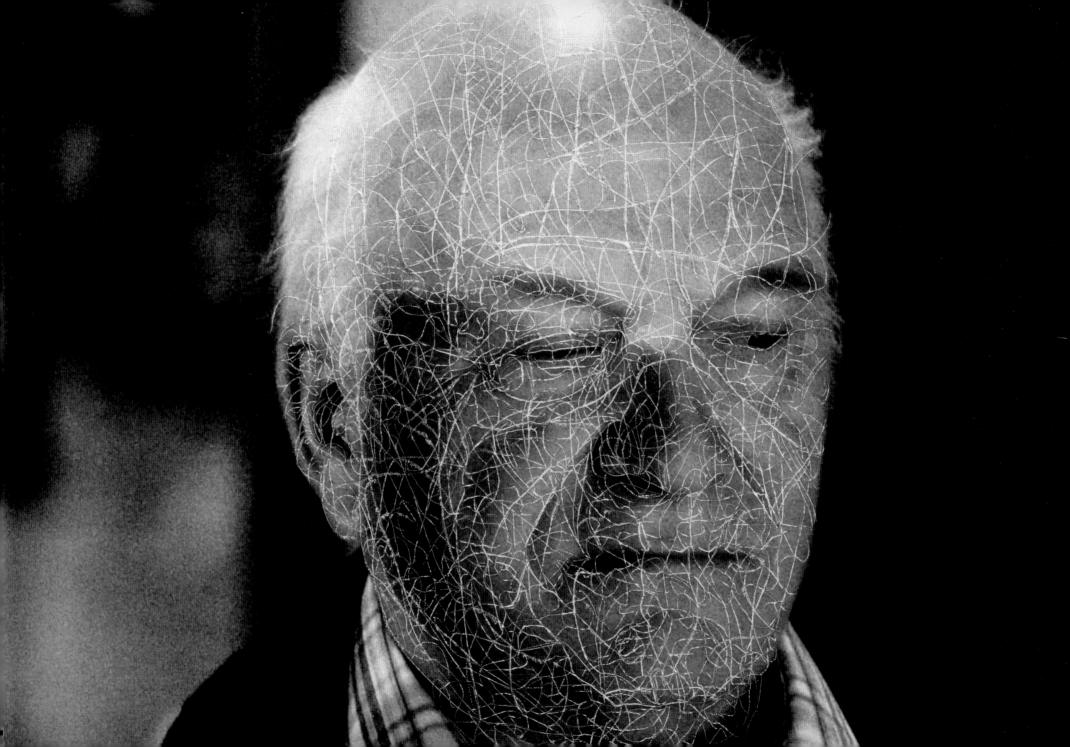

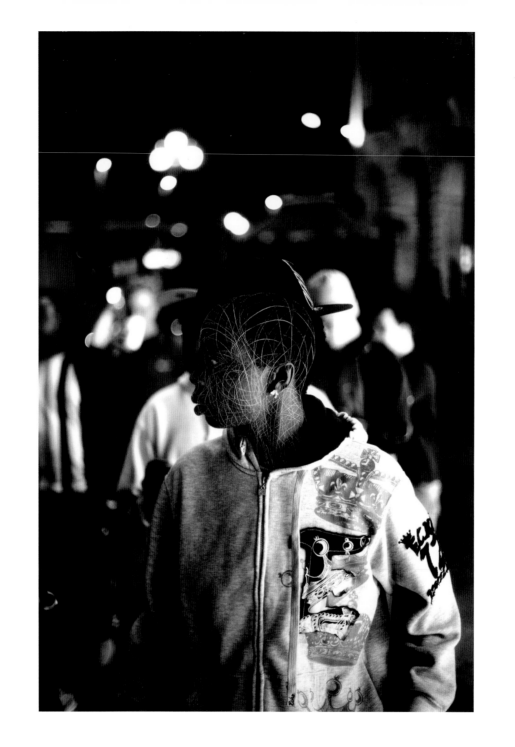

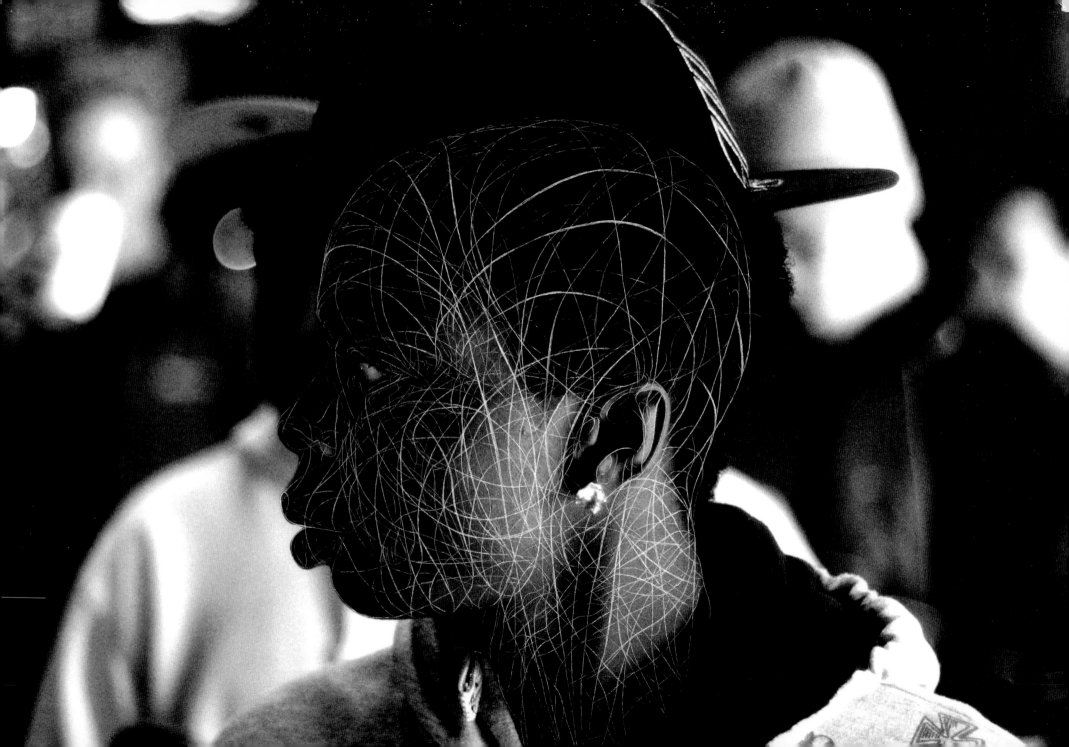

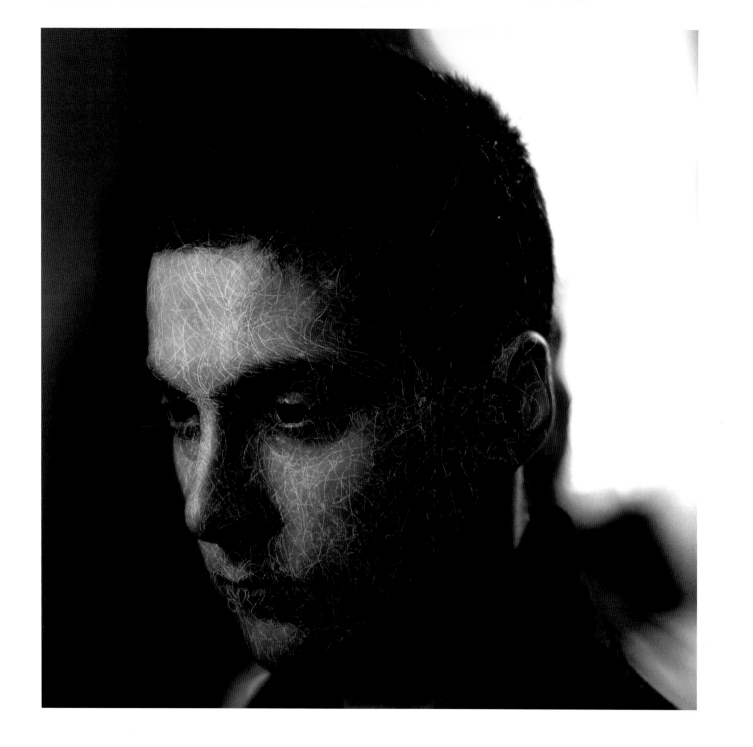

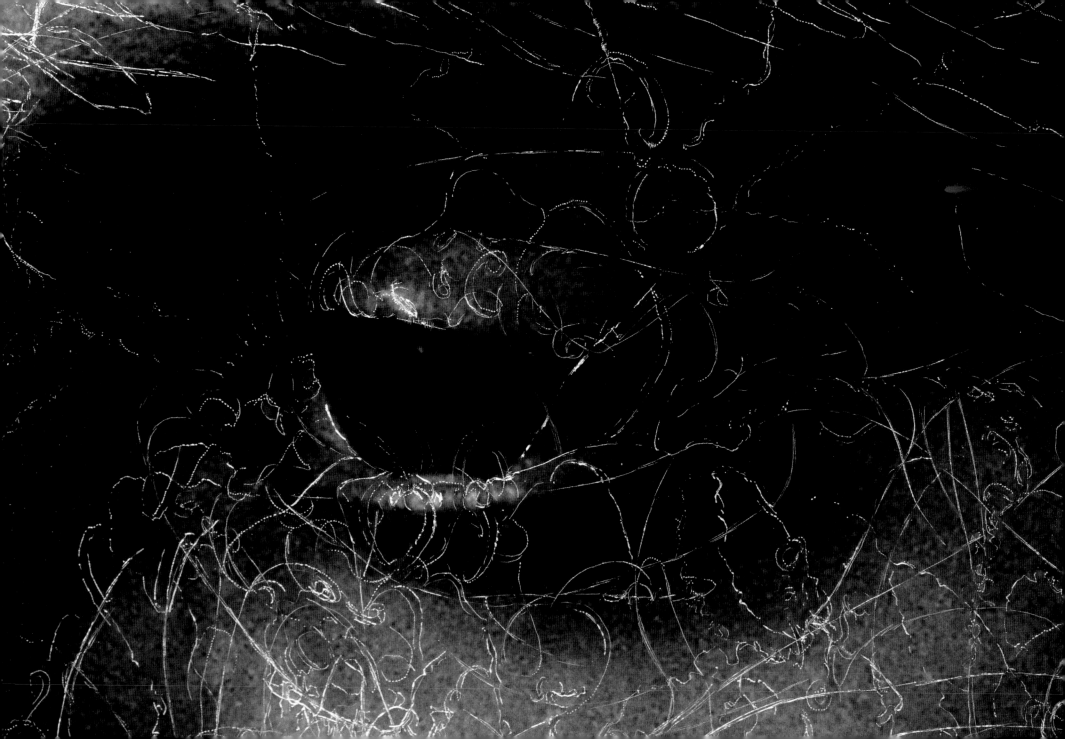

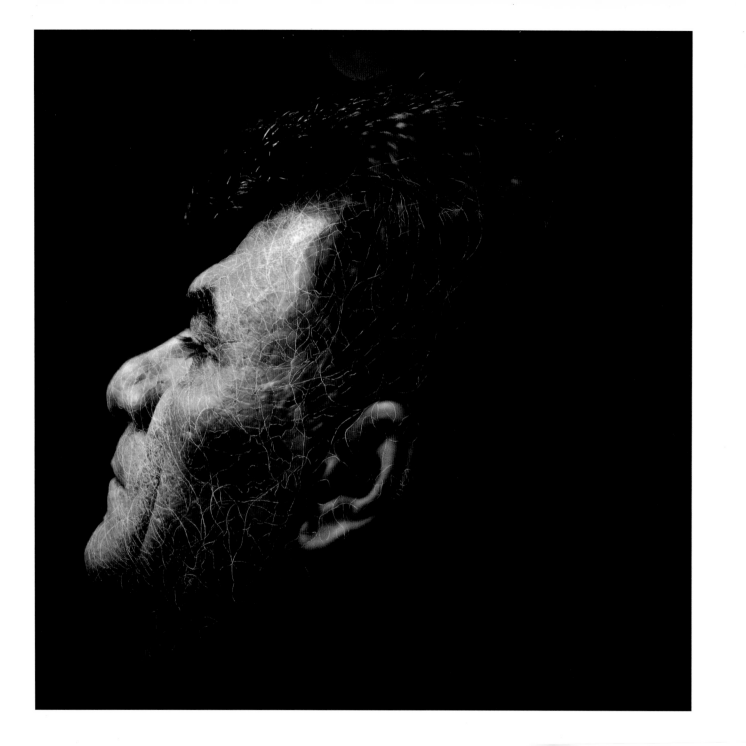

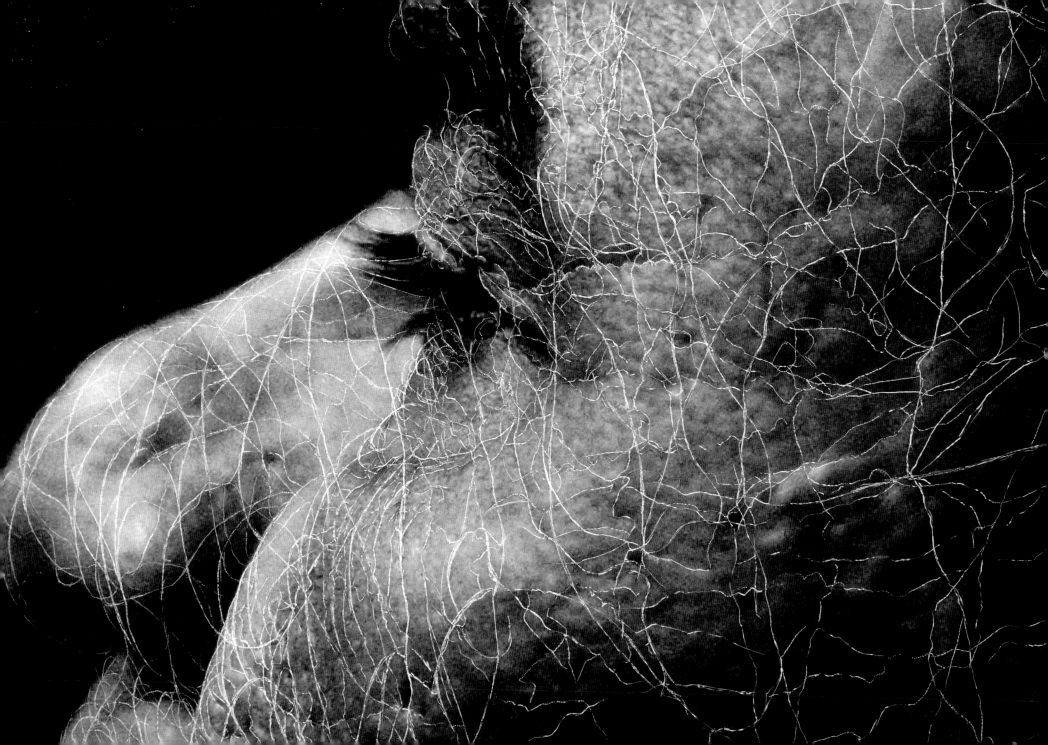

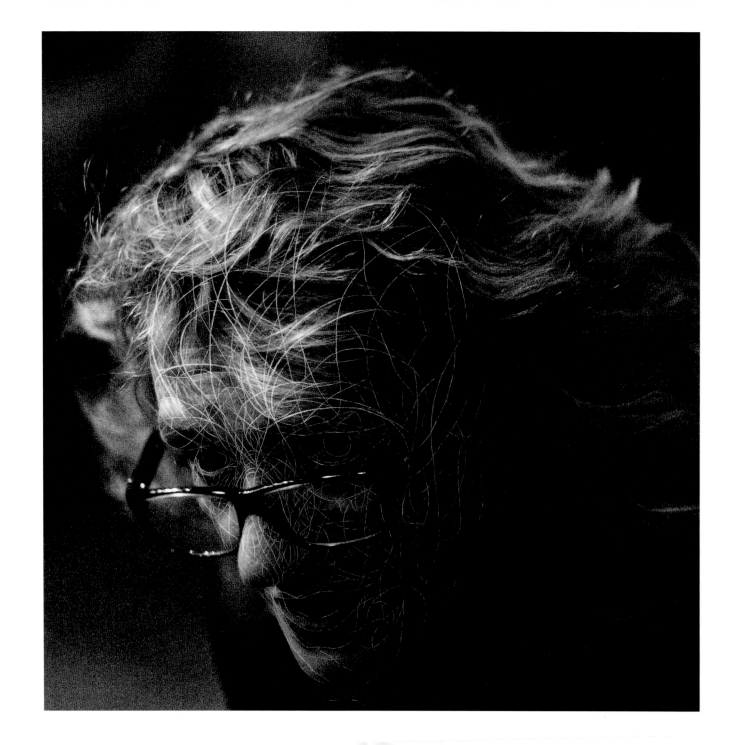

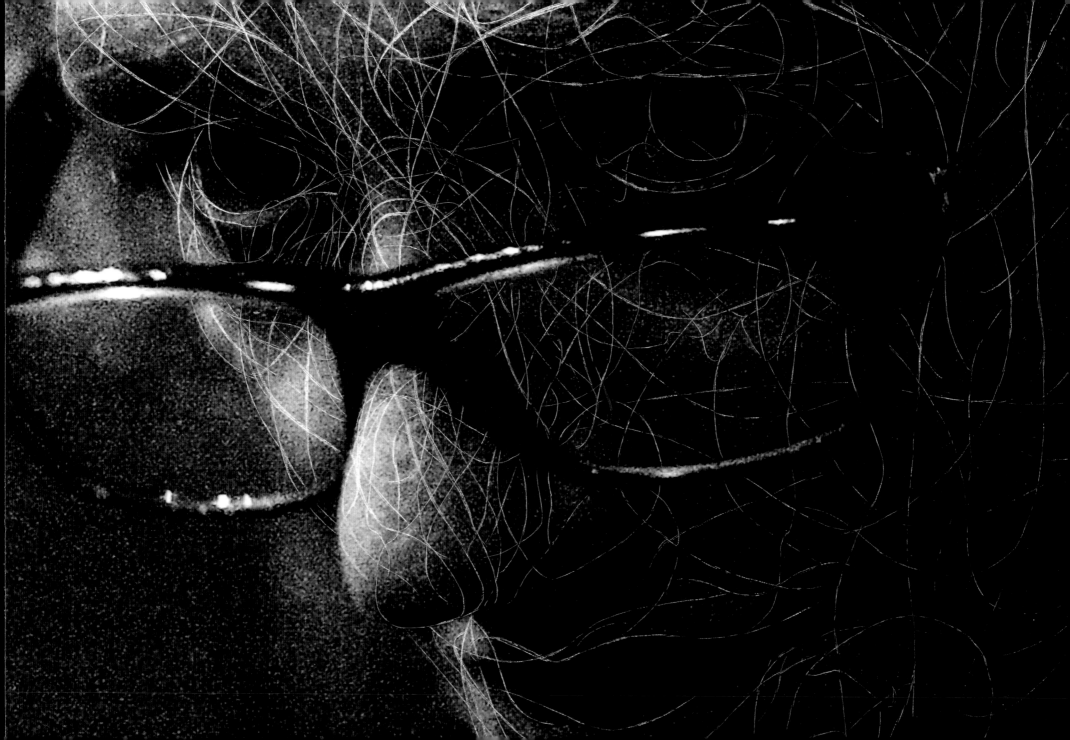

CAST

The title of this book, *Cast*, has over forty associated meanings, from casting a line to casting a shadow, from casting a film role to casting a sculpture, from casting suspicion to casting a spell. All Dryden Goodwin's titles tend to have this plurality of potential readings, a plurality and ambiguity that draws from and echoes back into his work. The first work you see in this book is *State-City* (2004), a series of etchings of the London skyline. At first it is easy to assume that the title refers to the institutions of power the image seems to portray. However for me it refers more to the constitution of something, be it a liquid, solid or gas. In this work the city itself seems to almost dissolve or shimmer in front of our eyes, it moves from being a static image of a solid thing to something fluid and in transition, in a constantly changing state more akin to the vibrant, living and breathing and continually evolving nature of our cities themselves.

In many ways this portrayal of the city is analogous to Goodwin's methodology as an artist, which is shaped by his desire not to pin things down but instead to capture and present constant flux. One way he does this, and has always done this, is by the combining and interweaving of various media. Rather than simply take a photograph he will then draw over its surface,

for example, as he does in his two series *Cradle* and *Caul*. Or, in another work, *Casting*, he juxtaposes photographs of scenes with drawings he has made from them, picking out faces and characters and then suggesting, through repeated drawing and re-drawing, his extended process of looking and observing. And his recent work *Shapeshifter* takes this fascination with flux and change to an extreme, the work comprising nearly seven hundred small and rapidly made sketches (drawn from direct observation) of fellow passengers on trains and buses, which he shows separately but also amalgamates into one moving image work, where all the individual portraits merge uncannily into one composite face.

Importantly, this mixing of media and methods is a cross fertilisation, and perhaps a cross contamination, that infers the inadequacies of a single image or process. Drawing as an intervention into a photograph, for example, is a way to literally get into the surface of an image, to expand it beyond the constraints of its two-dimensionality in order to explore a 'third space' of the picture plane. It is a process that also suggests an attempt to reach back to the original space of the photographic encounter, the moment of exposure, and to make a connection between representation and the real. The animation work *Rock* is a prime example of this. The moving image usually encourages us to enter its illusory world but this is an experience that Goodwin's films never fully allow. In this new piece he plays and replays a sequence of drawings that pivot around in a way that disorientates the viewer. Rather than follow sequential time frames this piece holds us in stasis, both moving forward and back, so that it is impossible for the viewer not to be aware of the construction of the work. We are drawn in yet pushed away, constantly held on the cusp of the illusory space.

Made in London's commercial heart, on or near Oxford and Regent Street, these new pieces, like most of Goodwin's work, are firmly rooted in the contemporary urban experience. Those of us familiar with these areas might even catch

recognisable glimpses of locations on the bus stops and street hoardings in *Casting*. The artist is fascinated by the way that people inhabit this space, with the very particular attitude they take and his own brief relationship with them as passers by. The hustle and bustle of Oxford Street creates a tension, a push and shove in the crowd that those weary of London will seek to avoid. To make the works in *Cradle* Goodwin walked on those streets at night, but although he needed to get very close to people to take his shots, and despite the fact that those photographed would find it hard not to be aware of a tall man with a camera taking a picture of them, none of the subjects stopped or spoke to Goodwin or questioned what he was doing. Goodwin does not place himself outside or above the throng, at a critical distance from his subjects. He remains within the maelstrom, immersed with his subjects in the physicality of the street. And yet his reluctance to acknowledge others, and their tendency to ignore him, has enabled the artist to become almost invisible. He can become the anointed *flâneur* described by Baudelaire who can walk through the city and observe its inhabitants as his subjects without being observed himself: 'For the perfect flâneur, for the passionate spectator, it is an immense joy to set up house in the heart of the multitude, amid the ebb and flow of movement, in the midst of the fugitive and the infinite'.[1]

In choosing to take photographs on the city streets Goodwin revisits familiar territory for photography, which, from its inception has found this particularly fertile ground, as Walker Evans said: 'I go to the street for the education of my eye and for the sustenance that the eye needs – the hungry eye, and my eye is hungry.'[2] It was the succeeding generation of photographers in America, such as Robert Frank and Garry Winogrand, who were to make this genre their own from the 1950s to the 1970s. However, underlying the innovations of

individual artists, the development of this style of photography has also been closely connected to technological advances in camera design. The increasing mobility that small and portable cameras such as the Leica afforded, played a central role in emancipating photographers, allowing them to make work on the move. Although they were not rendered invisible – as is evidenced in the occasional shot where the photographer's shadow is cast into the image (as is so eloquently explored by Lee Friedlander across his work) – it did enable photographers to change their perspective and approach. Most importantly the quick street snapshot prevented those photographed from adopting a pose. However, so much of this process depended on chance and then on work done in the dark room and editing suite, selecting from the many the one image that worked. Recently available digital cameras have increasingly liberated street photographers, giving them a chance to quickly take shots, even at night and from a distance, in which a crisp image with a huge amount of data can be captured. The photograph can then be greatly enlarged in scale and then, as with series such as *Caul*, worked on in the studio. And for Goodwin it is often the studio rather than the dark room in which this work is carried out.

The images in *Caul*, of passengers on the top decks of passing buses, are taken at night looking up from the street, and by increasing the digital camera's sensitivity and using a quick shutter speed Goodwin has been able to work in near darkness yet attain clear, sharp images. It is important to Goodwin that he works with what he has taken, so light levels are not adjusted and features are not changed digitally. However, there is of course one obvious intervention the artist makes, and that, in the case of *Caul*, is to digitally draw, by means of a digital stylus and tablet, over the face of the subjects he has chosen to zoom in and focus on.

Central to all this work is the fact that Goodwin is making portraits of strangers and in doing so he is interested in the mix of anonymity and intimacy in his implied relationship with them. There is a state of mind and expression shared by all his subjects which reminds me of a description of Walker Evans' New York subway portraits: 'suspended in the limbo of the subway car and lost in thought, the people seemed to express pure, unselfconscious emotions – of sadness or exhaustion, boredom or concern, and even, occasionally joy – and they did so in a way that was devoid of artifice or sentimentality'.[3]

Interestingly all the people photographed in Goodwin's work are also in transit: for *Shapeshifter* they are sitting on trains; for Cradle and Casting they are walking on the street and in Caul they sit on buses. Goodwin has said that he is particularly drawn to people at moments of quiet reflection, when their interior life is in some way manifest in a public setting. Of course to capture these reflective moments the subject has to be unaware at the point they are photographed. For Evans to achieve this he had to find ways to conceal his camera. Sitting directly opposite his subject he hid his camera in his coat with its lens barely visible between two buttons. Goodwin did not have to go to such lengths: in *Caul* he was equipped with lenses that could photograph people clearly from afar and in *Cradle* he used the street's own code of avoidance, people's reluctance to see what was right in front of them, to make the work. But, however the photographs were actually taken, there remain ethical issues around taking and then using an image of someone who is not complicit in that act. Walker Evans was not unaware of this and referred to himself as acting like a spy. Goodwin is similarly conscious that this is inherently problematic. Traditions of drawing from life in some ways circumvent these issues as the process of drawing is, of course, less a record and more an 'artist's

1] Charles Baudelaire, *The Painter of Modern Life,* 1859.

2] G. Moran and J.T. Hill, *Walker Evans: The Hungry Eye,* Thames and Hudson, London, 1993, p. 8.

3] S. Greenough, *Walker Evans: Subways and Streets,* National Gallery of Art, Washington, 1991, p. 9.

impression' of a person. And the fact that Goodwin covers the face with a mesh of lines does allow his subjects some degree of anonymity. Yet his implied intrusions also reflect the nature of individual experience now in public space. The areas in which Goodwin is working, as in any major city or town, are ones in which we are constantly being watched and filmed by CCTV surveillance. And, as his work suggests and partly demonstrates, we have no real awareness, let alone control, over how these images are being used, who is storing them and why.

Goodwin's practice of scratching over the faces of the people he photographs and into the surface of the print, creates one of the pivotal tensions in his work. Several artists have employed this strategy before, perhaps most notably the existential Austrian artist Arnulf Rainer, who for years drew over self-portraits and found images including death masks. His marks were at times obsessive but always vibrant, reactive and sometimes even destructive to the image underneath. Rainer was an exponent of 'Tachisme', a specifically European movement post-World War II, that had parallels with American Abstract Expressionism. It involved the spontaneous interplay of marks as signs and gestures expressing the emotional condition of the artist. There are undoubted similarities between Rainer's and Goodwin's markings as both artists work spontaneously over the image, particularly the face. However, whereas Rainer's work often seems an attempt to obliterate that which lies underneath it, Goodwin's work is more ambiguous, and despite the intrusive, potentially hostile nature of his marks they also seem to encase, cocoon or protect his subjects.

This sense of empathy, of caring and protecting, is enhanced by the slightly elevated angle, looking downward, from which the photographs are taken. Goodwin's physical height produces this effect, his markings in turn appearing perhaps as the gestural

traces of some overseeing guardian angel. As Goodwin inscribes into the photograph, reaching back to his subjects' pensive moments of reflection, his title, *Cradle*, takes on a literal tone, the work as a site of nurturing in which he wonders about these strangers and imagines an affinity and even an intimacy with them.

Linking Goodwin's inscribing to a form of intimacy introduces the idea of the haptic trace, and the artist reaching out to touch his subjects. And the fact that this touch is also a scratching in *Cradle*, might also be read as a violation, a sense of the work again imbued with ambiguity. For *Caul*, however, the touch is not such a physical one, in that Goodwin has employed a new digital process for this work. In this work the drawing on the face is carried out using a Wacom tablet, which has a touch sensitive, membrane-like surface onto which the artist presses with the digital stylus. The more pressure he exerts the deeper and more luminous the line he draws. As in *Cradle* his drawing and working, on what is now a digital surface, produces a web of lines over the faces of his subjects.

Goodwin's title, *Caul*, refers to a portion of the amniotic sac that can be left over a child's face at birth, something that reinforces the visceral quality of the distinctive red lines that cover the faces of the people in the work, like blood vessels or raw tissue. This corporeal reference continues in many ways through all Goodwin's work. At the start of this essay I suggested that in *State* the city is shown as a vibrant and breathing space. If this metaphor is extended and London is seen as a body, its commercial West End can be seen as its beating heart. The roads, trains and bus routes on which Goodwin's subjects travel become the arteries that flow from that heart and the passengers who travel on them are the blood pumping through the city's veins. The use of blood-red on both the livery of the bus but

also across the faces of his subjects in *Caul* further emphasises this very corporeal portrayal of the city. Looking through Goodwin's new work there is both a tenderness and humility as we become aware of the transitory, and ultimately insignificant, role we each individually play in the huge human drama that unfolds around us.

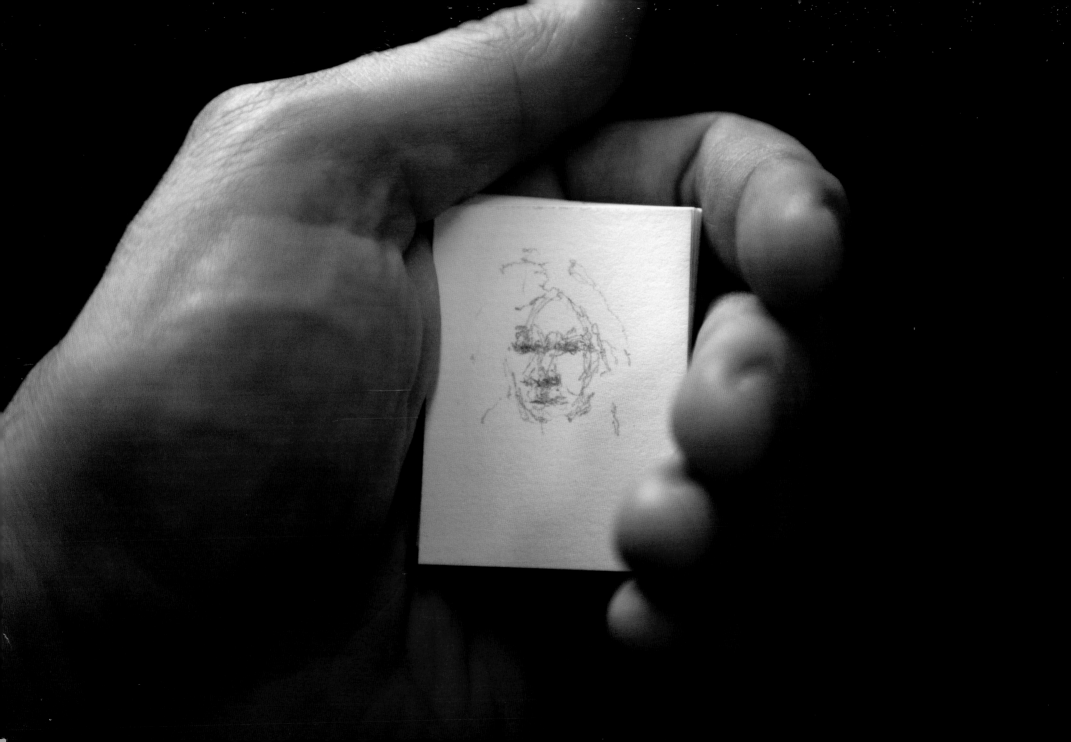

DIALOGUE

DC] The relationship between drawing and photography as a means of representation, but also of communication, has become fundamental to your work. Could you begin by expanding on the nature of that relationship? It might seem on the face of it an uneasy alliance.

DG] I'm fascinated by the particular way, through the act of drawing 'from', 'on' or 'into' a photographic print, that my imagination can go beyond its surface, projecting back into the four-dimensional space the photograph was originally taken in. I'm attracted to the different layers of mystery and connection in this process: firstly the moment of seeing a stranger, then the act of taking the photograph, bringing the image back to the studio, printing it, and then the time invested in drawing from or over the person's head and face with a matrix of marks. It's the different spatial relationships and temporal frames that this opens up that interests me, allowing me to engage with these strangers at different stages of the process.

There is something very powerful and emotionally charged about channelling all these tiers of focus into a single moment or image. Layering up concentrated periods of time to attempt to give the ephemeral greater density, almost in a sculptural way; to find an ambiguous tenderness against accelerated change. I am interested by how this process might ignite the imagination, how it might suggest something about these depicted individuals and by association myself and also more generally human nature. I'm intrigued by the contradictions within the works, as drawing often destroys the thing that you think you are pursuing and want to identify. It eclipses or hijacks it, something else is often created and takes its place. Moving from the 'actual' space of the encounter to a photographic print in the studio and then on to a photograph with a layer of worked drawing over it or next to it in the gallery, I have this sense of weaving a new time fabric, a kind of parallel reality, one that is revealing and reflective on the original.

DC] This practice of marking the face, particularly as you have described it as projecting back into the space of the original encounter on the street, seems very suggestive of touching, it's an intimate gesture.

DG] Yes, the idea of drawing as touch is central. I find it very compelling the idea of a drawn mark being a kind of contact between artist and subject, between one individual and another. Also how it's an ambiguous gesture, it can suggest empathy or hostility, it can be a caress or an imposition. Drawing is some sort of exchange, offering the ability to be receptive to information and tune into frequencies being generated, but also enabling the possibility to project an idea or feeling across space towards something, somewhere or someone.

DC] The process itself then is very important, it seems part of the meaning of the work?

DG] I hope there is the potential for some level of meaning to be discovered by understanding the method I've used to create a piece of work. Making a viewer aware of how a work has been made is almost as important as what it becomes. Both the duration and something of the nature of time the work has been made in, sometimes has to be more than just implicit; the processes need to have a degree of transparency.

There are distinctions and nuances when working at different scales, with different drawing methods or onto different surfaces, between drawing someone from direct observation or via a photograph. I like the shift in emphasis that drawing someone with an etching needle has, for example, from working with a pencil or a digital stylus, or from working onto a photographic print, a piece of paper or drawing into a digital image. Each has their own physical sensations which contribute to a distinctive experience when engaging with a specific person or place.

DC] You have always emphasised the speculative nature of drawing, a form that as you have said is forever slipping, its end point always falling away. The repetition in much of your work, the insistence on the accumulating mass of rapid sketches in *Shapeshifter* for example, gives the sense, as you have said, of an attempt to deal with an unsolvable problem. We have talked before about a sense of 'worrying' about drawing in your work, a restless enquiry that argues with and challenges the form even as it takes it forward. Could you say more about this?

DG] The very act of drawing suggests the desire for knowledge and yet I'm interested in questioning the possibility of real insight or understanding, especially in a world where there seems to be access to so much information. As with my drawing process there is this constant tension between what is being revealed and what is obscured, or what is invented or imposed. It seems to me there is a need to be in a constant state of questioning and reassessing in order to survive; always attempting to make things whole but always experiencing constant fluctuation, never completely settling. There's always inconsistency and therefore incompleteness.

There are also contradictions in what I feel drawing can achieve. The element of repetition in many of the drawings I make is important. I may speculate through drawing repeatedly about someone who is somewhere doing something at a particular point in time. There is often this sense that I'm dealing with an unsolvable problem or sum. There are elements of testing myself, Can I do that? Do I have the capacity to do that? Or is it beyond practical and imaginative solutions? Repetition can also release you, it keeps giving you another chance to try and state or discover something. I'm also aware of the transformative power of drawing, the element of fiction and fantasy it can create.

On other days drawing seems a kind of super sense, like a superhuman power, in some ways like Spiderman casting his spidery web, but more like a luminary stethoscope with the ability to discover more, to evoke and attempt to reveal complexity. It can seem like a magic spell helping to conjure into form something transient. The sense that I've held or grasped something and given it substance is most intense for me at the point of making the drawings, but this feeling is

only temporary. Drawing doesn't create stability but seems to emphasise fluidity, it's never harnessed, it's constantly returning to something like its molten state. It's the drive to push against this that sustains me in these explorations. The drawings are always an attempt to create a refuge of thought, to delineate a zone, an area of intensity and intimacy.

As with past work the information and ideas in the images release themselves over time. This is true not only in the making but also in the experience of someone looking at the work. I think of various notions of 'exposure' in this process: firstly, in a photographic sense, the duration of time in which an image is first collected via a camera or via drawing, and secondly in terms of the contact between the subject and myself. Inferences are caught in these initial moments but different things are revealed the longer I'm exposed to the images in my studio. In *Shapeshifter*, I've made hundreds of small drawings of people on trains directly from life rather than via the conduit of a photograph. As the length of time increases from looking directly at each person and drawing them — although the drawings still act as prompts — the recollections become increasingly uneven.

For the other works — *Casting*, *Cradle* and *Caul* — after time spent immersed in the photographs, my sense of the people in them changes. It's something like a close relative where you lose objectivity and it's hard to see what they really look like. In the *Casting* street scenes, over time I slowly notice off-centre details embedded in the scenes that act as counterpoints: a Robert Doisneau kiss between a young couple; a predatory scorpion in an advert on a bus; a large drawing of a young man in the graphics of a siding display; illuminated advertising for Disney's 'Enchanted'; a shop

selling lingerie called 'Intimissimi'. All these things inflect the process, colouring the imagined narratives of the people I single out. I think the final sense of exposure comes when people look at the work. The experience of looking at the photographs might be slowed down by the presence of the drawing, as in the *Cradle* or *Caul* series. In the *Casting* diptychs there is the possibility for the viewer to scan across the sequences of drawn heads to reanimate them in different combinations. With *Shapeshifter*, a person might return to the work time and again and notice an aspect of a head that wasn't clear to them before.

DC] One of the most persistent themes in your work is the relationship between the still and animated image, not just between still photography and film but between the time-locked quality of photography – that apparent closing of time when the shutter is released – and the working in time of the drawing, its fluidity, the sinuous line that always seems to imply a movement over not just the surface of image but across that moment in time of the exposure. In one sense series such as *Cradle* and *Caul* seem imbued with a kind of pathos about your subjects' loss of their animate life in the image, the drawing and scratching could be seen as a kind of coaxing, or the gathering of a life-line back to the world of the moving hand, and of physical contact or intimacy.

DG] A key idea at the centre of these new works is that there is something locked away in the photographs and in different ways I am trying to reanimate what appear as frozen moments, to investigate them further. For example, in the *Cradle* series this is a big part of what the scratching is about, disrupting the fixed still surface of the photograph with animated lines, attempting to resuscitate its flatness, to create a flicker of

dimensions from two into three, and even four and back again. Or, in making the multiple drawings in *Casting*, I constantly revisit the heads of different people to make them current, to resurrect, to revive. During this activity I wear a magnifying visor, it makes me feel like my physical dimensions change enabling me to project further into the photographs and get closer to the drawings. With *Cradle*, I hover on and scratch just into the physical surface of the print, it feels important not to completely pierce the depth of the photograph. Simultaneously I work in the illusory space of the image. As I make the scratched marks I react to contours and structures of the face, feeling the skin and around the bone. In *Caul* the screen and digital surface is totally traversed and the illusory space is again projected into. It's more than just tapping on pictures on the Internet, this feels tactile and physical.

DC] The sense of a multitude of lives that intersect at random, and mostly only momentarily, is one of the defining ideas of the modern metropolis, and of urban experience; that sense of overwhelming complexity, of alienation, but also of vast human potential. The street is a place of unlimited individual experience but collectively it is also one of missed connections and opportunities. These ideas are obviously at the heart of your work, that simultaneous proximity and distance between strangers, the impersonal and the intimate drawn together.

DG] I definitely feel an uncomfortable tension in these works. I'm very aware of the questionable act of stealing a person's image when someone isn't complicit in the making of the work. There are varying degrees of this tension across the different pieces. The initial photographs or drawings are made on the move, as the strangers and I momentarily pass

through these spaces, I take hundreds of photographs and make hundreds of drawings. If I were to contrive the encounters or somehow retrospectively seek permission the dynamics would completely change. These people would no longer be completely unknown. For a long time I have been conscious of shifting in various directions, between principles and ethics of engagement, attempting to discover new nuances and associations. Of course there is a kind of thrill in taking someone's photograph or drawing over someone's face. However, I have a strong sense as the artist that my role needs to balance representing these people with providing degrees of protection. The scratched and digital marks in *Cradle* and *Caul* partially veil and change the appearance of the faces, or in the *Casting* series the distance that the selected people are photographed from means that very little concrete physical information is captured. There is always for me a friction between the desire to get close and the need to hold back. There is a balance to be struck between voyeurism and absorption. There is a threshold where through drawing you almost feel you become what you are looking at. It's important for these particular works that this aspect is never resolved, I'm reaching out but never quite obtaining.

I feel I need to tread this fine line between drawing as an invasion and drawing as an act of empathy, drawing objectifying someone and drawing being sympathetic. Even mark to mark I'm conscious to a degree of the nuances of different lines, a different thickness and a sense of touch, the amount of pressure on a pencil or an etching needle or a digital pen, for me this richness is all there at the point of making a drawing. Through the time spent drawing over and from these people, my imagination becomes very much

entwined with them as individuals, I become involved and feel strangely connected. I'm literally casting them as characters, imagining their life with its dimensions, caught up in envisaging their experiences. But this degree of focus can create a kind of obsessive and distorted vision, a series of fixations, so it also has unsettling connotations. It's an important disturbance in the work that there is this other reading in complete opposition, one which is impersonal, automatic, dispassionate, compulsive and disconnected.

If it is too much about sentiment there is a danger of it becoming mawkish, if the processes seem overtly dispassionate, they could appear one dimensional and unfeeling; again I see richness in this friction. When drawing or photographing — whether I'm moving around the city or in my studio — I have to keep alert; when my focus and sense of responsibility wanders I have to realign. The marks I make are either thought through or intensely felt and I try not to compromise these individuals by making them appear ridiculous. There is an incredible amount of rethinking and re-imagining, without this I think the whole process would be empty for me.

Of course, these works also engage with the omnipresent web of surveillance and observation that we are all caught up in, examining a society where we're increasingly watched, where there are anxieties surrounding otherness and constant undertones of suspicion and fear.

DC] Given that the works gain so much through the process of their making, it's tempting to trace their intensity back to something distinctly personal. Is this ever true? Could you say a little more about the structures of emotion in your work.

DG] In retrospect I can see that there have been a number of personal experiences that have triggered aspects of my work. For example, the film *Hold* (1996) followed the suicide of a close friend. The structuring of that film, a different person on each frame, attempted to preserve the raw feelings of loss, without making it sentimental or exclusive. I photographed over 5000 strangers for the four and half-minute stop frame film, they became in a way like potential surrogates for my friend.

The personal experiences underpinning my work aren't ever overtly expressed but hopefully they give what I have discovered through its making a certain intensity. Equally I use the material nature of the different mediums I work with to try and create structural metaphors for the various sensations and ideas I want to express. Often I have discovered the singular and intimate aspects of my work within overwhelming environments such as airports, hospitals, cathedrals and the city itself. I have thought of these places as contained universes with their own laws and distinctive emotional and practical infrastructures. It is through identifying detailed physical and emotional relationships, also people and their gestures, that I am trying to understand forces and processes beyond human scale and control. Walking hand in hand with this fascination with strangers, there is an inevitable process of superimposing, that through these explorations I am reflecting back on people who I know well and maybe intimately.

DC] Finally, the relationship between drawing and photography has a long and rich history, at least from Fox Talbot onwards. Does this history inform your work, and how? And, perhaps in the course of answering that question could you say something about any possible sources, precedents and/or inspirations for your practice?

DG] There have been different sources. In 1991, in a book covering 250 years of Russian academic life drawings, I remember discovering a preliminary sketch positioned to the side of a piece of paper next to a resolved drawing of an old lady. The quick study jarred because there were marks on it that didn't seem to directly describe her head. There was a sort of substructure, indicators of spatial relationships, it was evidence of where the artist had looked and the pattern of his thinking. In 2002 I discovered similar notions of layering when I used a Camera Lucida designed by Fox Talbot. This device enables you, through the use of lenses, to see a scene and the paper you are drawing on simultaneously, as a single layered image.

During a residency in 2003 at Lacock Abbey where the Fox Talbot archive is housed, I was shown blank parchments that were all that remained of some of his early photographic negatives. They had completely faded. The archivist described a chemical process able to bring these images back into being, called 'Reviving', this notion propelled me to think about the idea of reactivating something that is hidden or lost. Almost in complete opposition I remember as a teenager a scene in Michael Radford's film of *1984*, where, in his job at the Ministry of Truth, Winston Smith (played by John Hurt) must doctor photographs and rewrite newspaper articles, revising information to match the changing party line. In complete contrast to Smith's internal questioning of this monopoly on the truth, he placed strips of brown tape over photographs of people in the newspaper because the Party had said these individuals had become 'unpersons'. There was also something disturbing and incredibly tactile about the blunt metal instrument he used to delete articles, using swift diagonal strokes, leaving scored lines on the newsprint.

As powerfully tangible as this are the drawings of Alberto Giacometti, pushing and pulling as he struggled to fix a person in space, layers and layers of revision as he reworked the surface, through the process the page having been in constant flux. I rediscovered the idea of things changing over time and an emphasis on materials during an Erasmus exchange in 1995 to the 'Städelschule' in Frankfurt. The medium here was film and it was the first time I came into contact with the experimental films of Peter Kubelka, Ernie Gehr, Stan Brakhage and many others. As well as other techniques these filmmakers were scratching, staining and applying different matter to the surface of the film; it made time seem to have substance. Also, seeing Peter Kubelka's abstract film portrait of his friend Arnulf Rainer, made me aware of Rainer's own photographic self-portraits with their marked and animated surfaces, a dialogue between the lens and the hand, a visceral sense of time and emotion distilled into a photograph.

Also important for me are notions of *Gestalt*. The finding of interrelationships across form and between apparent disparate entities reinforced for me what I'd discovered in Cezanne's writings, drawings and paintings, the notion that there is an underlying structure that underpins everything. It is a matter of revealing this structure rather than imposing it, tuning in and recognising and literally drawing it out. This seems such a powerful idea, that this phenomenon exists whereby, if you are looking for it, you can actually see the interconnectivity between things and people, both physically and emotionally.

CASTING

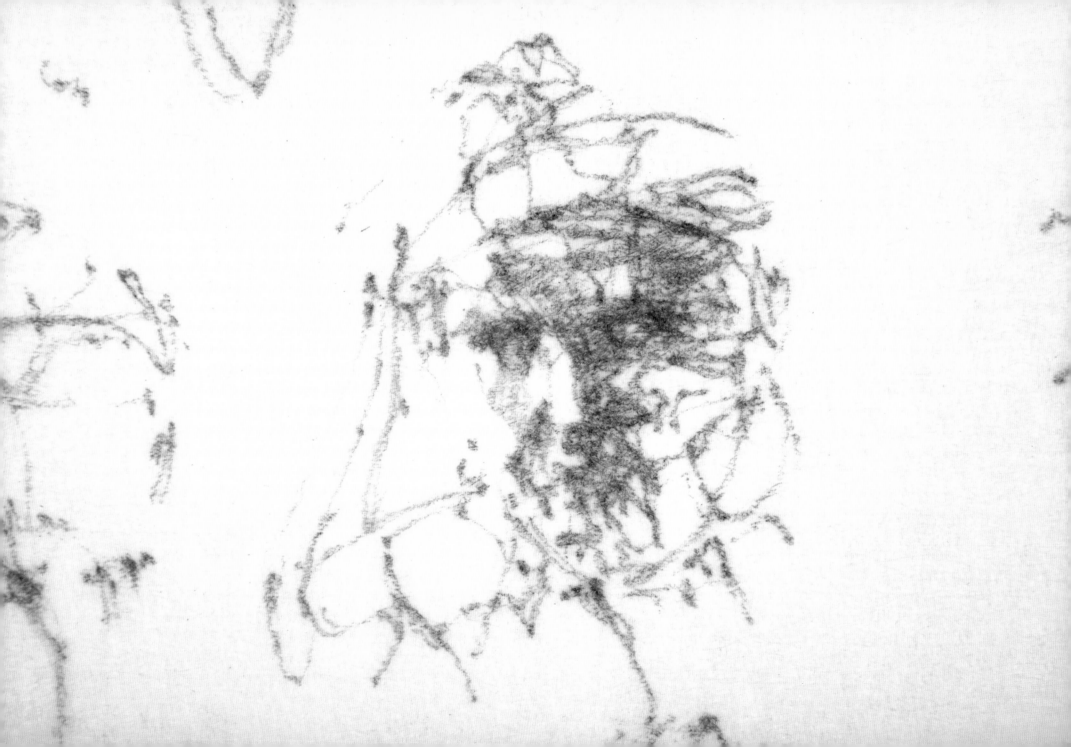

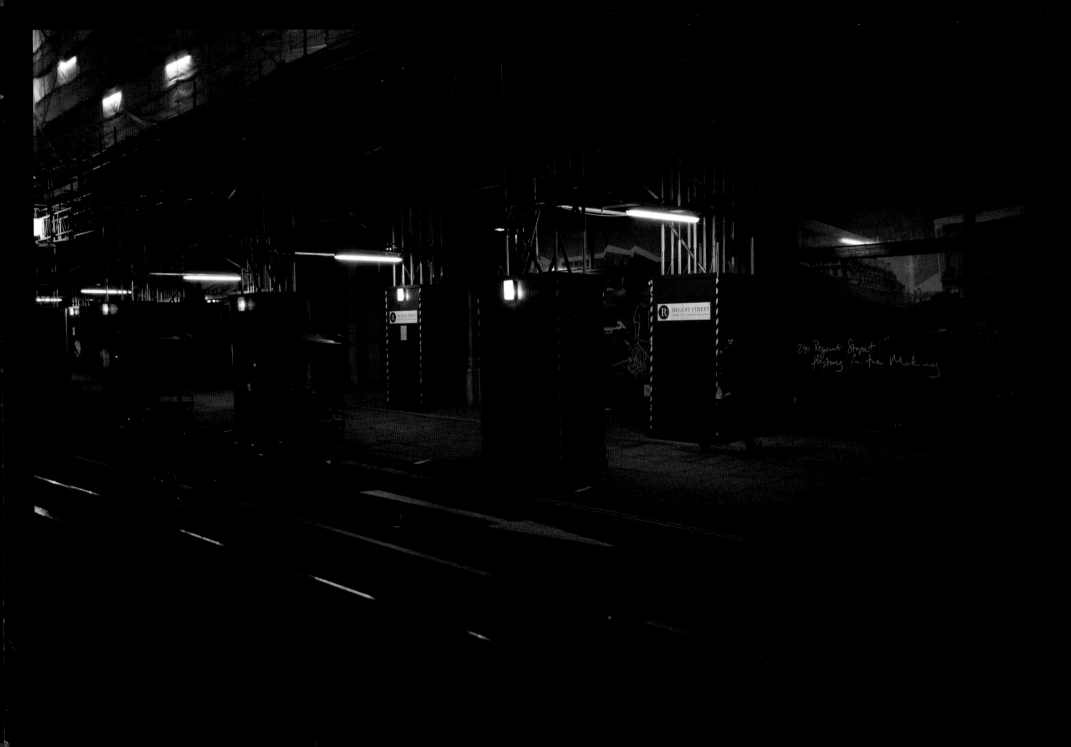

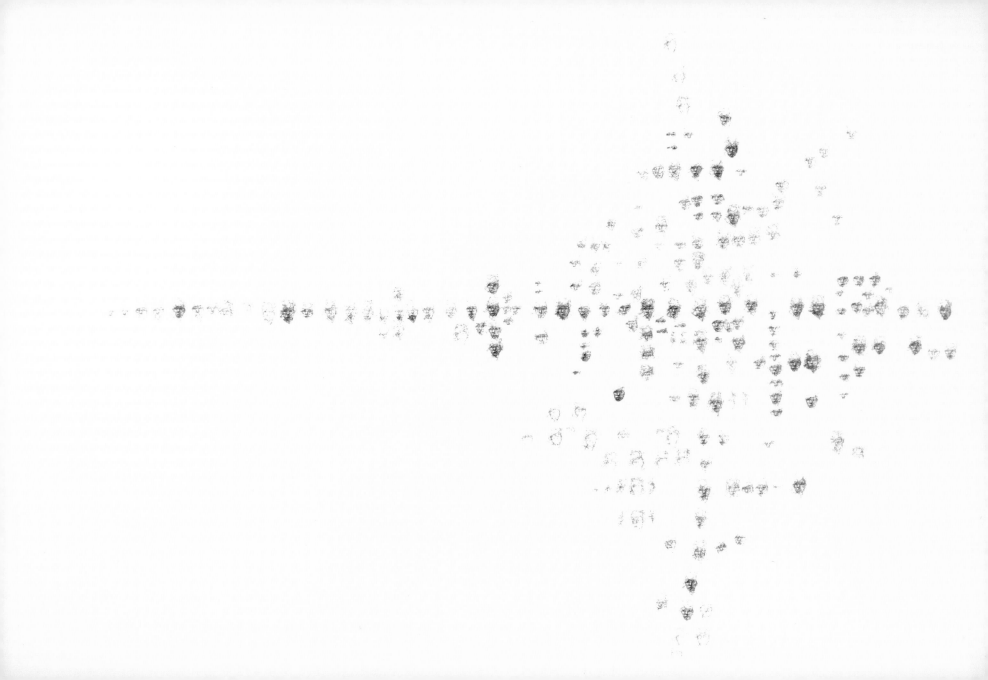

REGENT STREET
WHERE TIME IS ALWAYS WELL SPENT

sp

240 Regent Street
History in the

P.
REGENT STREET

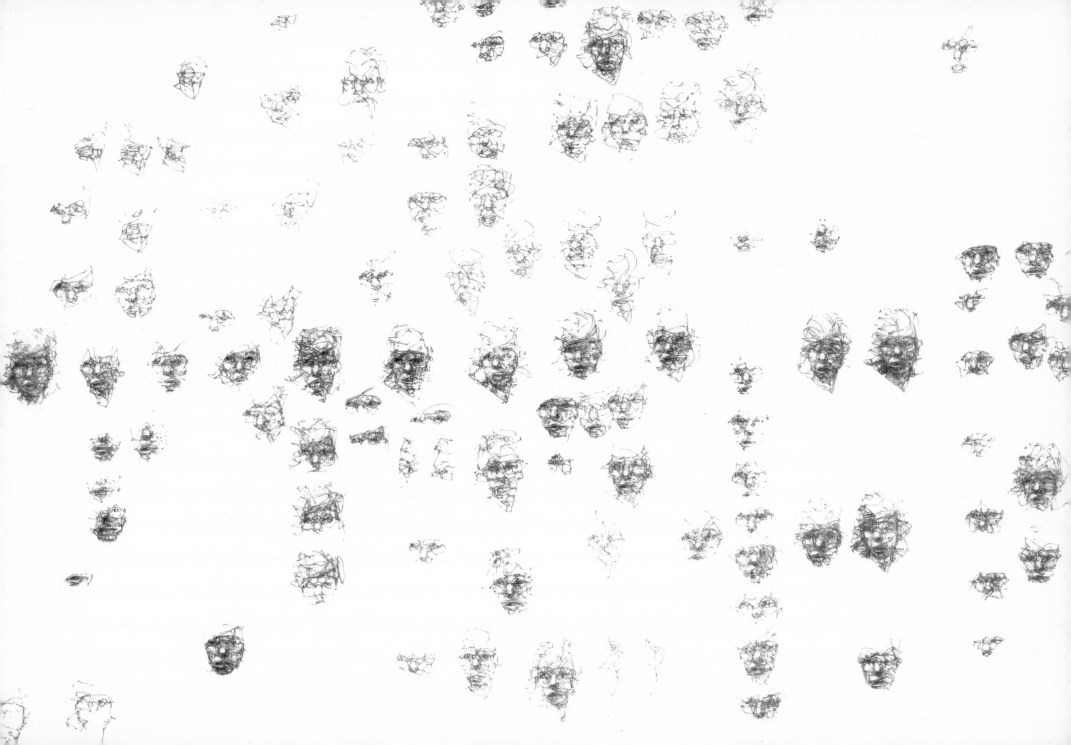

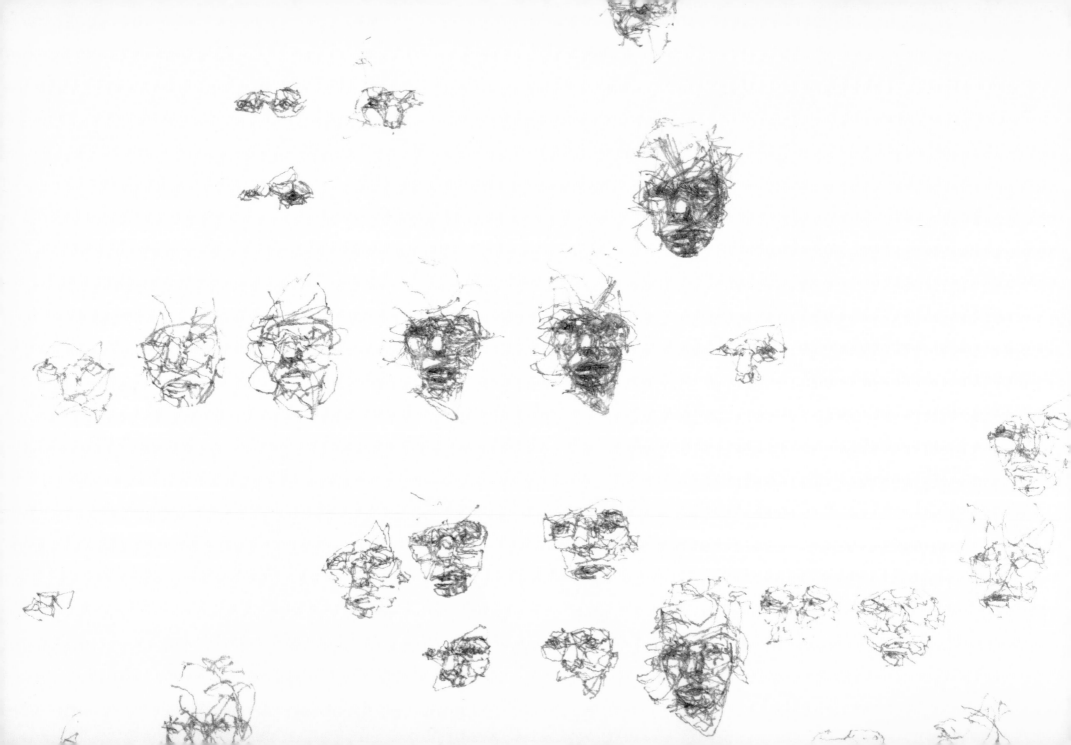

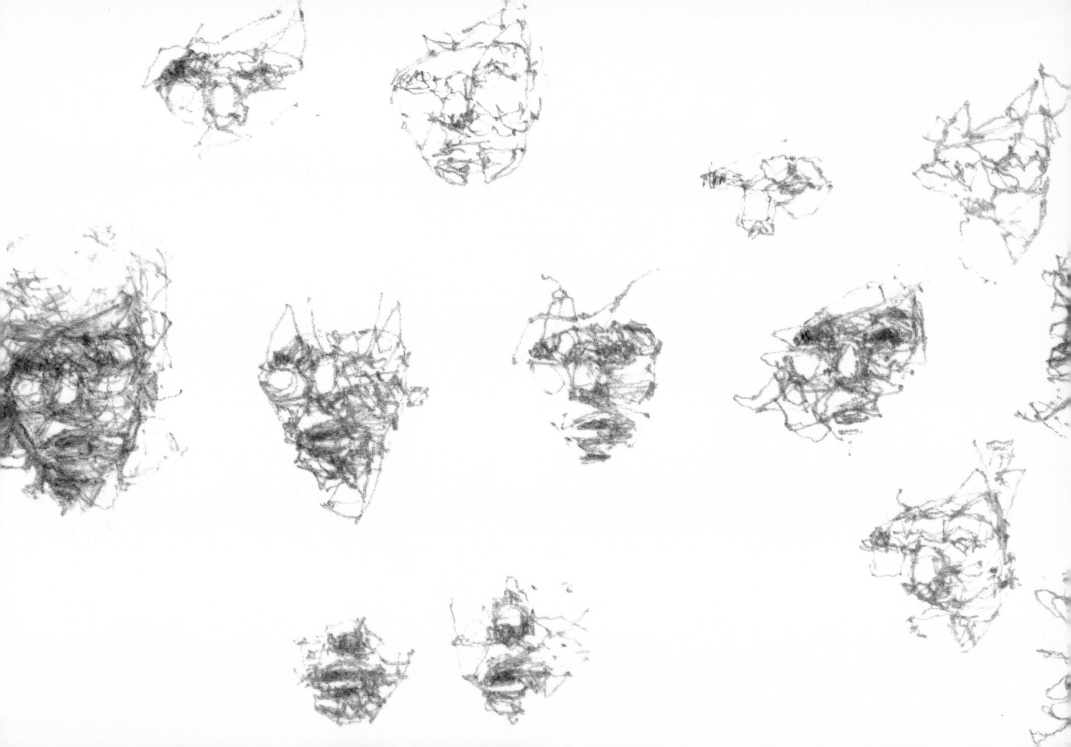

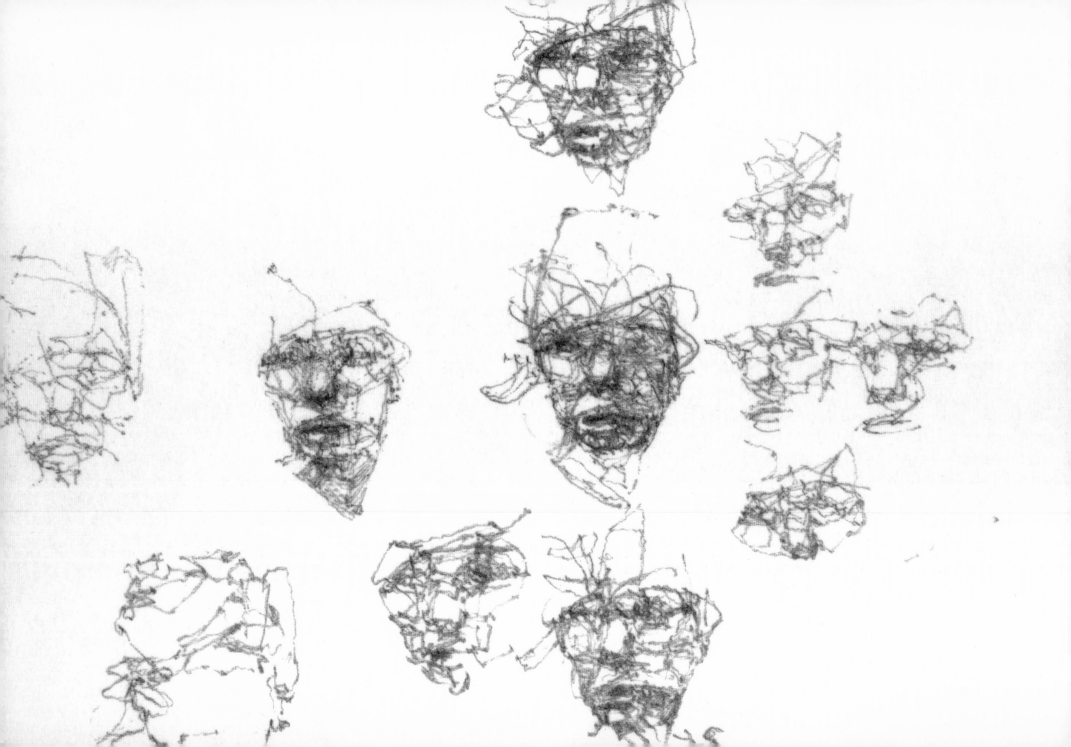

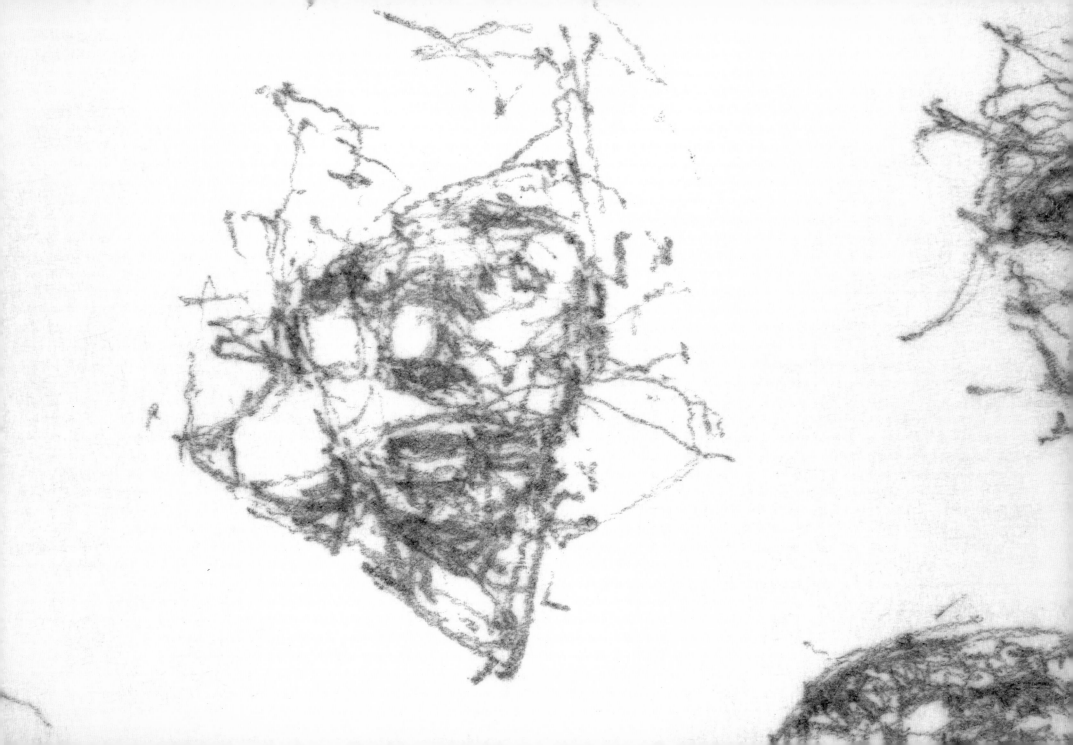

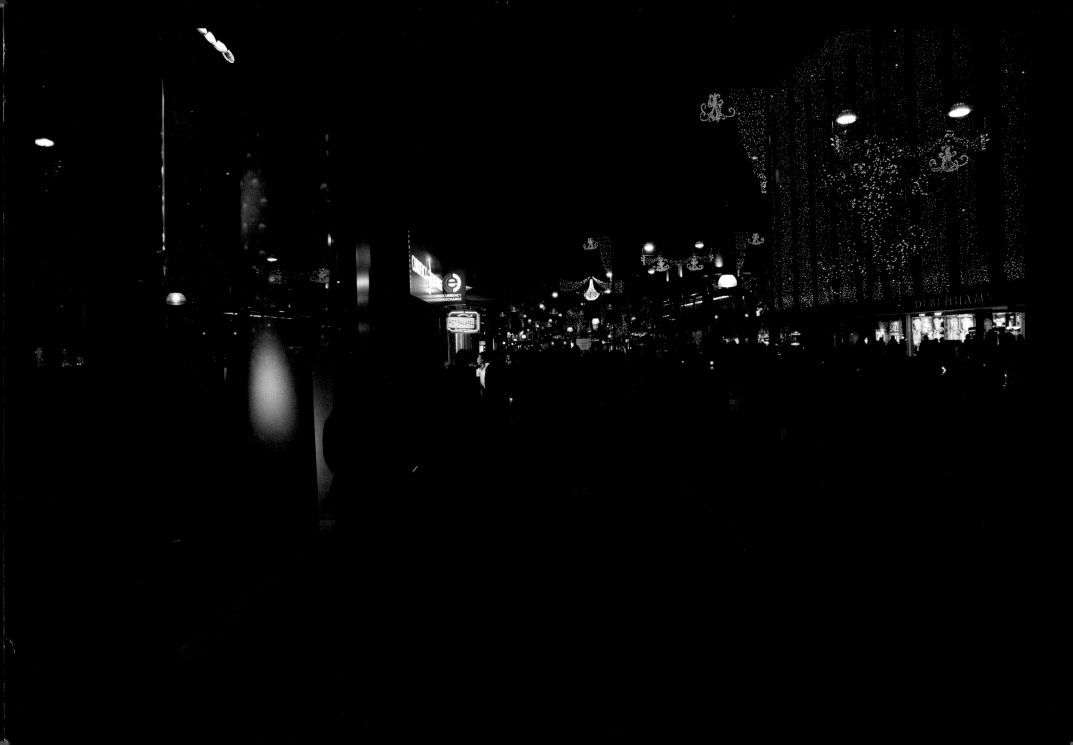

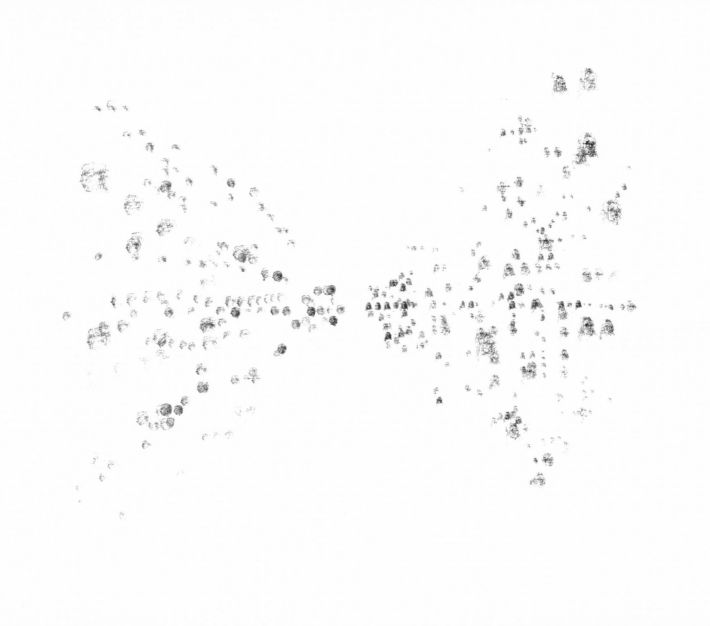

CURRENCY
EXCHANGE

HOT FALAFEL

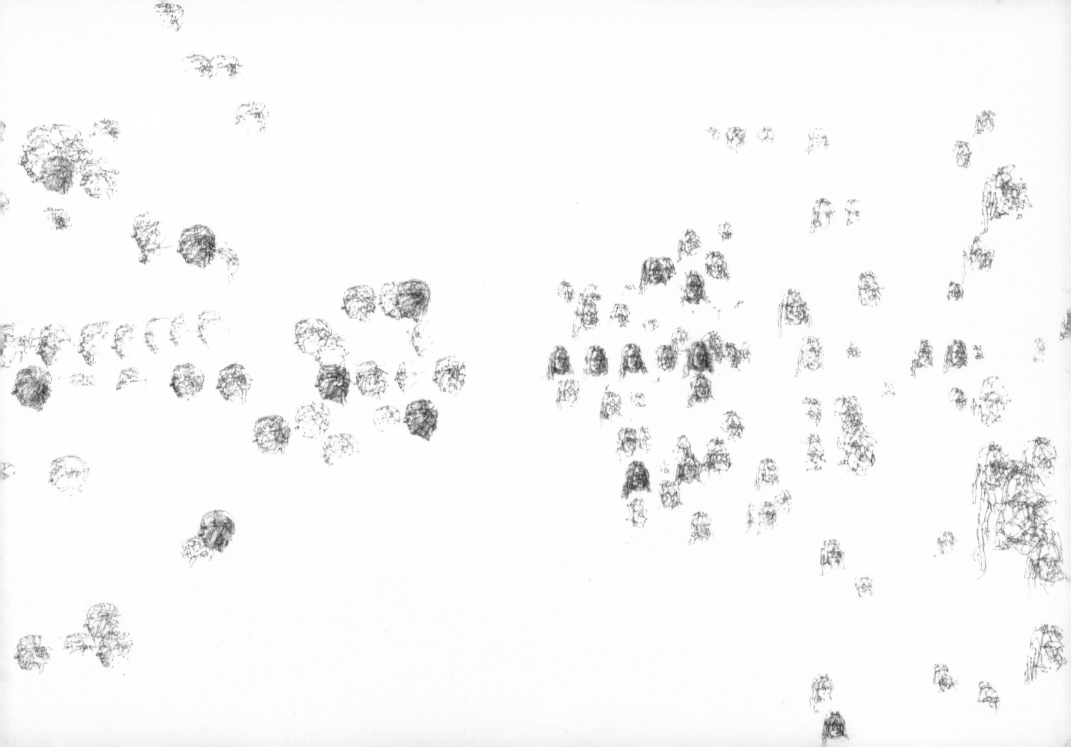

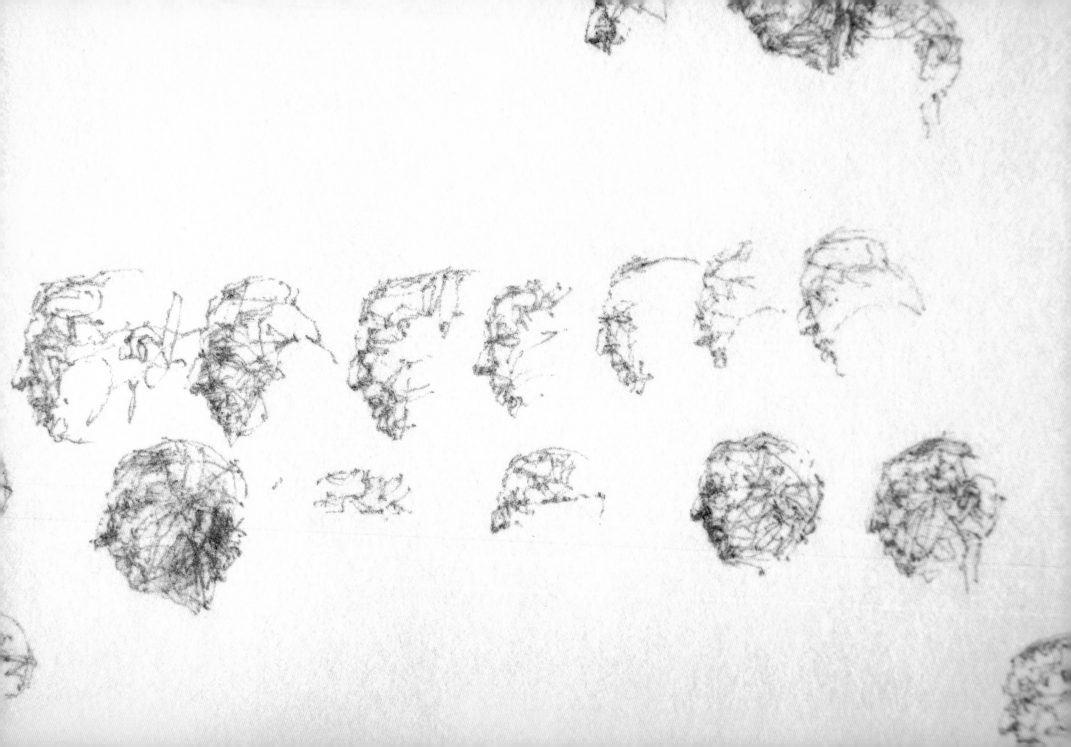

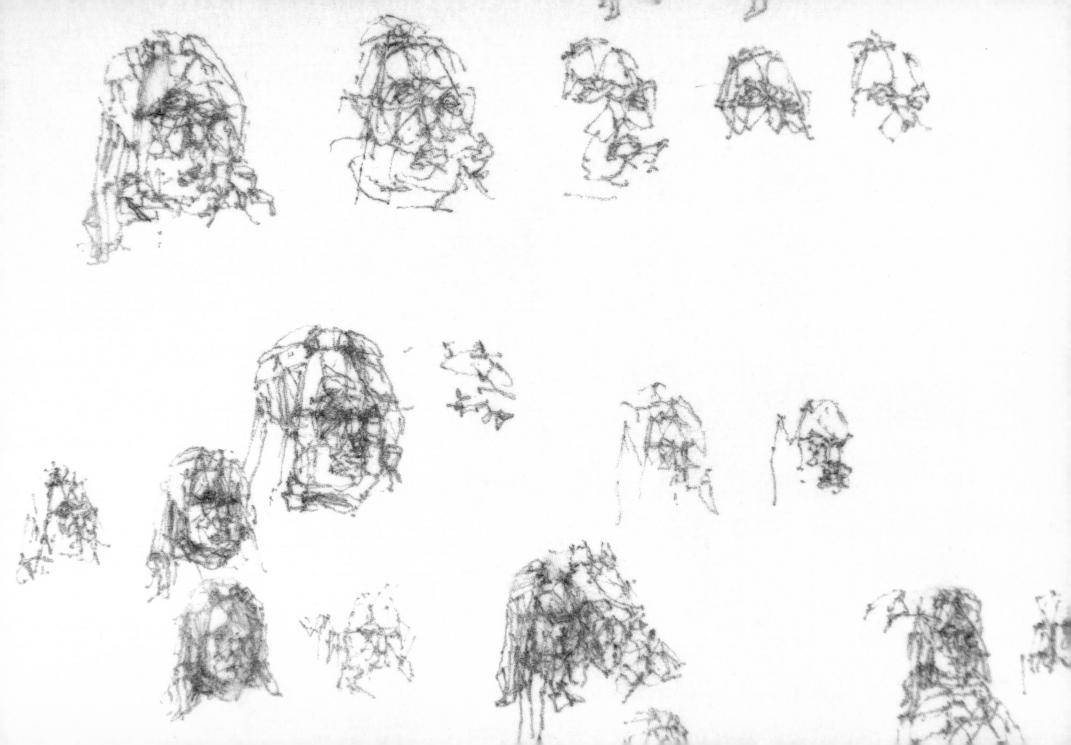

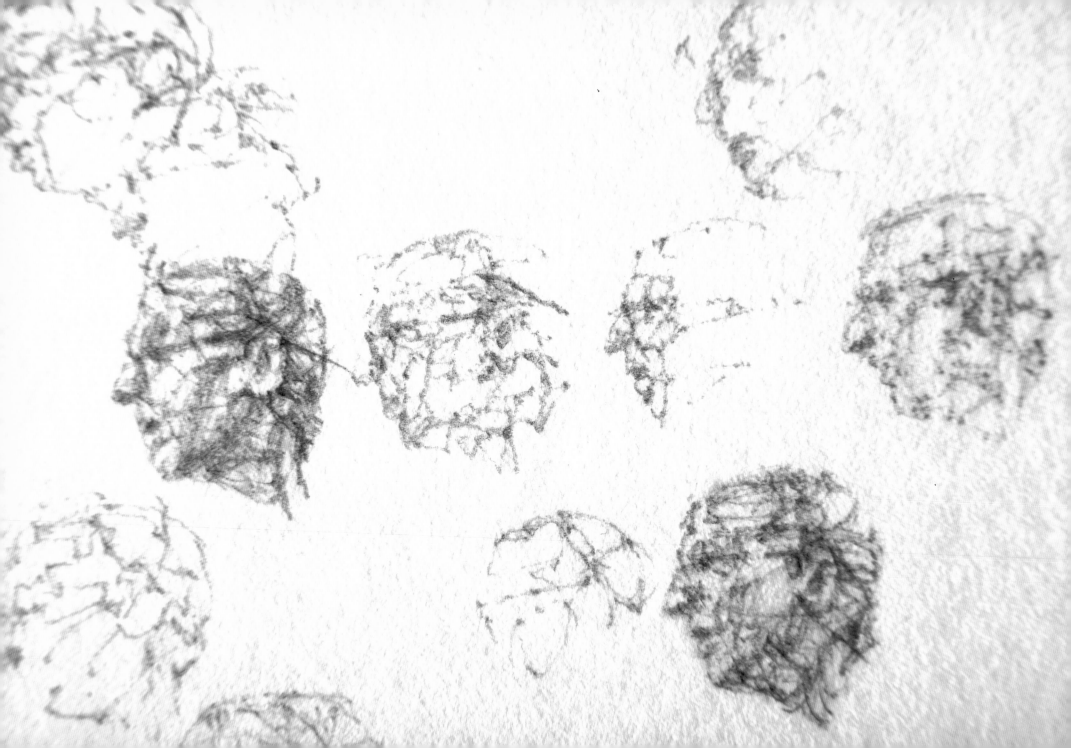

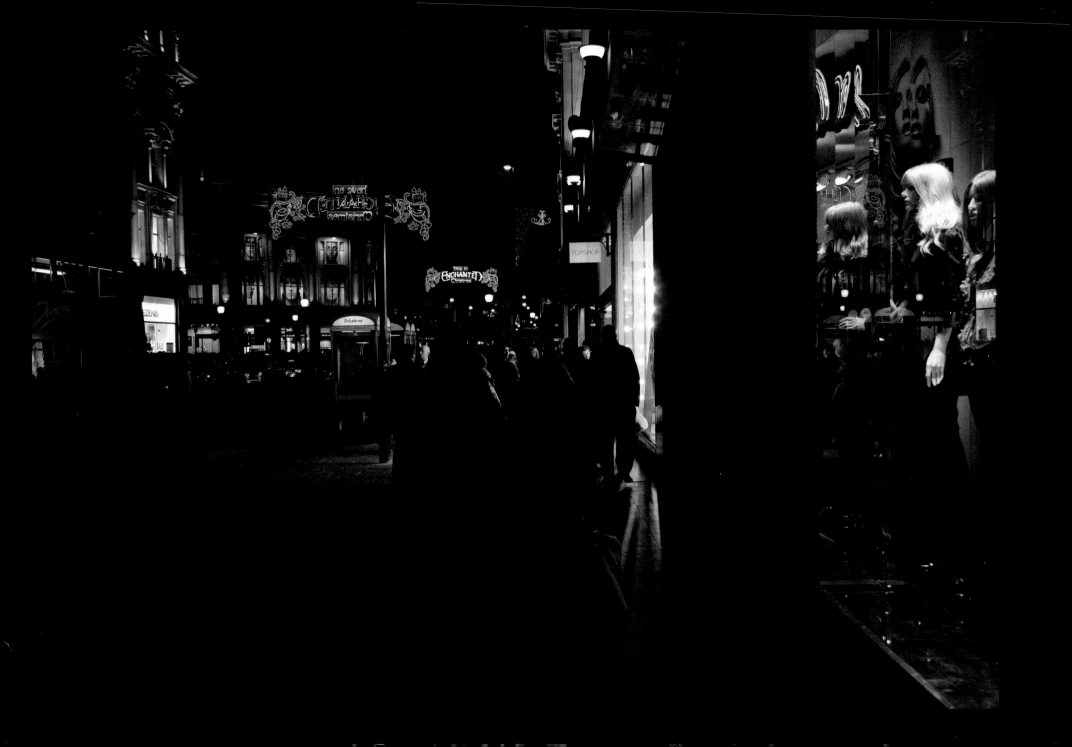

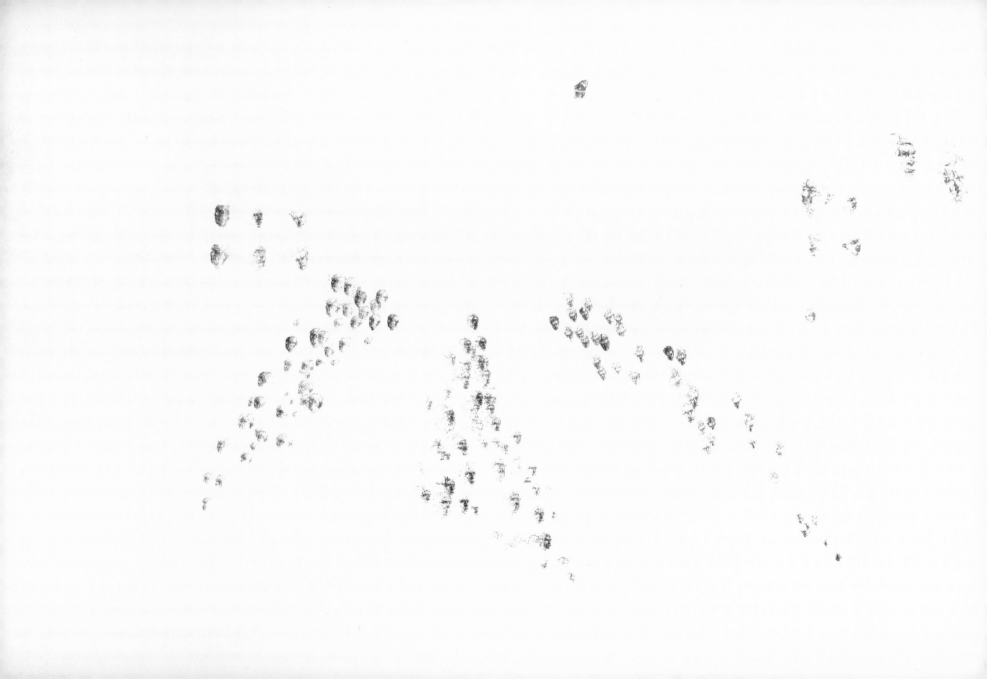

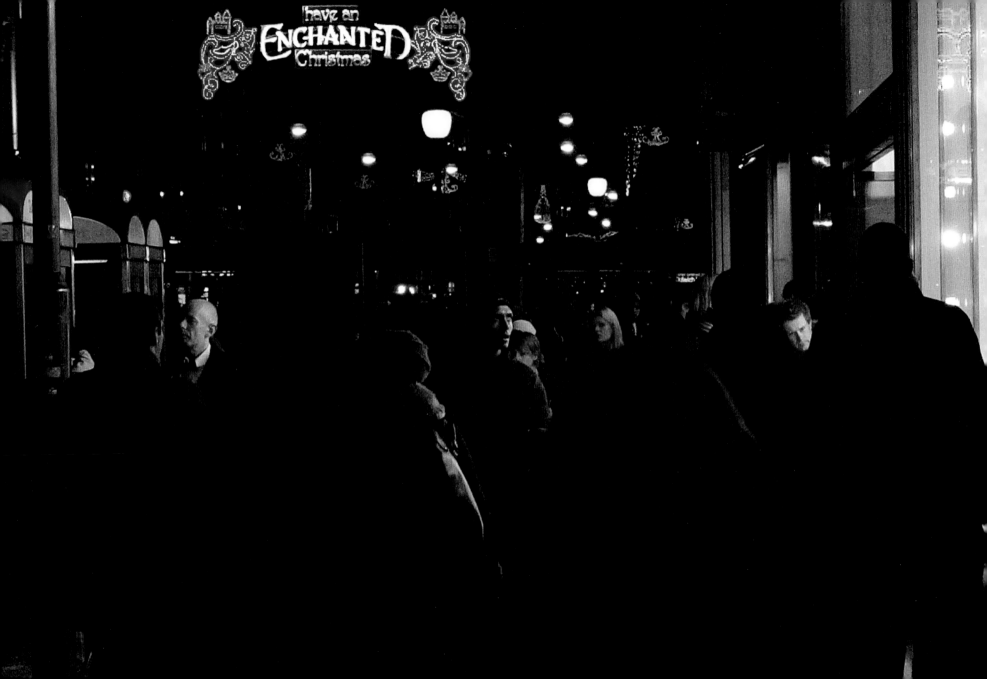

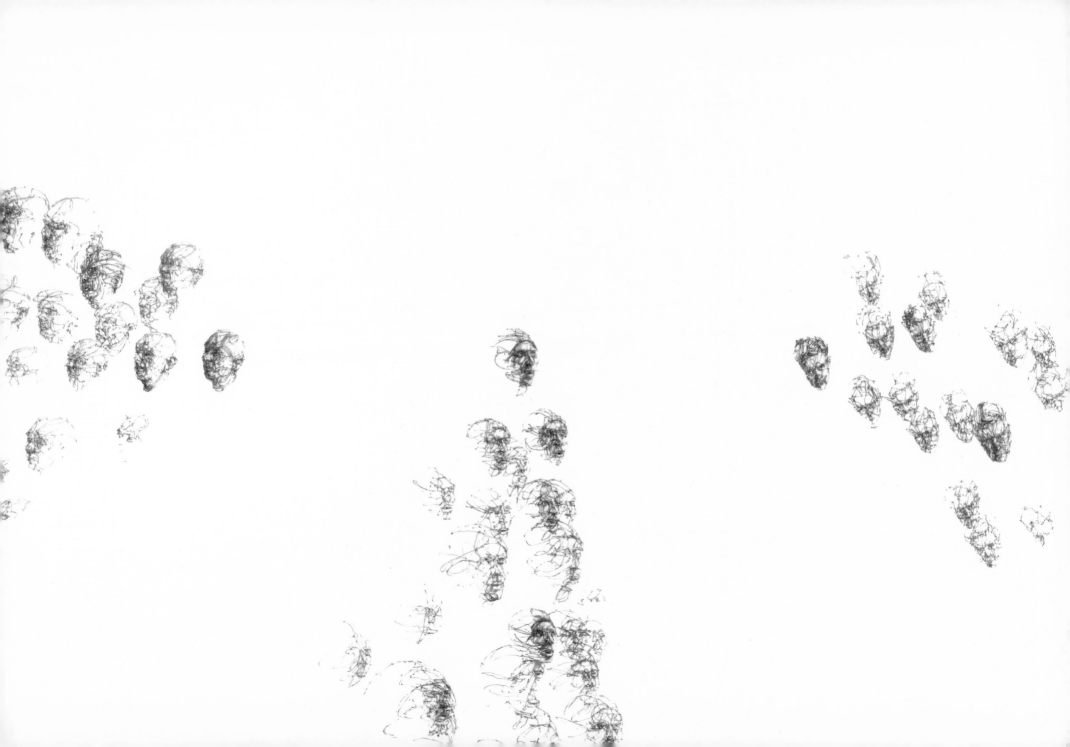

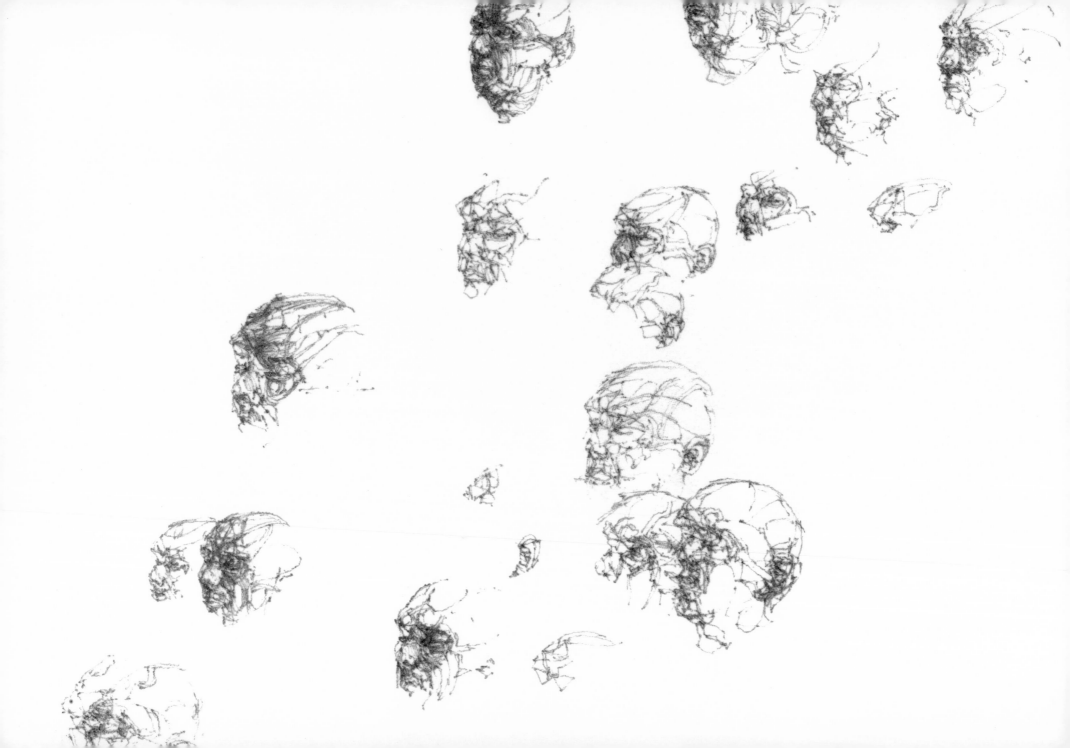

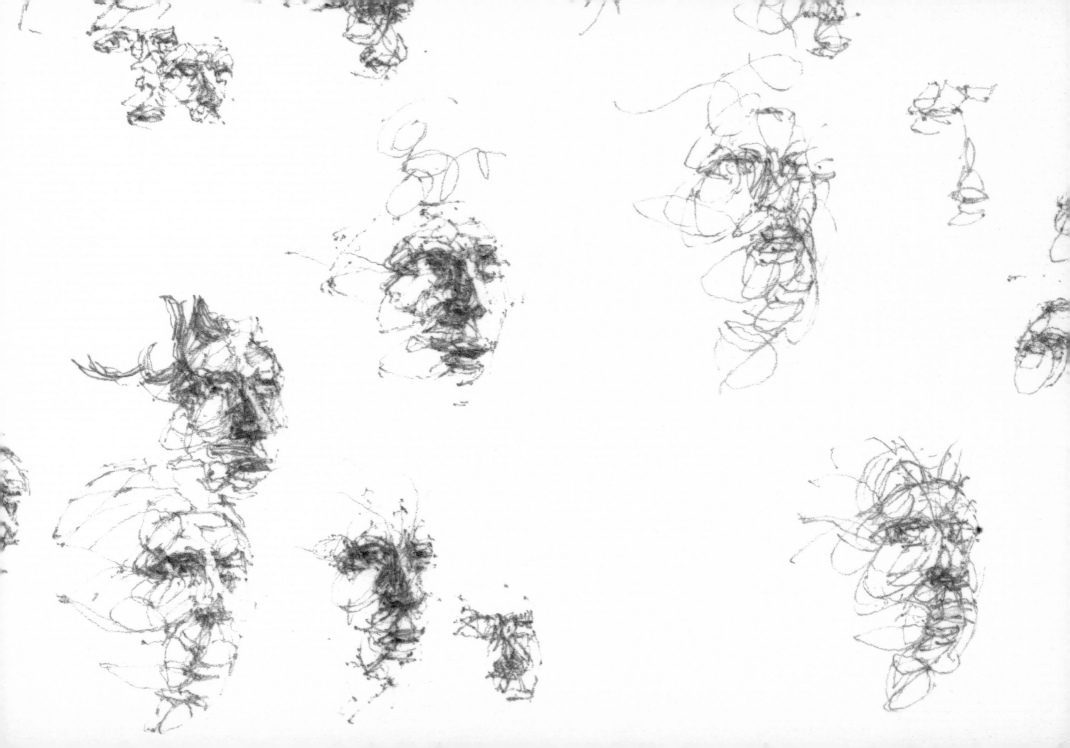

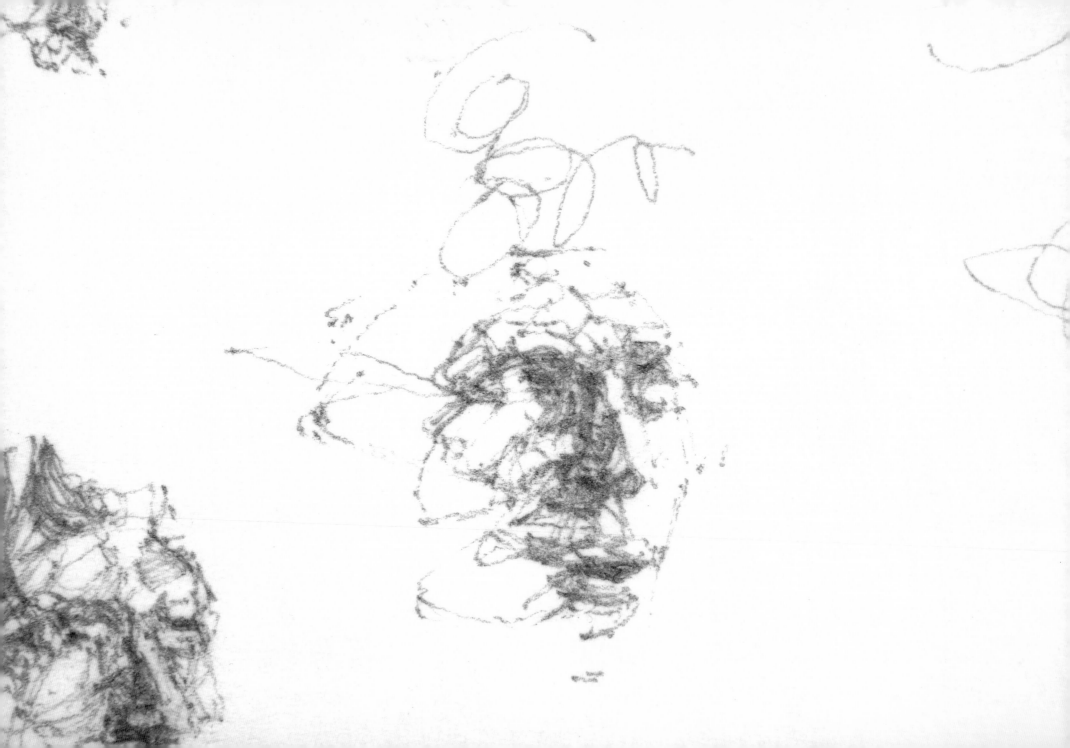

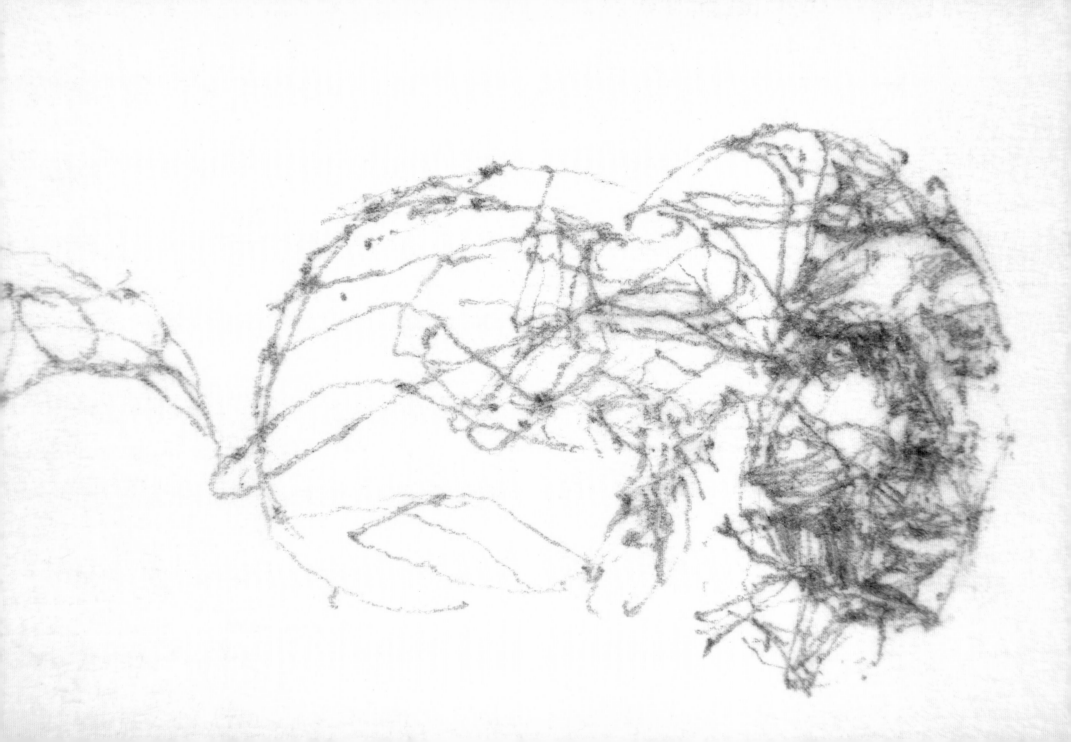

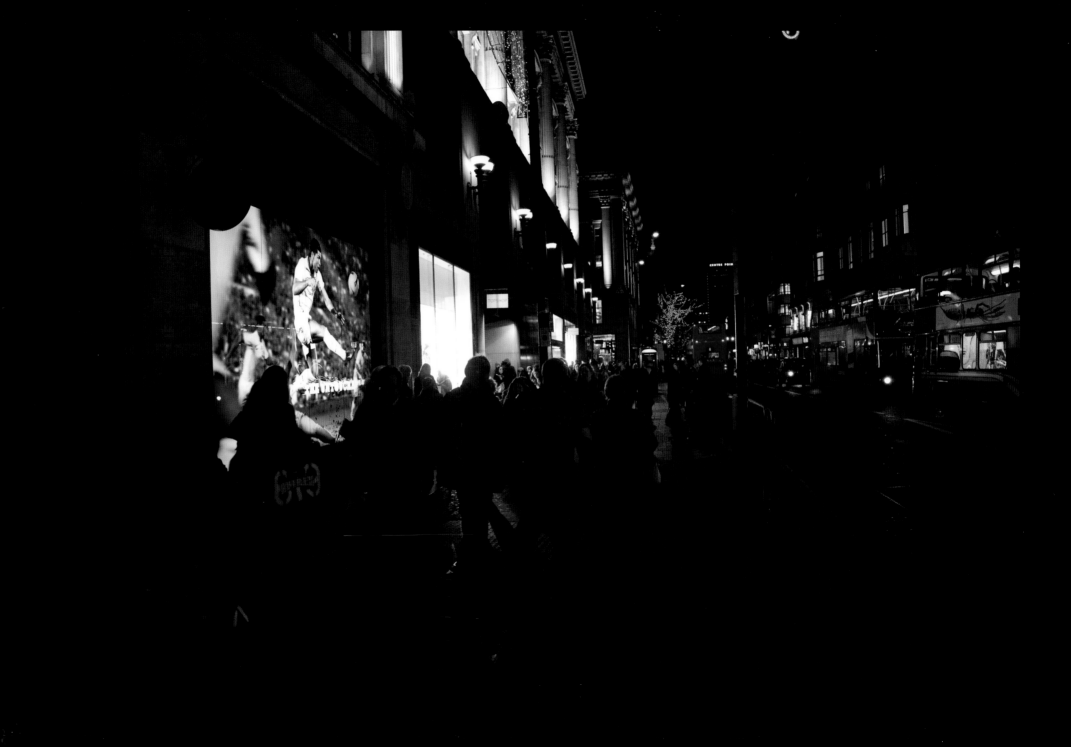

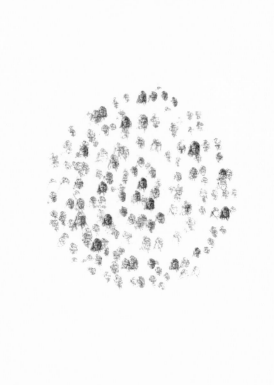

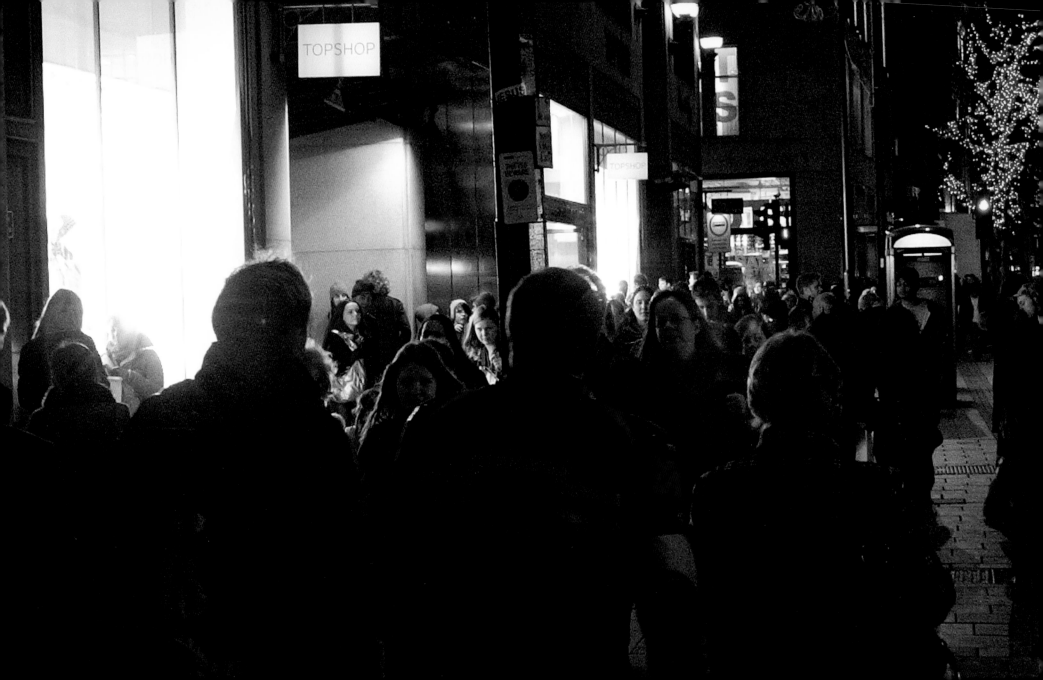

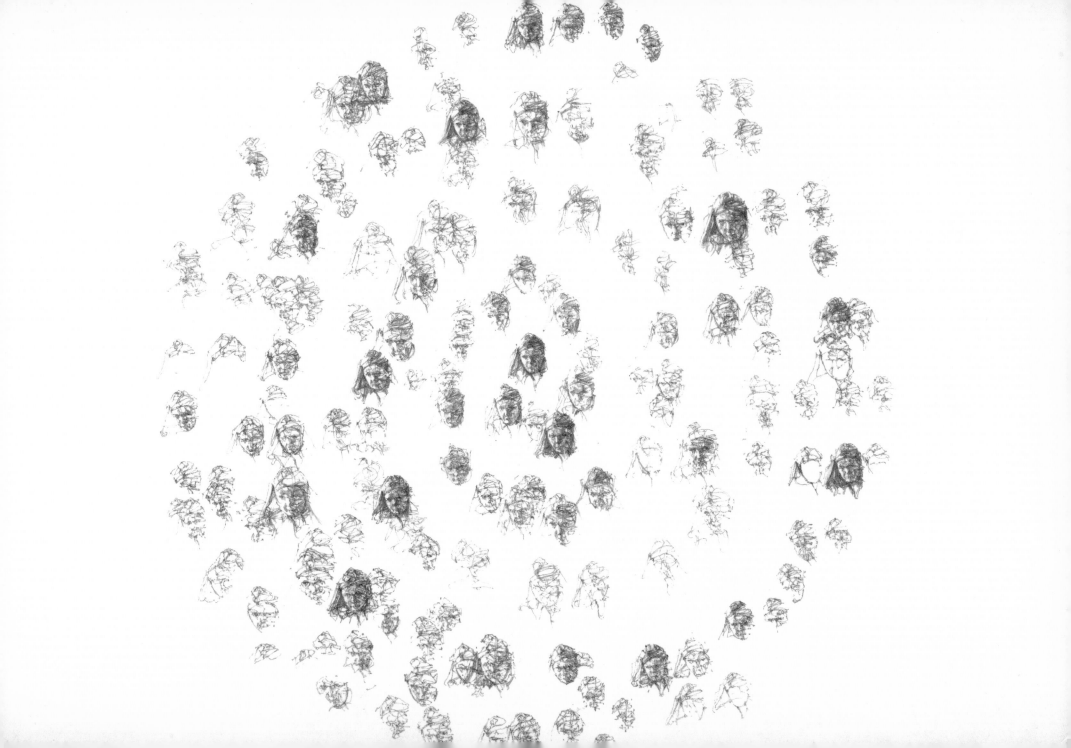

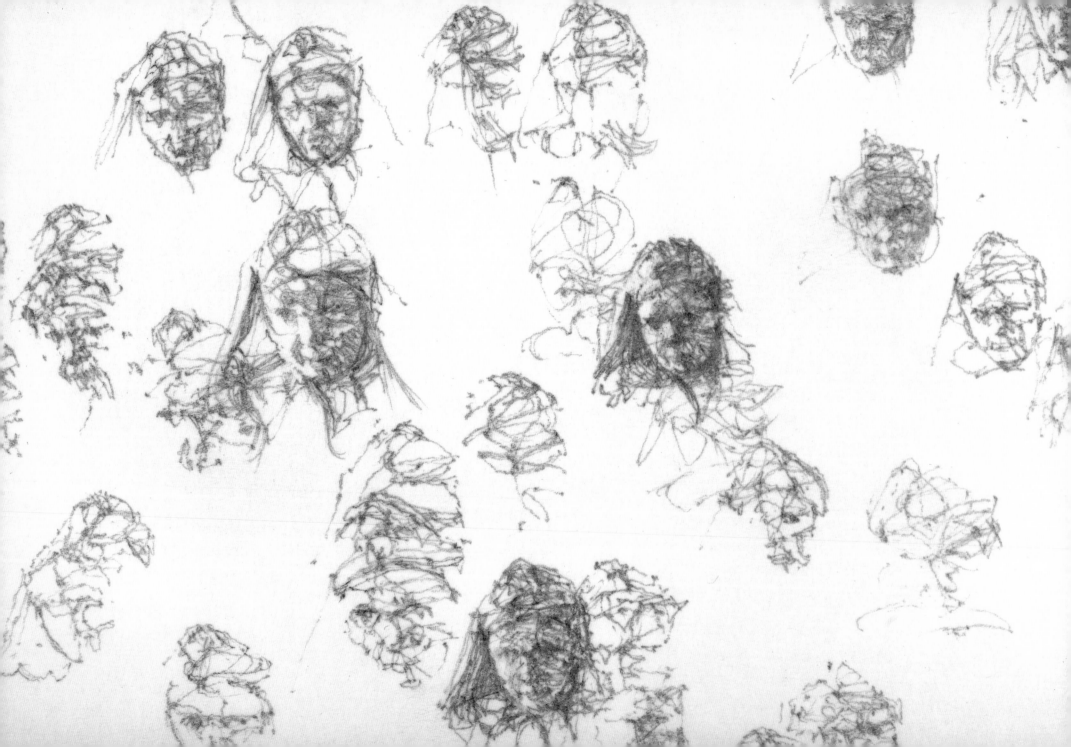

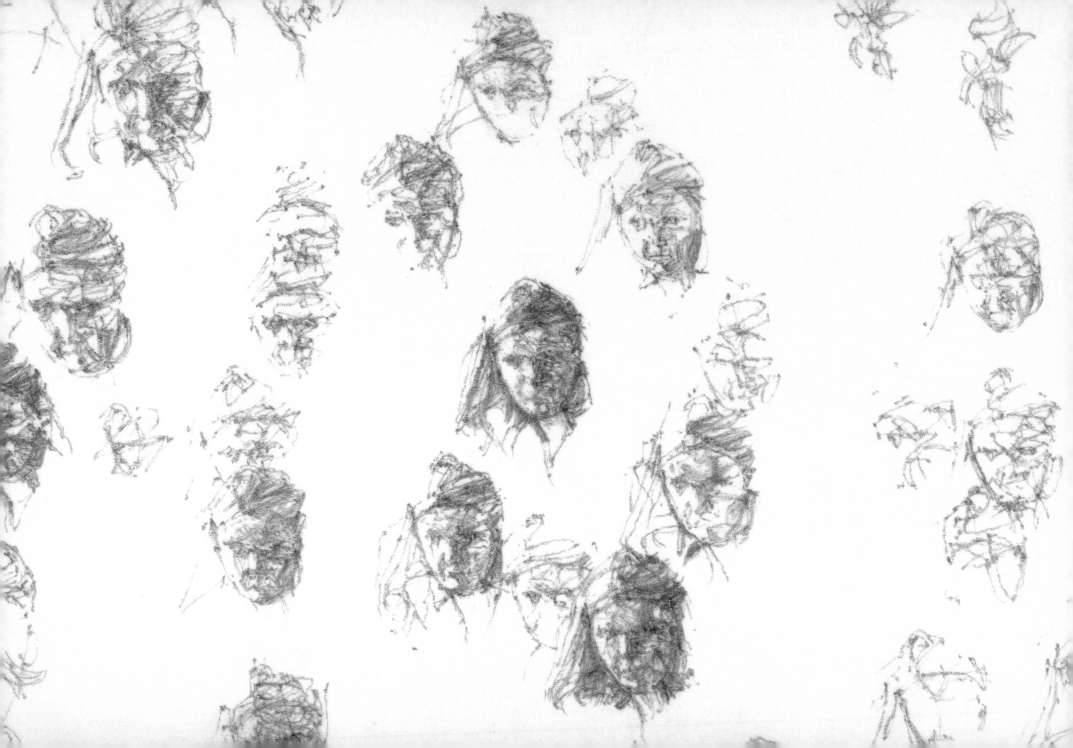

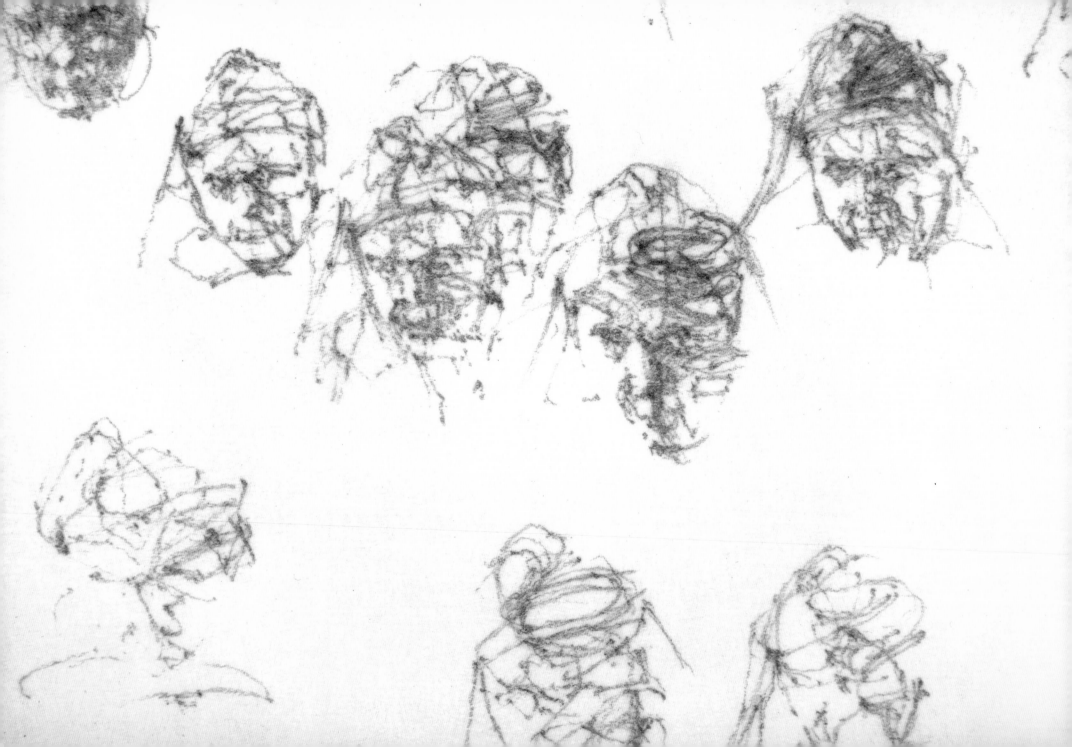

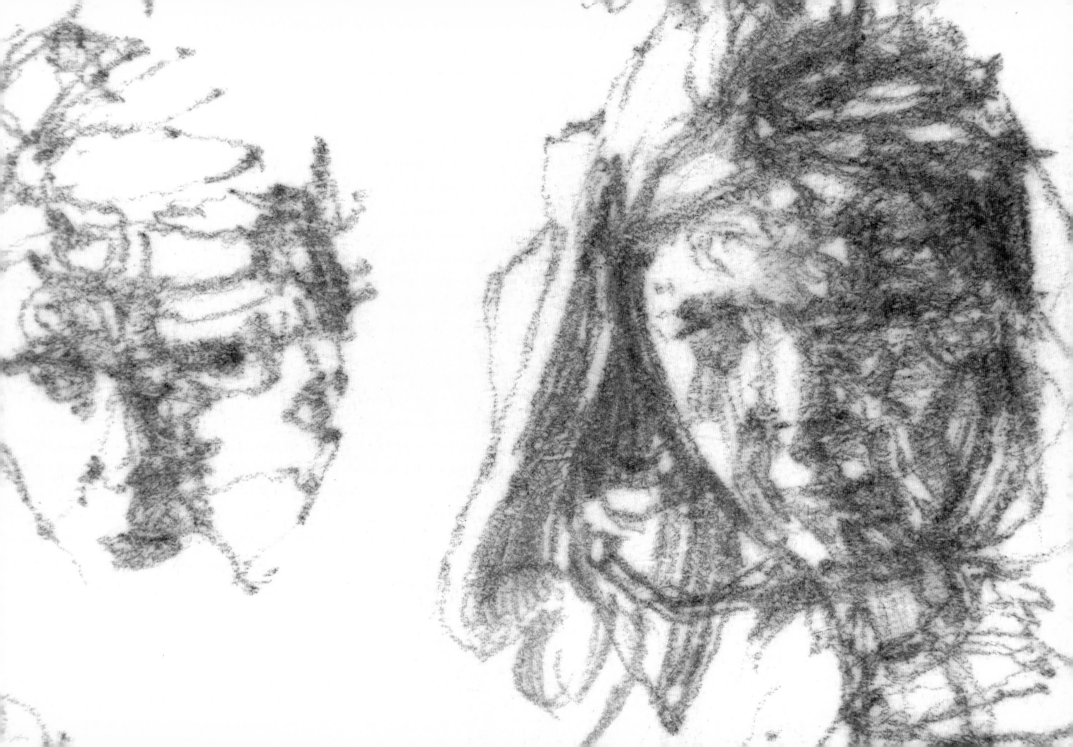

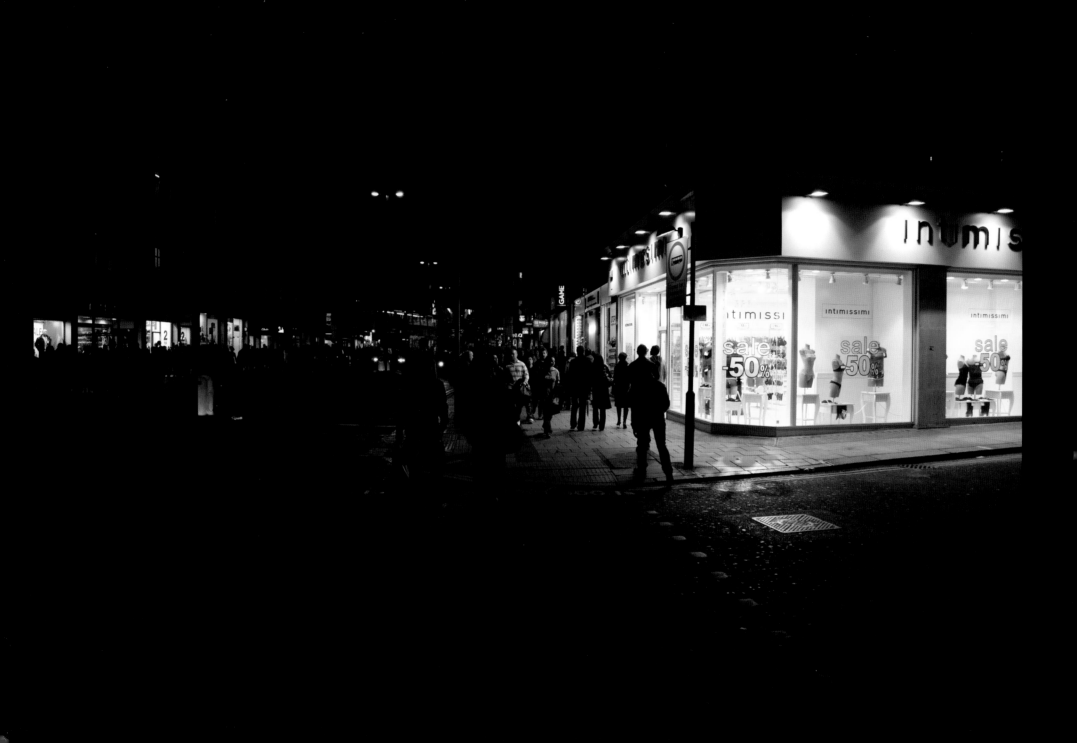

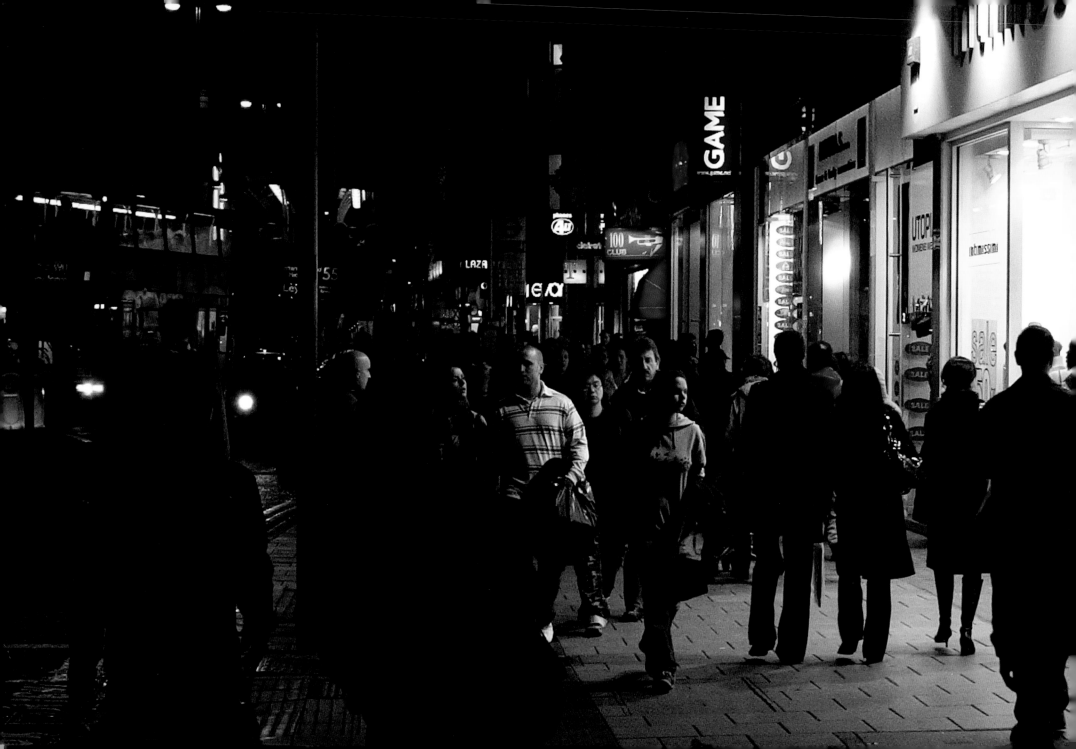

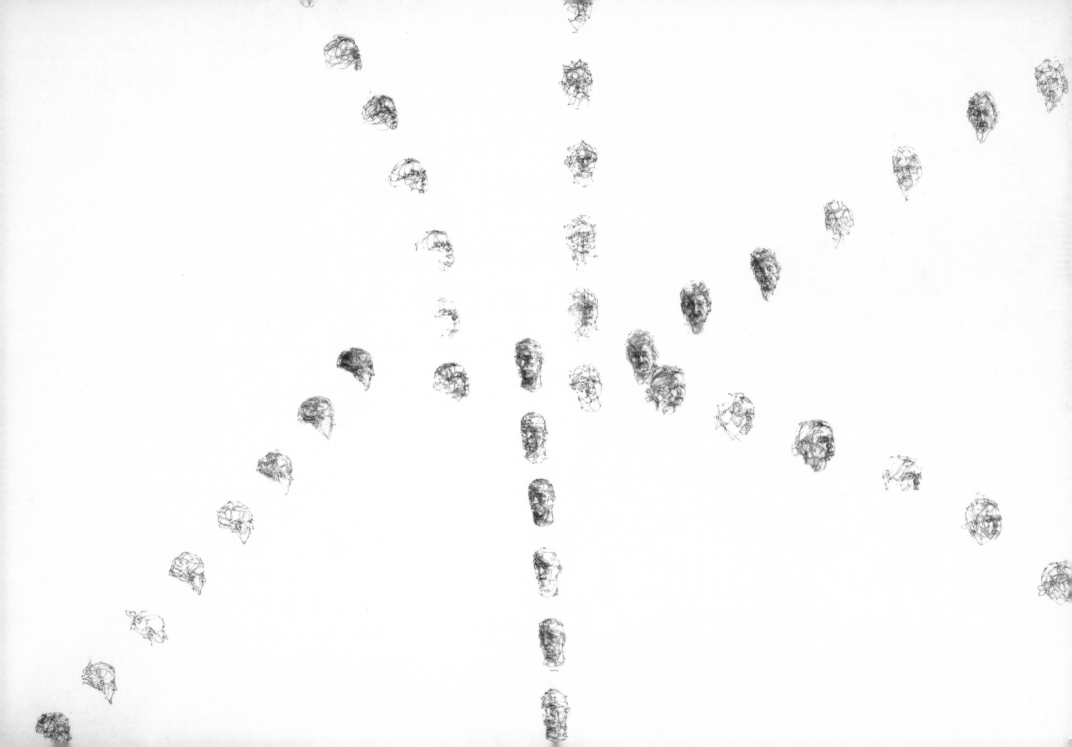

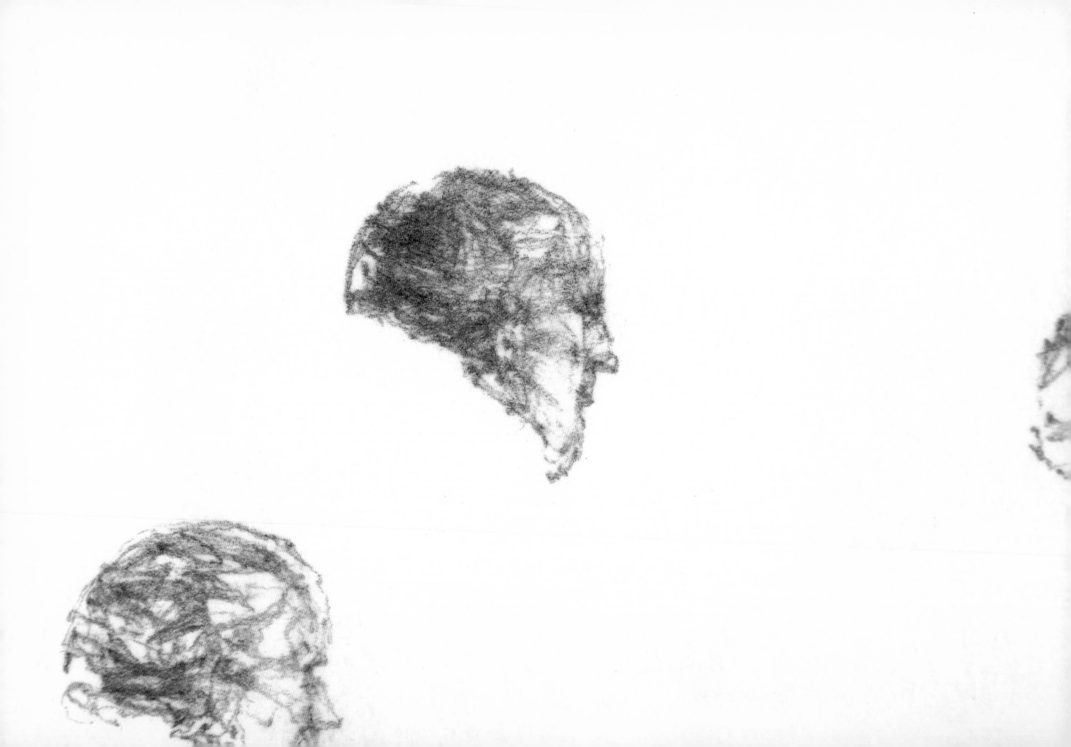

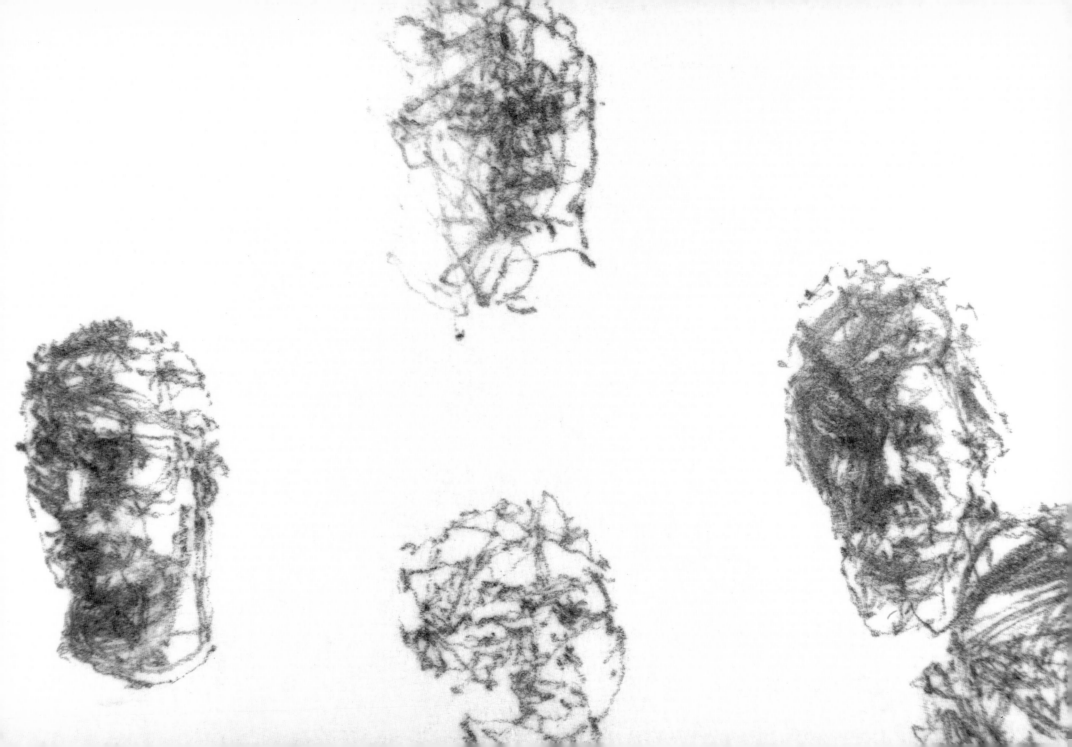

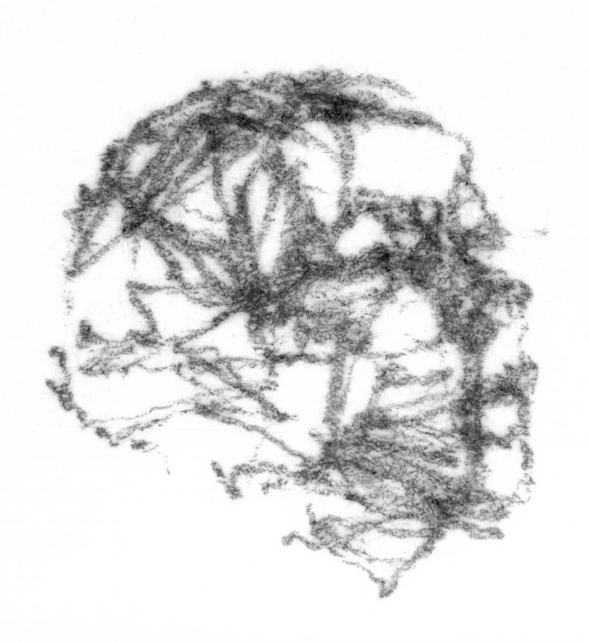

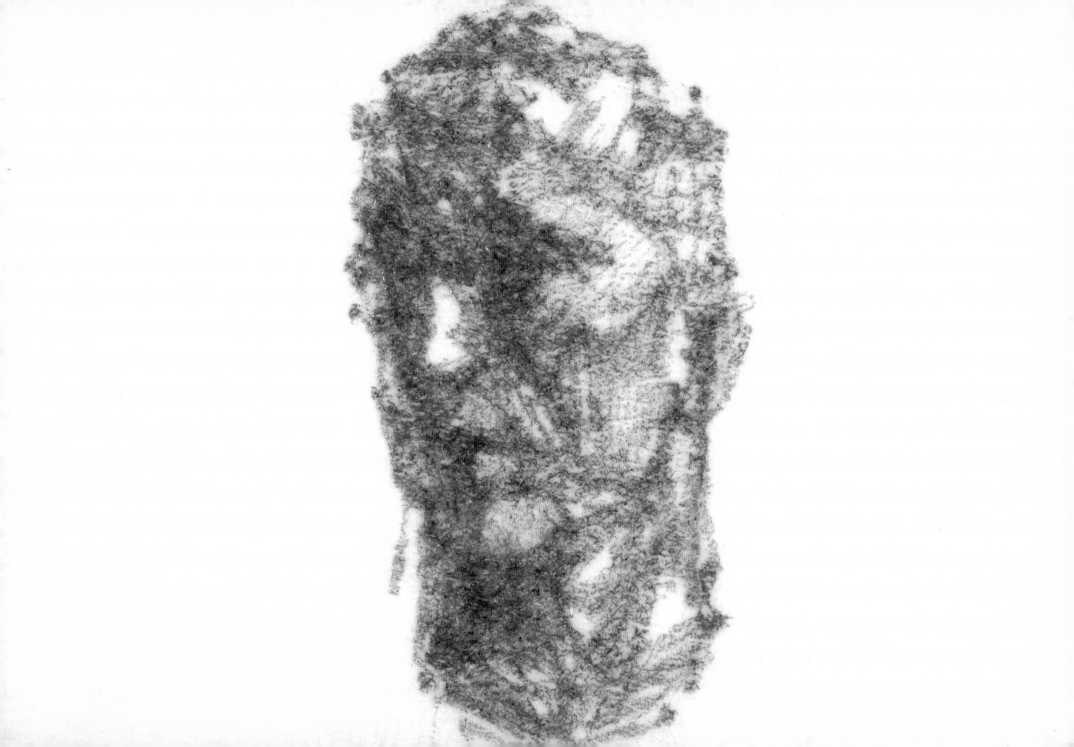

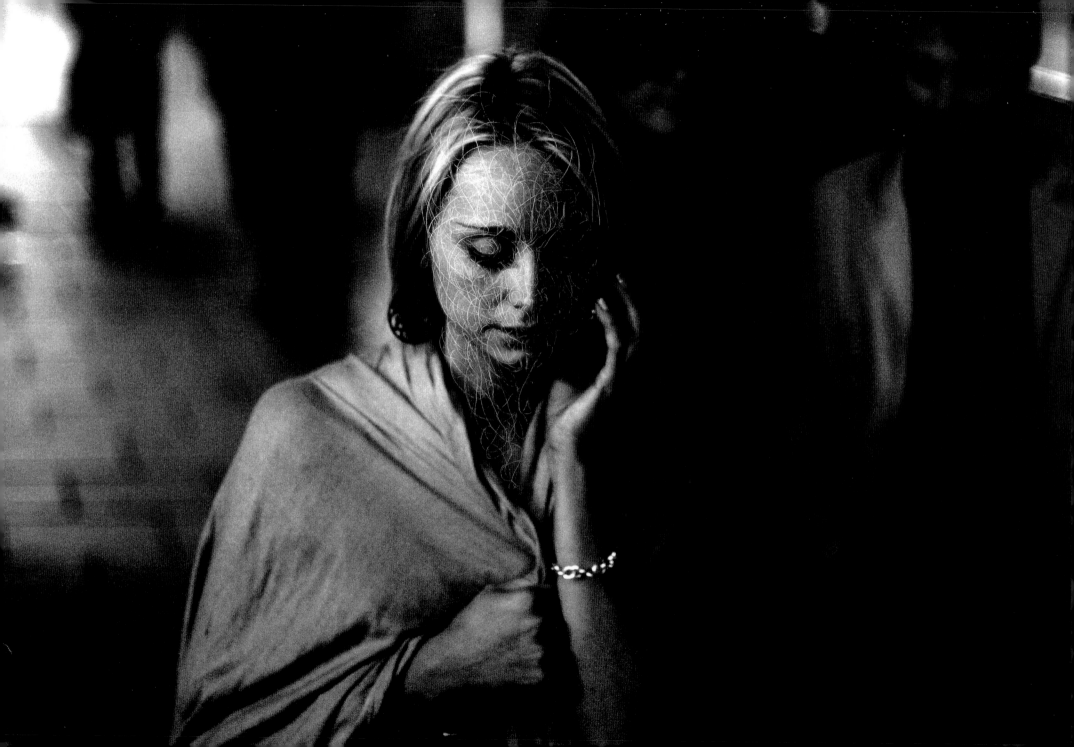

INCOMPLETION

1] Quoted in Vicki Goldberg
(ed), *Photography in Print:
Writings from 1816 to
the Present*, New York:
Touchstone, 1981, p. 385.

2] For a discussion of Cartier-
Bresson's affiliations with
Zen Buddhism see Colin
Westerbeck and Joel
Meyerowitz, *Bystander:
A History of Street
Photography*, Thames and
Hudson, London, 1994,
p. 165-166.

3] Quoted in Westerbeck
and Meyerowitz, p. 154.
Cartier-Bresson was
referring specifically to
an evenness of tone in
his prints, but one might
equally extend that term
to a sense of overall
connectedness in
the image.

Drawing is central to Dryden Goodwin's art, and yet he has always stressed its speculative quality, its incompleteness; its final form as a means of representation remains for him, in some important sense, forever elusive. In contrast, so much 'creative' photography has been fuelled by a drive towards something complete: reality condensed into neatly framed segments, edited for formal strength, finely printed, the photograph arrests time and seals it, preserves it in great detail and with an authority — some underlying truth — that purists would still argue is the very foundation of photographic art. For many conceptual artists however, from the 1960s onwards, photography was attractive not because of its formal beauty or the eloquence of its inherent 'language', but precisely because it was so banal, so mechanical and so removed from the waning ideas of 'expression' and 'the gesture' and all the assumptions about art that went with them. Yet in Dryden Goodwin's work, photography has been absorbed into a practice that retains a distinct sense of the expressive. There seems, in his increasingly hybrid practice, a determination to preserve drawing, and particularly drawing of the human face, with a quality of sinuous line that might be said to deliberately counter the ways in which photographic culture reflects our lives back to us. In the following notes I reflect briefly on some of these ideas, to open up and broaden the context of Goodwin's work particularly in the direction of photography and its history, those things with which the artist has formed such an uneasy alliance.

I The Tapestry

Much of modern photography has been in thrall to the idea of the 'decisive moment', a point at which the observed world coheres into a formal arrangement of visual intensity and interconnectedness before the camera lens. For Cartier-Bresson, with whom the term is so closely associated, achieving that point depended on working 'in unison with movement', with a recognition that 'inside movement there is one moment at which the elements in motion are in balance. Photography must seize upon this moment and hold immobile the equilibrium of it'[1]. There is a strong sense in this statement of a Zen-like physical mastery[2], a level of difficulty and possible accomplishment that might be acquired but not exactly learned. Embedded in this, too, is an impulse towards perfection, of perfect poise on the part of the photographer and a finely tuned completeness to the photographic image, some higher visual order grasped and sealed within the warm tones and smooth surface of the print, like the 'tapestry' that, as John Szarkowski once recounted, Cartier-Bresson wanted his prints to resemble[3]. Although this notion of the complete, balanced photograph has permeated deeply into the photographic imagination it has been an especially durable model for the street photographer, for whom this seemingly miraculous rendering of harmony in the face of continuous flux and urban chaos is only made more fascinating and alluring by its essentially equivocal nature. For many critics of course it is precisely these formal arrangements of light and shade, implying shafts of unspecified insight, that reveal the essentially reductionist, fictive world of the photograph, a world Susan Sontag, writing in *On Photography* in 1977, saw as nothing more

than 'a series of unrelated, free-standing particles… The camera makes reality atomic, manageable, and opaque'. For Sontag, in her seminal text, all photographs offered was 'the character of mystery'[4], which ultimately worked against any meaning or understanding that might be derived from them.

But, for many, the making of photographs, and street photographs in particular, is not a rational process but one steeped in instinct and physicality; the magic of photographs can never be completely 'understood' but is rather an extension of the senses, of the body reacting to the world. This is how Joel Meyerowitz, a photographer renowned for his pictures of the street and urban environments, describes his experience of photographing: 'It's like going out into the sea and letting the waves break over you. You feel the power of the sea. On the street each successive wave brings a whole new cast of characters. You take wave after wave, you bathe in it. There is something exciting about being in the crowd, in all that chance and change – it's tough out there – but if you can keep paying attention something will reveal itself…'.[5] The implication is that the skill and finesse of the street photographer is bound in a sensory world, to do with minutely calibrated combinations of anticipation and action, to sense and to act; the photograph is derived from purely physical reflexes that the camera becomes an integral part of. The 'Decisive Moment' the title of Cartier-Bresson's 1952 publication was, as Colin Westerbeck has pointed out, in fact a misleading English translation of *Images a la Sauvette* (roughly 'Images on the run'); 'the moment referred to is that just before a decision is made, the moment of anticipation rather than conclusion.'[6] Truman Capote remembered watching Cartier-Bresson at work on a street in New Orleans, 'dancing along the pavement…click, click, click (the camera seems to be part of his own body), clicking away with a joyous intensity, a religious absorption.'[7]

4] Susan Sontag, *On Photography*, Penguin, Harmondsworth, 1979, p. 23.
5] Westerbeck and Meyerowitz, op cit., p.2-3.
6] Ibid., p. 156.
7] Ibid., p.156.

II The Hand

If, according to Barthes, the finger is the true organ of photography, if it is the hand and not the eye that sets the photographic process into action, then it is also the hand that habitually hovers over its final prints, compelled to touch and to trace, to bring the photograph back to life or otherwise to obliterate it.

The idea of the camera/body – both the body as a machine, and the camera as a sensory 'limb' – is widespread in the evolving character of the photographer as the prime social observer of modernity. But the physical connection, the presence of the body and specifically the hand, is something that persists beyond the point of exposure, through the processing (at least in the pre-digital era) and the articulation of the photographic work. The final print, guided through the darkroom by hand, is an object of reverence for the photographer and those first permitted to view it at close quarters (the partner, the curator, the student, another photographer…). Carefully unveiled and handled, it is the hand that then commonly plays a central part as the photograph is introduced, explained and discussed. At first broad gestures will tend to sweep across the print's surface, and then a finger will begin to locate different points, places or things in the picture while also drawing imaginary connecting lines between them. The pointing finger gradually criss-crosses the image weaving an invisible net, another form of 'tapestry' perhaps, that somehow holds that elusive meaning, the equivocal heart of the photograph.

The gentle holding, hovering, delineating, stroking and pointing hand of the photographer as the photograph is teased into existence and into contact with its audience, might be likened to that of someone who traces the outline of an absent lover's face on a cherished photograph. In both the act is a kind

of summoning, a surrogate form of intimacy, and a gesture toward the life, the place, the experience that presented itself, that was there and then was lost in the brief moment of exposure.

III The Damage Done

And then, up there in the fourth floor bed-sit, the stalker's loving traces so carefully, so gently follow the outline of the face in the portrait, that object of their desire. Time passes, day into night, and the touch gradually turns into an erasing rub and then to a feverish scratching, until the coveted thing, the image, the photograph, is destroyed. Elsewhere, across the city, as multiple images flicker over banks of computer screens, the surveillance operative sits in an unkempt control room, litter from the latest take-away drifting onto the sticky carpet-tiled floor. Looking up from his half-eaten hamburger and into one central monitor, the man idly zooms in on the figure of a young woman walking briskly across the street. It is 11pm. Closer, moving in to focus on her head, he freeze-frames the image and moves the cursor across her face in a winding, curving pattern, carefully, invisibly erasing her features.

IV Resistance and Revenge

The urge towards a uniquely expressive, yet equivocal, completeness in a photograph, a pattern of interconnecting parts in the image sealed within the unblemished surface sheen of the fine print, is paralleled throughout the medium's history by its negative, the urge to disrupt that sense of perfection in its time-locked spell, to challenge its authority, its simple blank permanence, to alter and damage its surface and to remake its image with the renegade marks of the hand.

The marking of photographs might be seen in this sense as a kind of revenge for the displacement of the more approximate, contingent act of drawing by the machine-like precision of the

camera and the verisimilitude of its images. It begins with the childish defacing of photographs, the ritualised masking of faces in newspapers and magazines. What better target than a particularly inane grin, the pompous look of a politician or the over-familiar, vacant smile of celebrity on which to enact some playful private resistance against the media's simultaneous clamour for our attention and disdain for our intelligence. But the impulse goes further, from Duchamp's Dadaist prankster to those artists who, in his wake, sought to depose the authority of the photograph in relation to, among other things, cultural identity, politics and objective truth. Among these various interventions the marking of the photograph takes on an emphatically visceral connotation when applied in relation to representations of the body, which often ally the photographic surface with skin and so infer the touching, damaging or puncturing of the flesh.

But more widely, beyond the considered acts of abrasion by artists, photographs are, and always have been, the subject of abuse as private, domestic talismans of love, affection and kinship. Enduring over time, photographs are often the most treasured of all objects in this regard, but they are agonisingly mute in the face of time's impact on and erosion of those very things they seem to so eloquently capture. It is their far-reaching significance and value that makes damaging precious photographs so severe and symbolic an act, and potentially such a satisfying gesture of anger or revenge: the former partner's face scratched or cut from every picture in the cherished family album; a photograph torn in two just as the family it represents has been; or perhaps even more emotionally charged, the small cut fragments of a photograph painstakingly reassembled to celebrate an unlikely and fragile reunion. Of course such potent objects have also, in turn, attracted the attention of artists, adding a hand-crafted, visceral intensity and a sense

8] Quoted in *Joachim Scmid: Photoworks 1982-2007*, Photoworks/Tang/Steidl, 2007, p. 21.

9] Quoted in David Alan Mellor, *The Barry Joule Archive: Works On Paper Attributed to Francis Bacon*, Irish Museum of Modern Art, Dublin, 2000, p. 31.

10] Max Kozloff, *Photography and Fascination*, Addison House, Danbury, New Hampshire, 1979, p. 28.

of what the artist Joachim Scmid has called 'voodoo-like ritual'[8] to the fascination for found photographs in an age when every creative approach to the medium, every angle, every idea and every nuance of style appears to have been exhausted.

V Retouching
The exhaustion, the weariness and dissatisfaction with the machinery of photographic production can be said to have been an implicit consequence of the growth of mass media. Increasingly, in this place of heightened desire, the photograph never quite matched up to the accelerating fantasy and ingrained idealising and dramatising of human experience that photographers, designers and picture editors — with some notable exceptions — were swept along by. Retouching photographs in this world became an obligatory retelling of the camera's dumb narrative, it was an art in itself, perhaps one of the great unseen, lost genres of photography. Readying an image for its half-tone reproduction could be surprisingly brash, like an expressionistic daub across a face or body, or it might involve the fine touch of a master craftsman, a highly prized skill of loving attention to detail.

All these things seem to have been interestingly conflicted for Richard Hamilton in the making of his well-known work based on a contact sheet of photographs of Marilyn Monroe, *My Marilyn* (1965), where private anxiety and the pressures of media fantasy converge: 'My source, my subject, was the marking by Marilyn Monroe as much as her image. The picture was also about her psychological response to the image of herself. If she disliked the way she looked in a photograph she tried to scrub herself out. It was a process of erasure — not painting in the sense of being a creative act. She used nail varnish, a lipstick or a nail file, scissors or anything that came to hand to obliterate. These were violently destructive reactions to the images

themselves. She would emphasise a frame with a rough outline and a tick if she found it more acceptable than others but she didn't tart them up. I've always been intrigued by the relationship between the photographic recording of 'reality' and a hand drawn mark. Something quite dramatic happens to a photograph when the surface is merely creased, faded or discoloured. An artistically-neutral hand-coloured black and white photograph can be fascinating. The effects become much stronger when the interaction is the result of the probing interaction of an artist.'[9]

VI Retouched
Still photographs compel us as much for what is missing as for what is there, what is actually represented. Photographs, in contrast to moving images, are what the American critic Max Kozloff once called 'iconically hushed', as the still camera does not recognise its subjects animate life it deprives them of the 'human right to put an alternative face on their inner being… they are as incapable of breaking out into a different gesture as they are of speech'. This, he says, really disturbs us but it is 'the mordant fact that gives photographs their distinction'[10], defining that uncomfortable closed world of the photograph. In one sense Dryden Goodwin's scratching of the surface of his photographs might be read as being imbued with the pathos of reaching out into that closed world and its lost time, to forcibly excavate it, and in the process return some sense of animate life to his subjects. By attempting to break back into the space of the original encounter on the street, by offering a life-line back to the world of action, the world of the moving hand, and by reinforcing a link between the photograph's transparency and its object-ness, Goodwin's mark making produces that very un-photographic thing, a third dimension, a tactile surface that, for once, the blind might read and understand.

SHAPESHIFTER

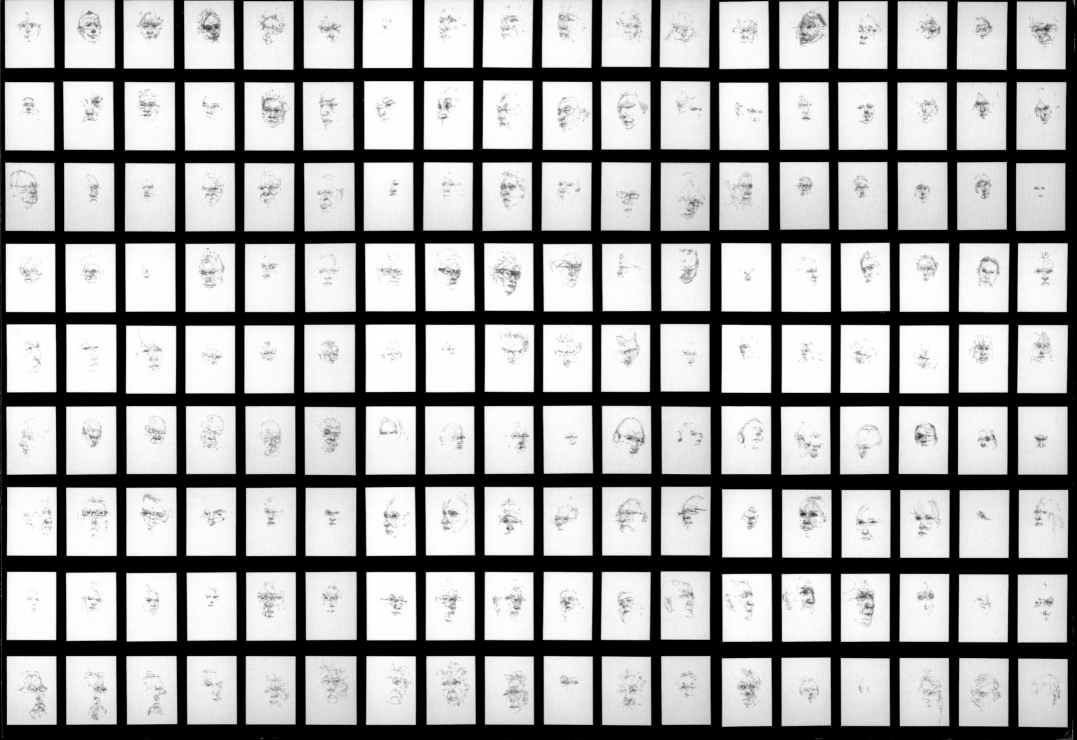

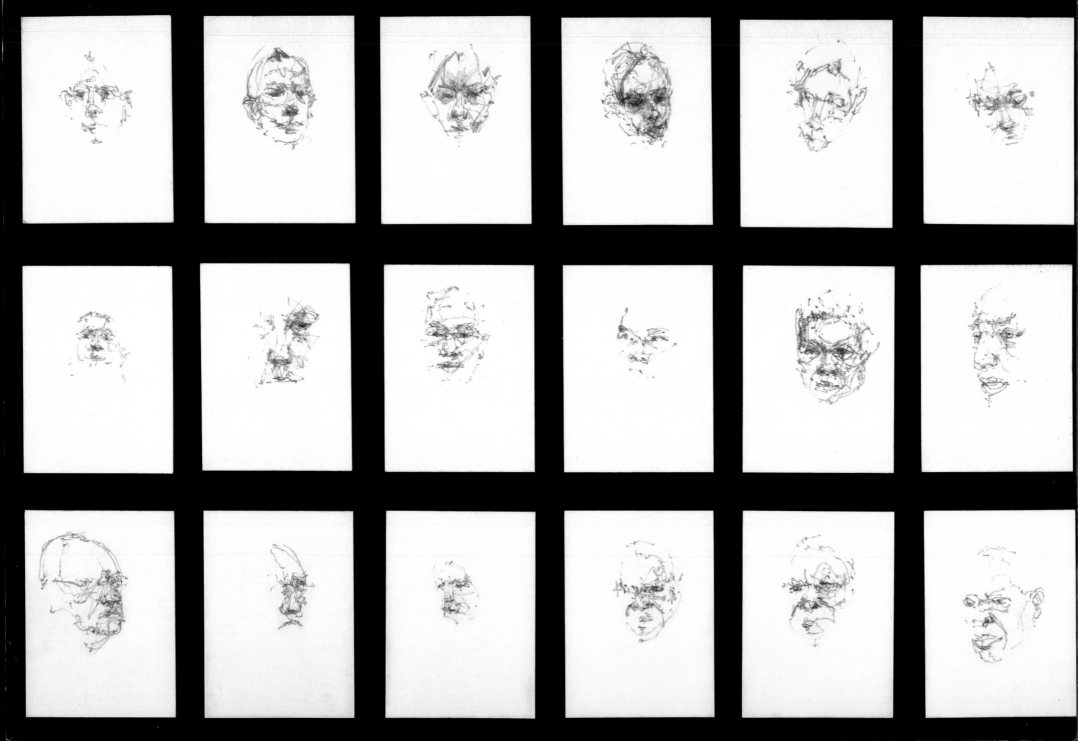

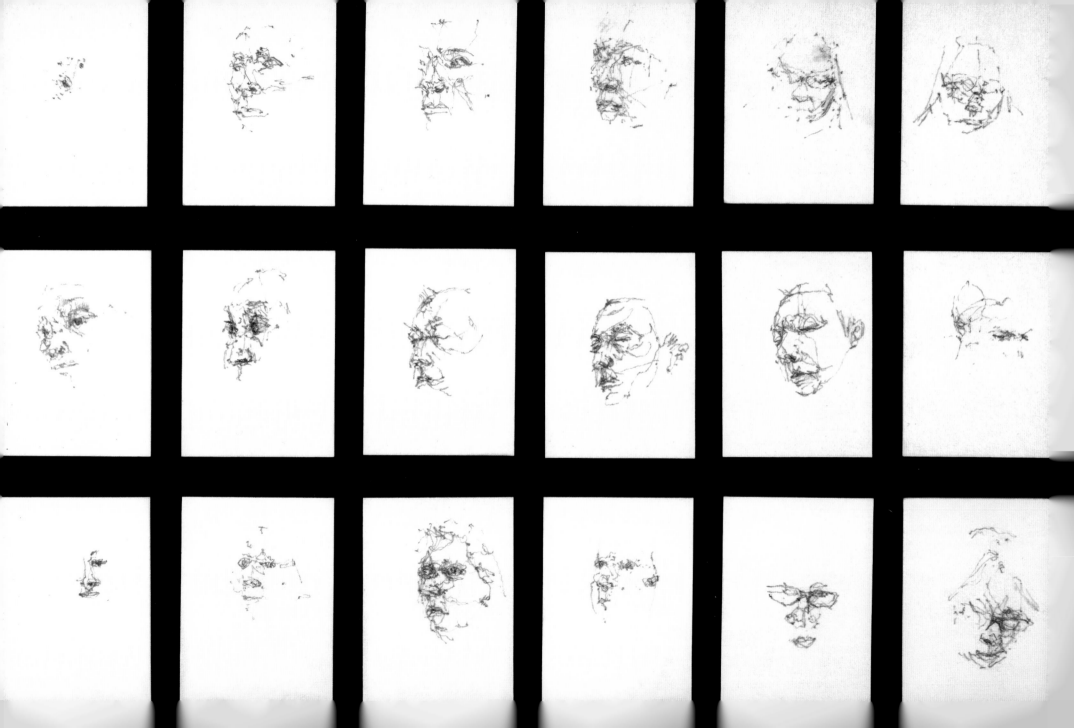

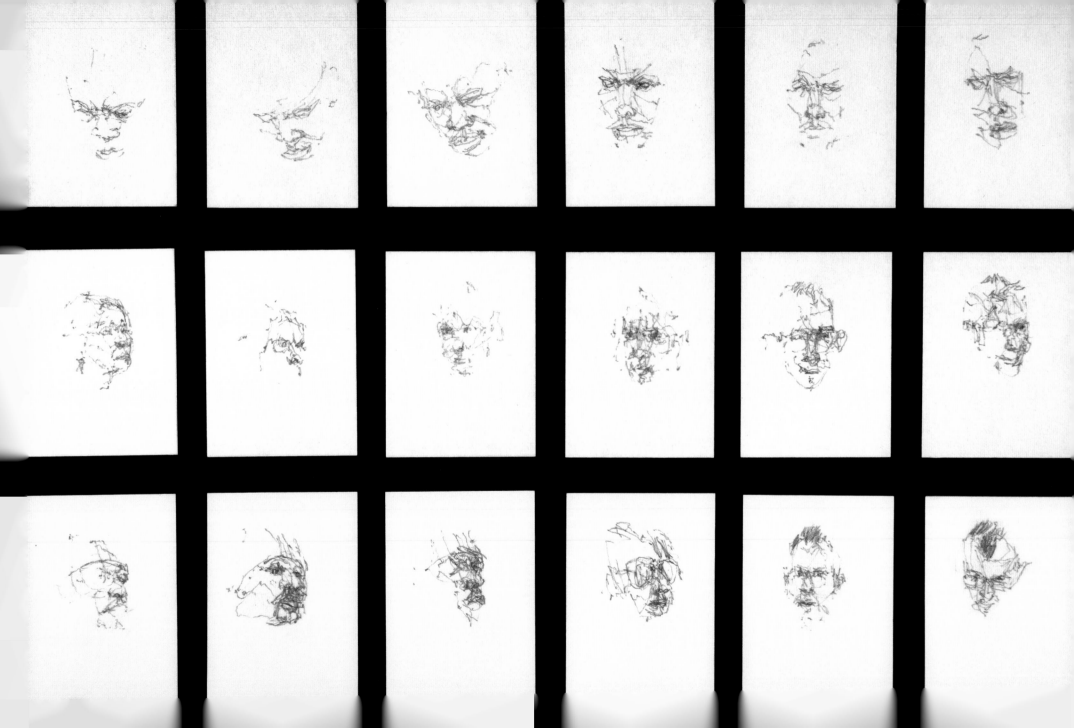

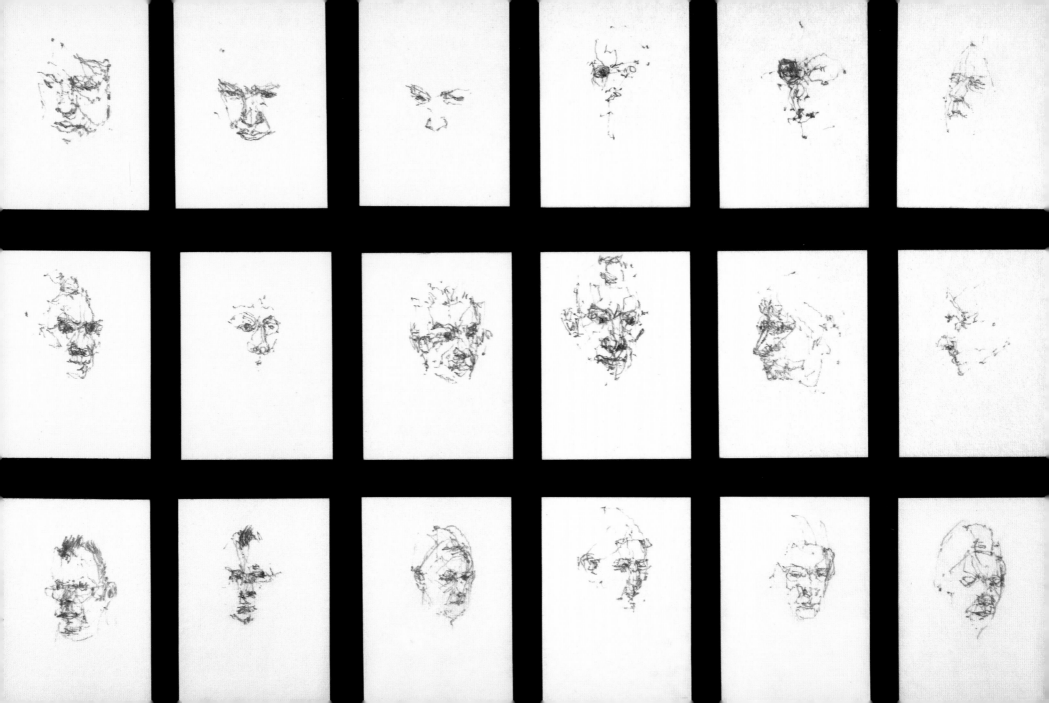

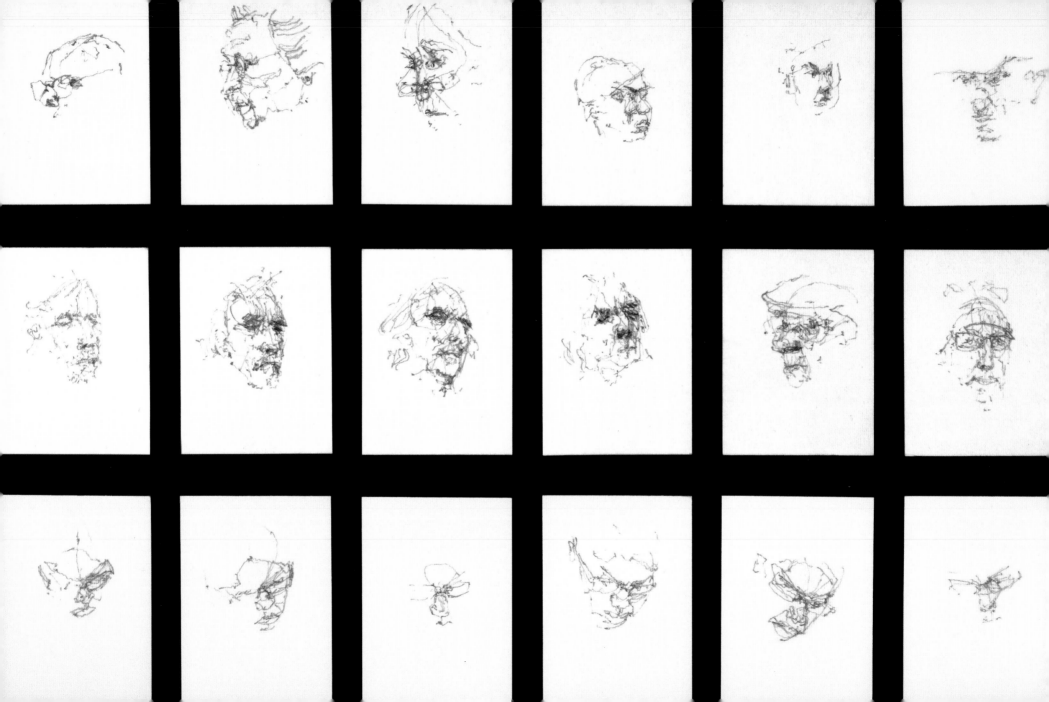

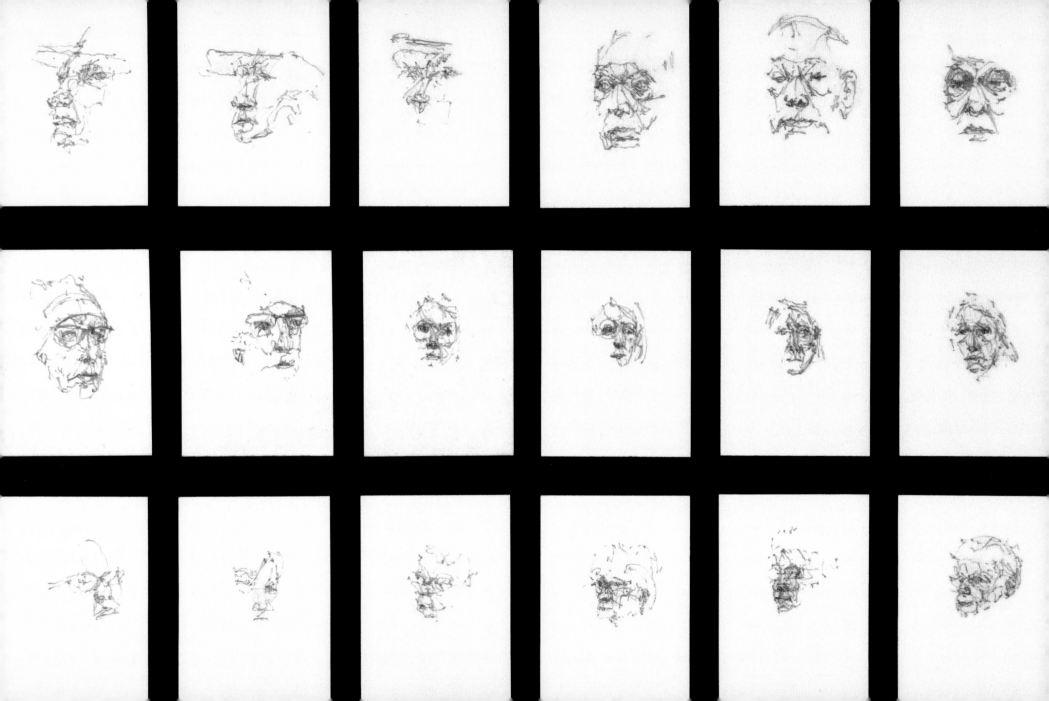

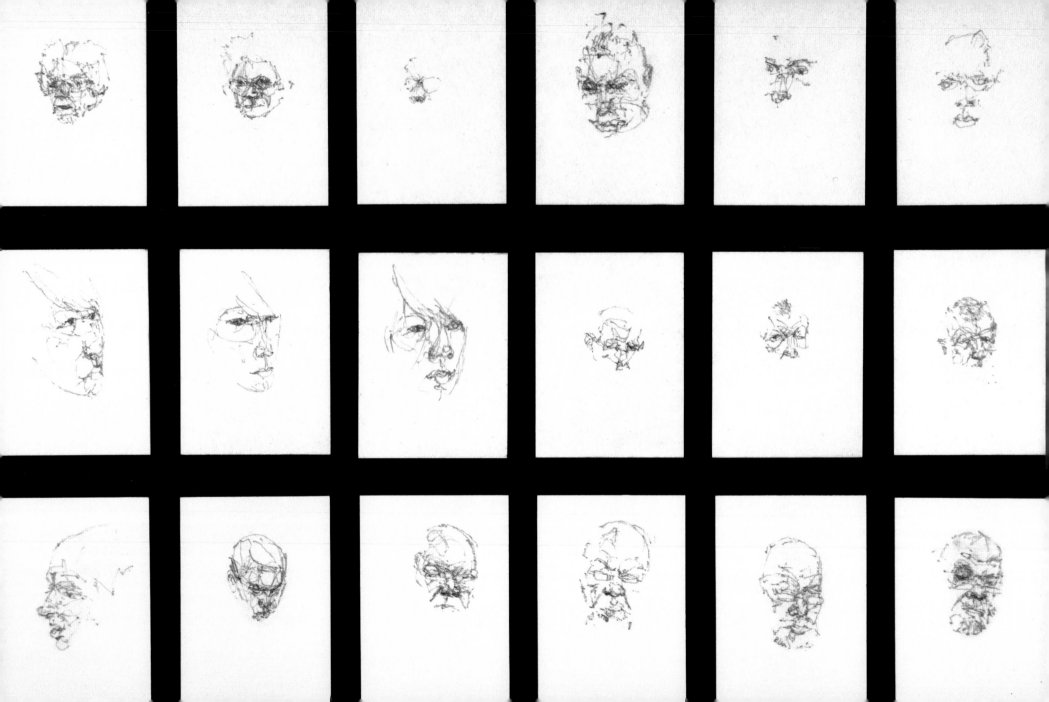

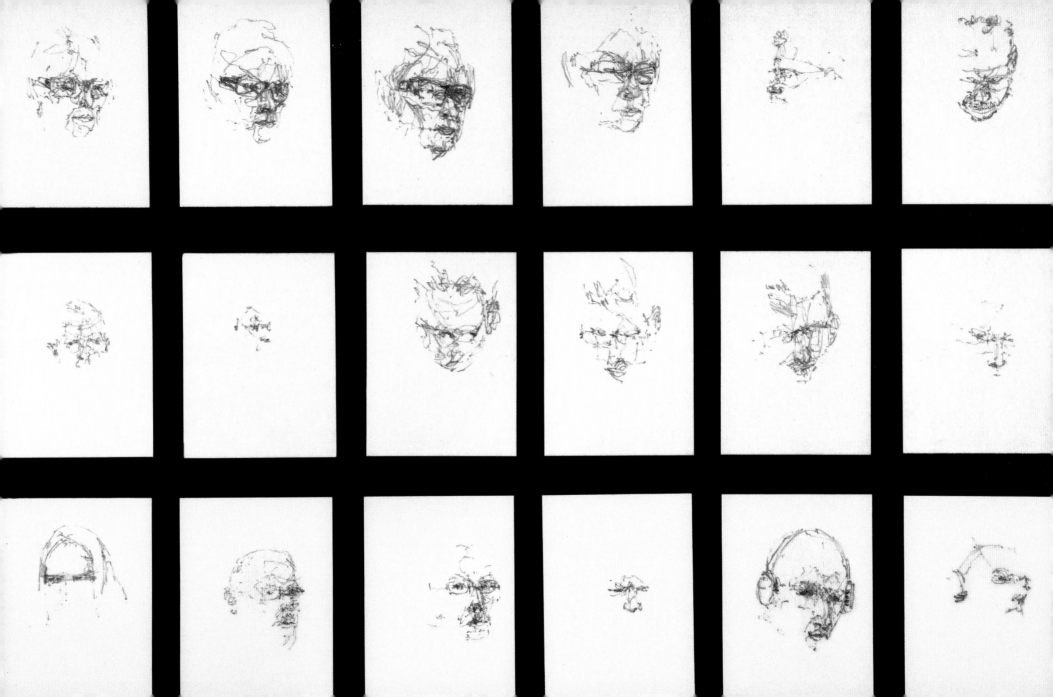

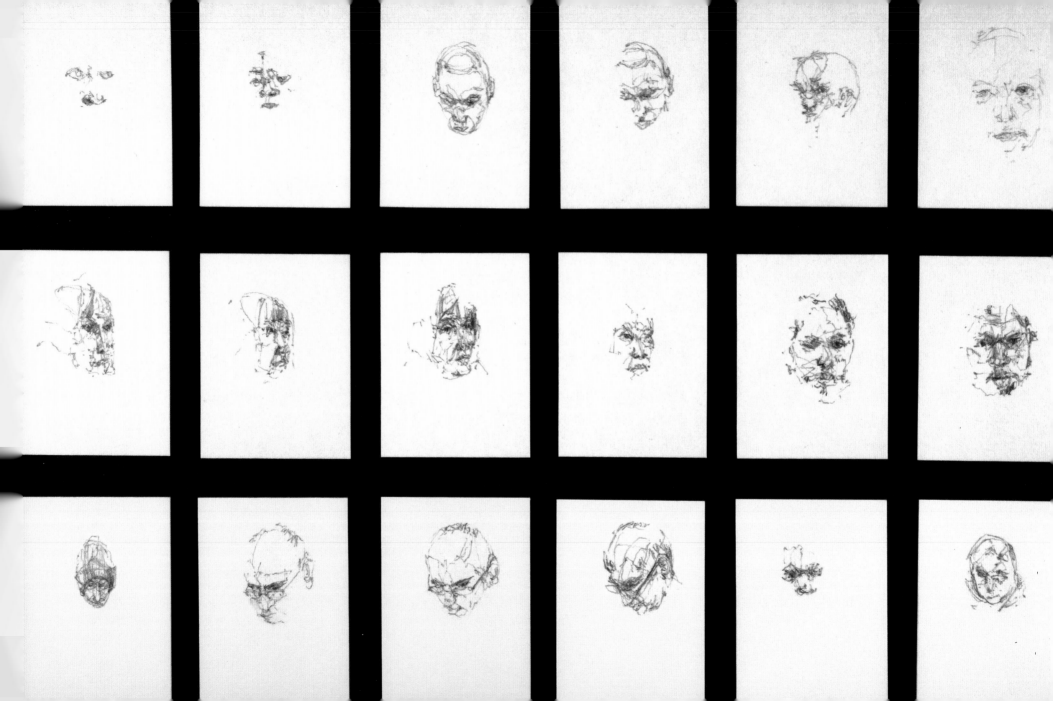

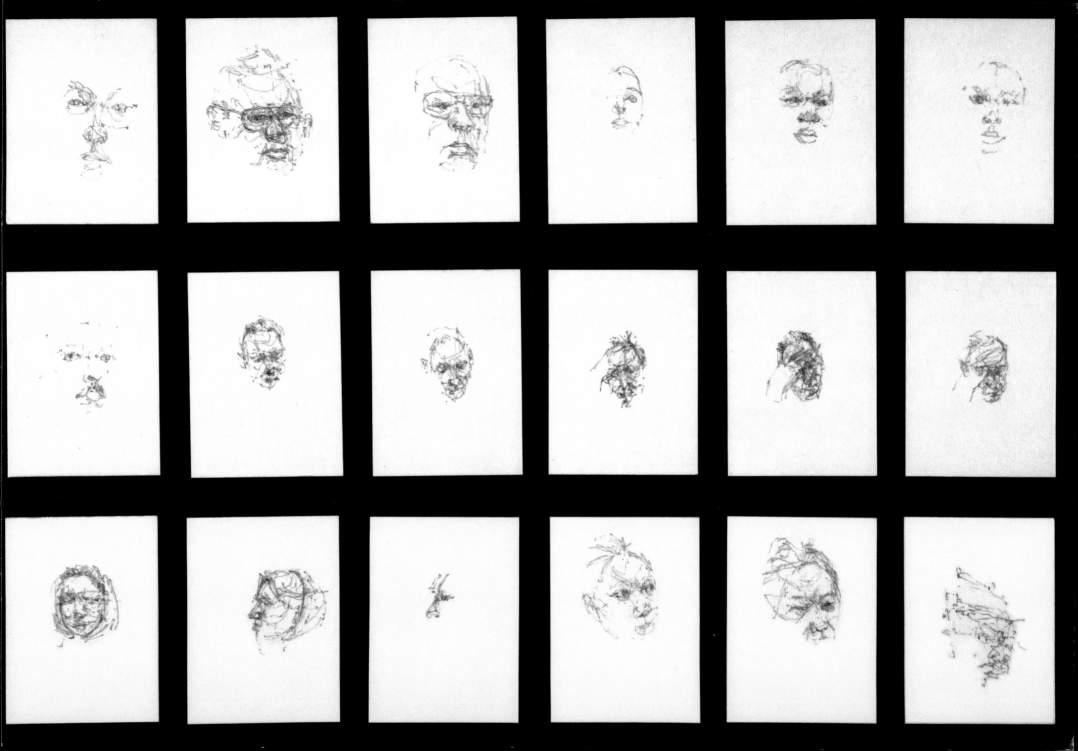

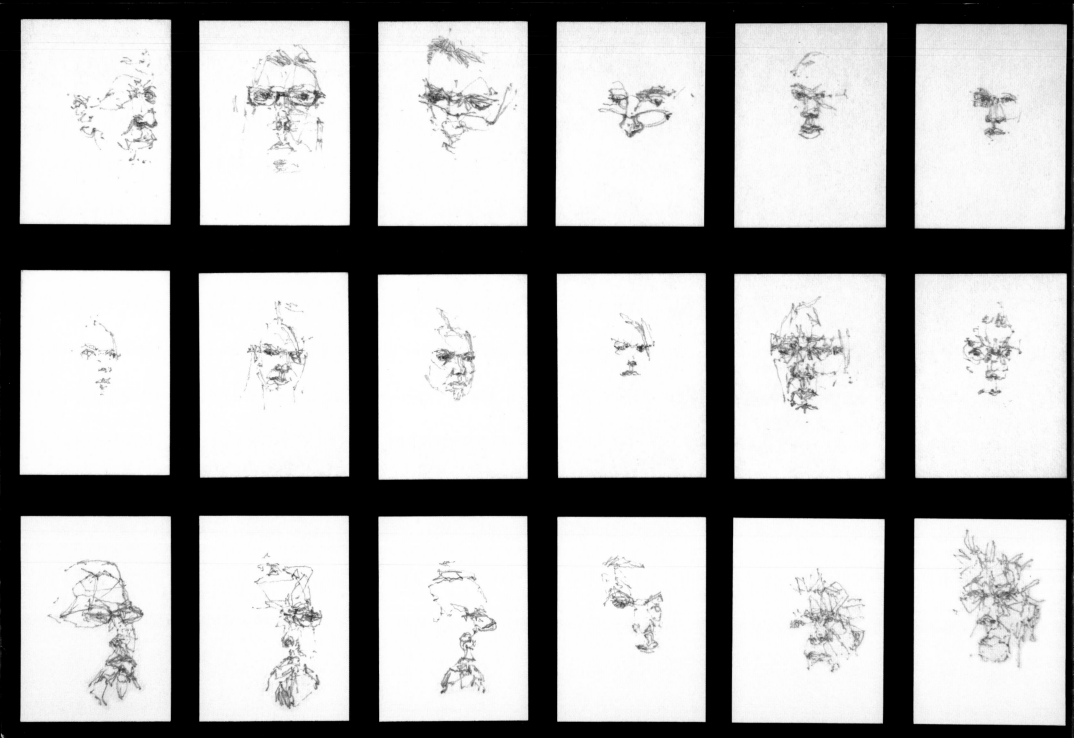

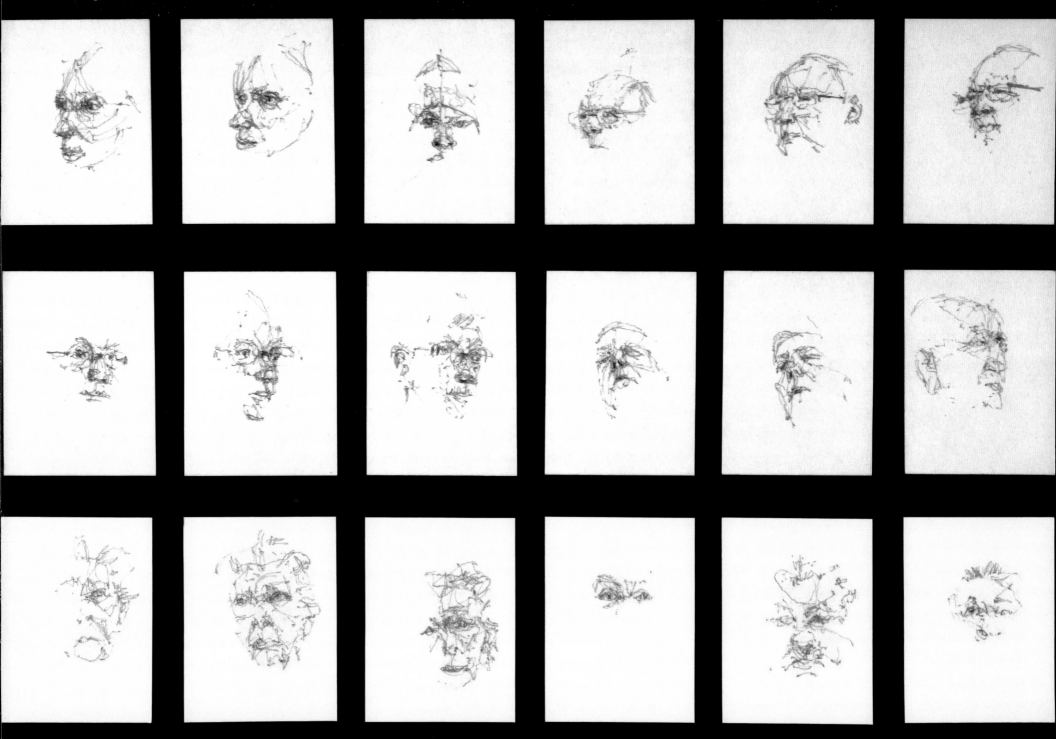

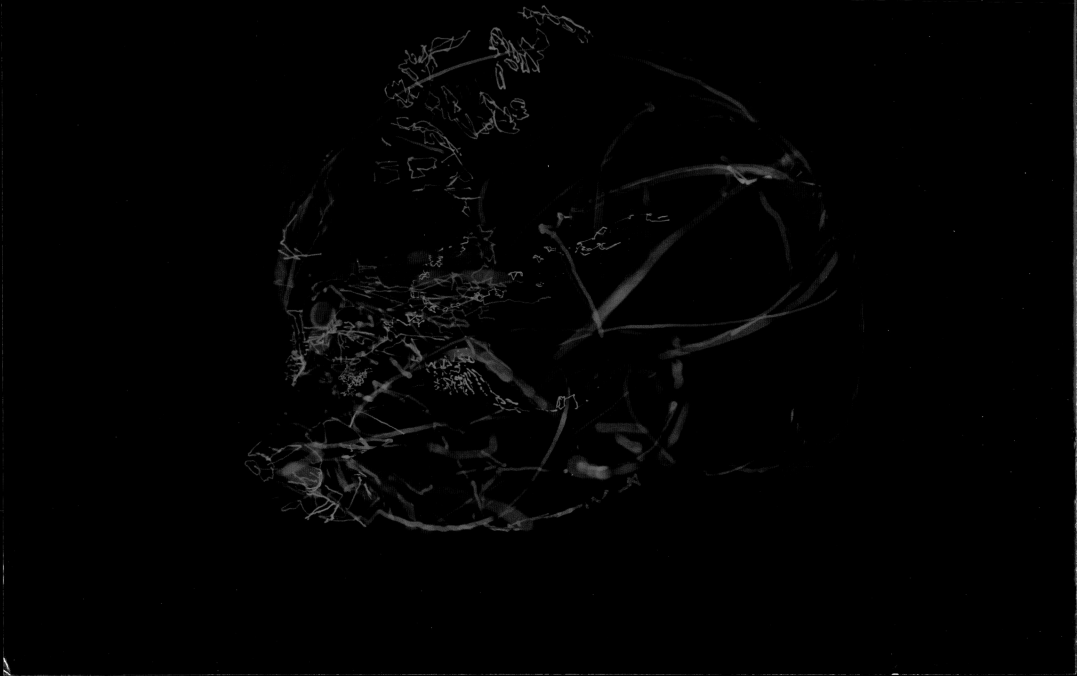

DRAMATIS PERSONAE

Home at last, to the glow of the screen; and the bookmarked page of the book of faces. Rain lashes the window, and rattles the frame. On the corner, a night bus brakes with a shudder at one of its final stops.

Hannah Hoxley has 230 friends (four more than when you last looked) Morgan Blain has 76 (the same as before). New-guy Tom (who people are starting to call Peeping Tom) has 25 (though some of them have gone strangely quiet).

I went up to Claire's room last night, and the computer was on. I shouldn't have, I know, but I couldn't resist taking a look. I called up her browser history to check through the sites that she'd visited, and there wasn't much at first, just some chats with her mates about some drawings they'd all been doing at school. But then I could see that he'd contacted her again, that they were back in touch…

Hi hun. I'm so sorry about last night. I don't know what's wrong with me at the moment. I feel like a total zombie all the time. What about next weekend? We could go to that place by the park. I'll call you…

He poked me a couple of times, but I wasn't interested in chatting, let alone meeting…

As I predicted, Ryan and Kenneth were the last to arrive. 'What time d'ya call this?' I said. But they were doing their usual cool thing. You know, like we need to tell you what we were up to… But they calmed down a bit when they got a drink in their hands, and when they found out Matt and Kerry were there. And then I looked around, and I realised it was the first time for, what, two years or something, that we were all together again. So I got out my phone and started taking these pictures. It was so great to see everyone there — one of those moments you never want to end. Though the woman behind the bar had other ideas, of course… It was funny, when she went round to pick up the glasses, she never once looked you in the eye, just kept muttering the same words over and over and over — HURRY UP PLEASE, ITS TIME. HURRY UP PLEASE IT'S TIME — in this really tiny voice, like a ghost. Anyway, guys, here are the photos. Hope you like 'em!

I remember that morning, in the darkness, an hour or so before the sun came up. I was off again, catching the red-eye, and I walked over towards you, ever so softly, so as not to wake you. I wanted to say goodbye, but something stopped me; I'm not sure what. As I stood there, in those last few seconds before leaving, I took a photo of you sleeping. It's a picture I still have to this day. Every time I look at it, I want to be back there with you, to step out from under my shadow, and to run my finger, ever so gently, over the curve of your cheek…

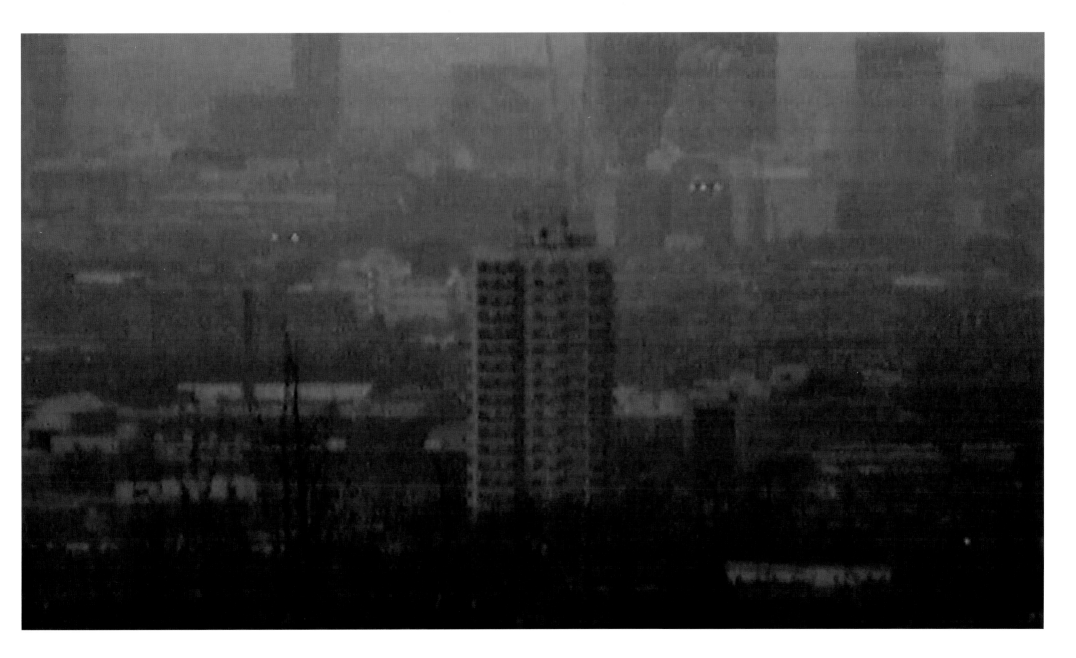

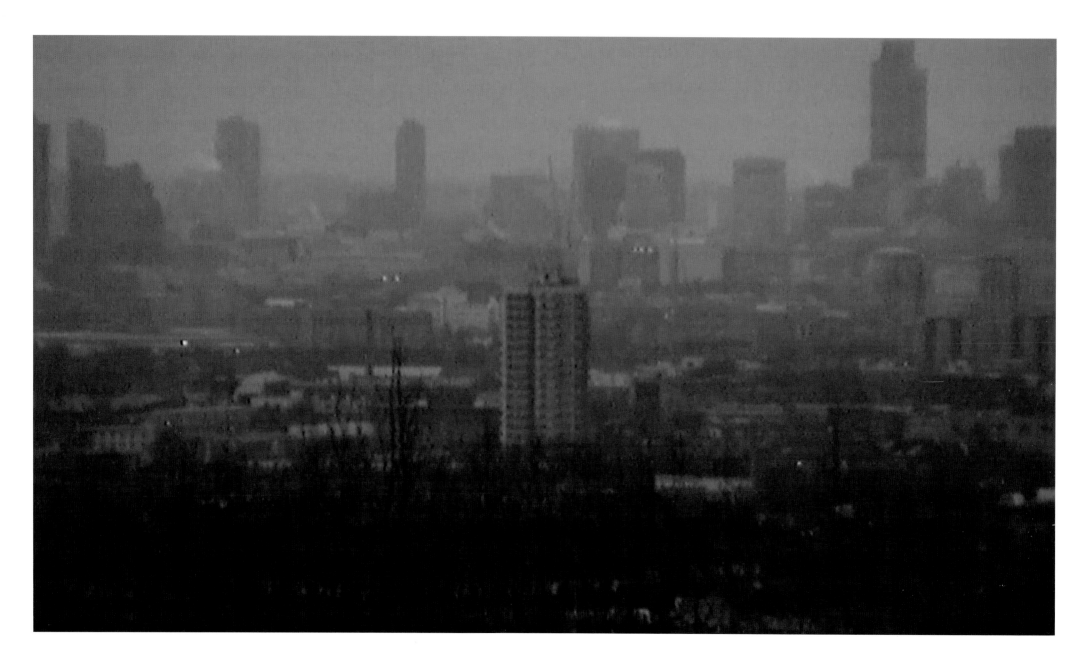

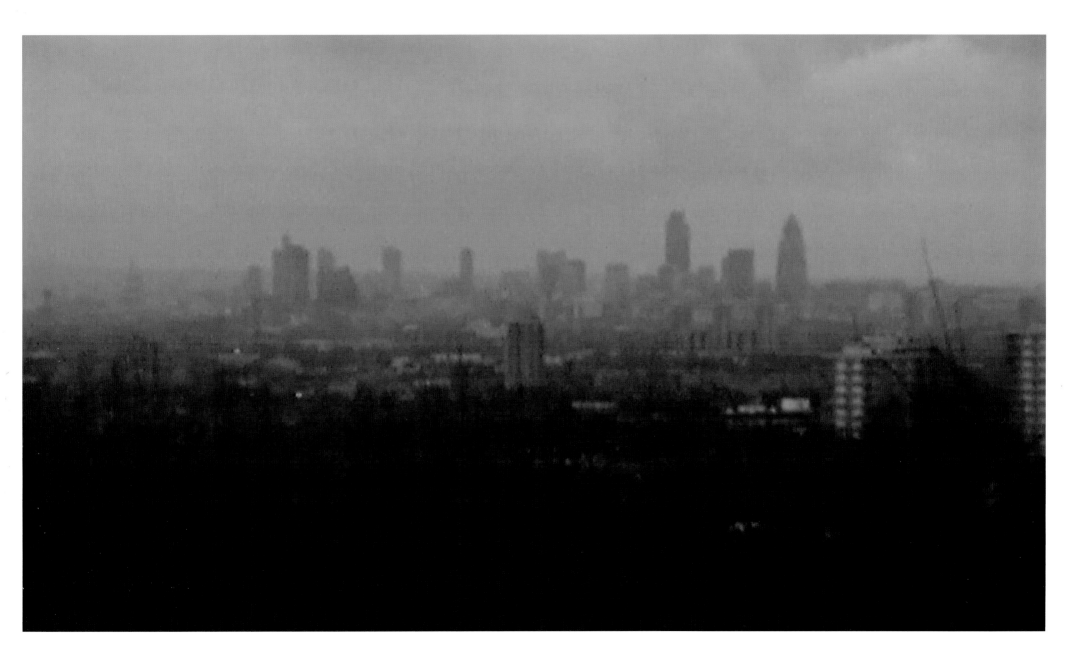

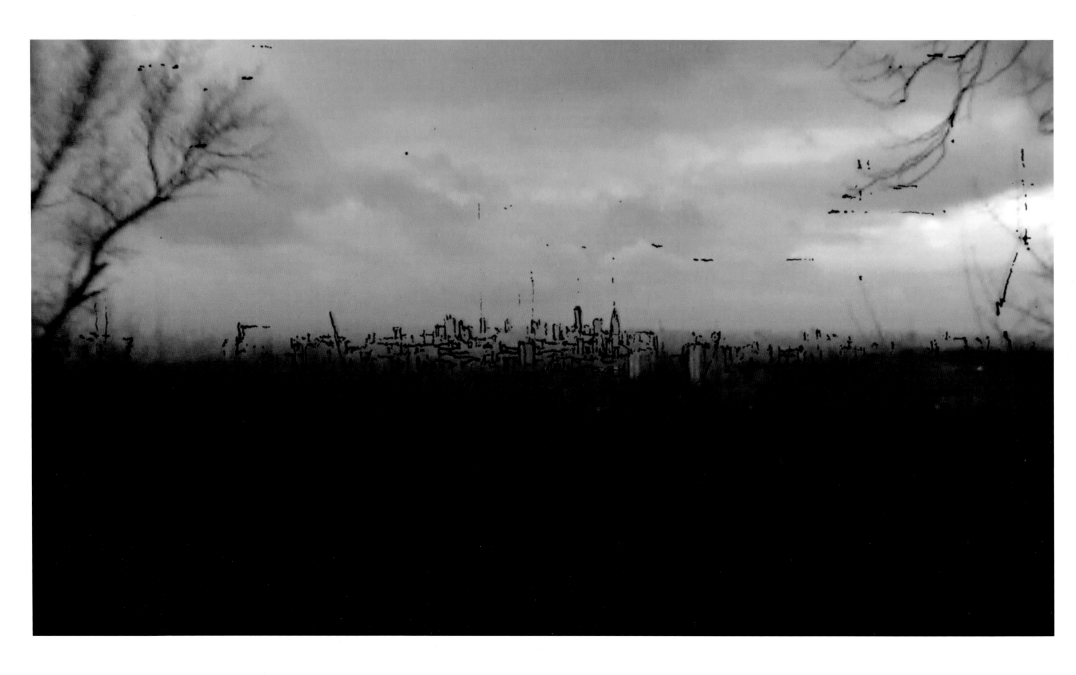

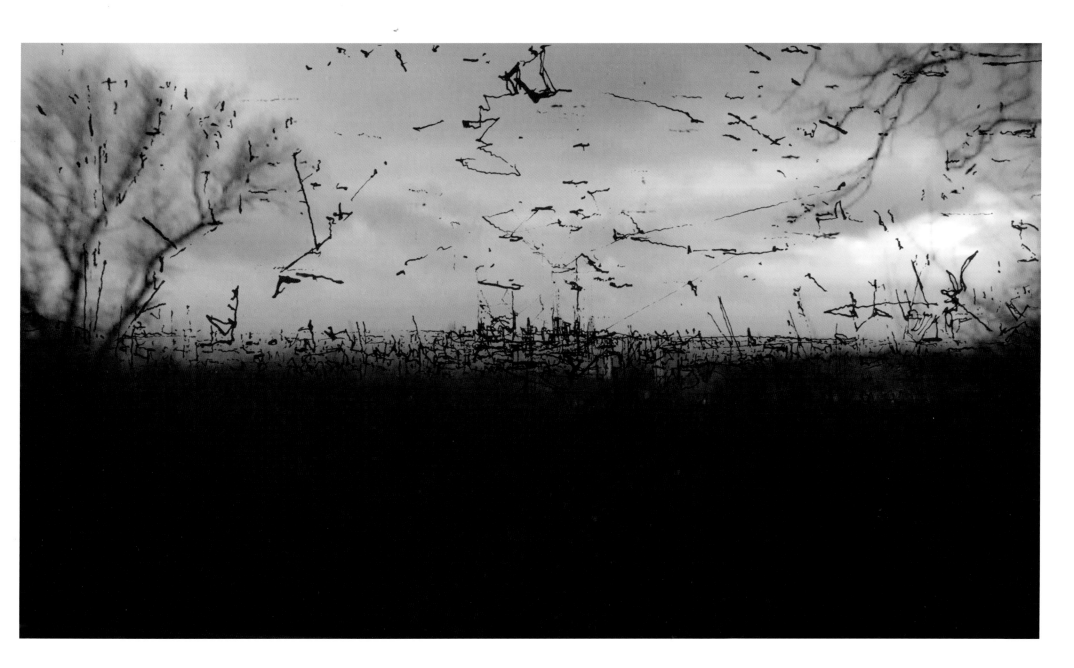

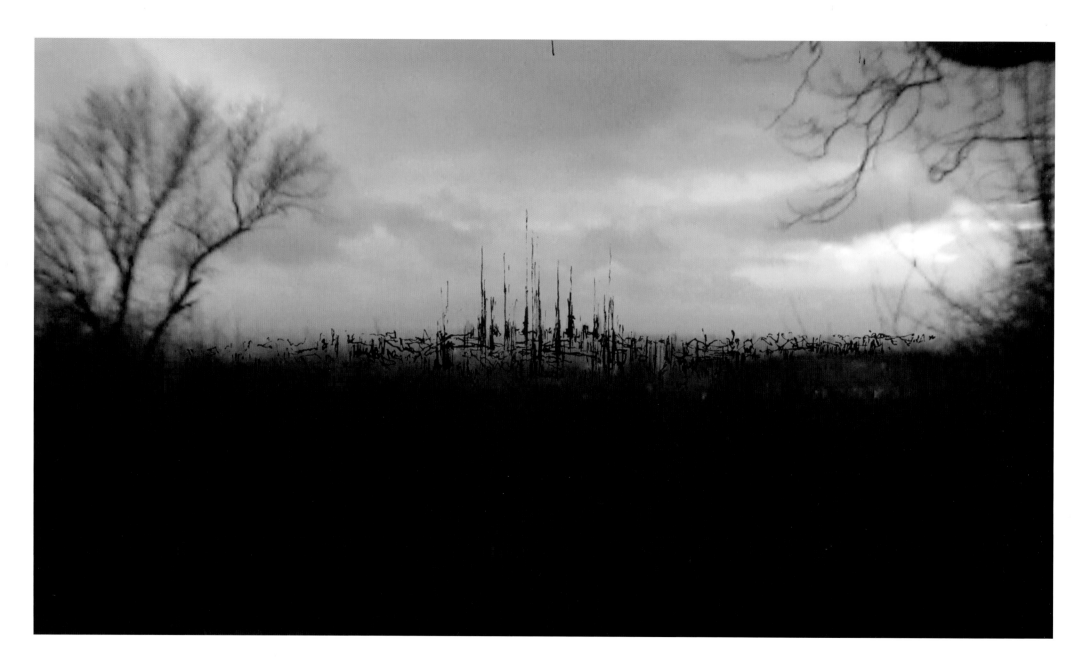

Previous:
Flight 2006
Installation
Five illuminated tables with
900 hundred drawings
Accompanied by a projected
film with soundtrack
7 mins 43 secs
DVD, Dip pen and ink on paper

Opening Series:
State–City 2004
(Details)
10 drypoint prints and one copper plate
Plate size 100 x 100mm
Framed prints 2420 x 265mm
Drypoint etching
Michael and Fiona King, London

State–Jeff 2004
(Details)
9 drypoint prints and one copper plate
Plate size 100 X 100mm
Framed prints 2200 X 265mm
Drypoint etching

State–Amit 2004
(Details)
9 drypoint prints and one copper plate
Plate size 100 X 100mm
Framed prints 2200 X 265mm
Drypoint etching
Lisa and John Miller, Hillsborough, USA

State–Jo 2004
(Details)
9 drypoint prints and one copper plate
Plate size 100 X 100mm
Framed prints 2200 X 265mm
Drypoint etching

Caul 2008
7 Diptychs
Caul 5
Caul 7
Caul 3
Caul 2
Caul 6
Caul 4
Caul 1
1225 x 450 mm
Digital photographs with digital drawing

Cradle 2008
7 Photographs
Cradle 9
Cradle 10
Cradle 11
Cradle 12
Cradle 13
Cradle 14
Cradle 15
1600 x 1110 mm
Scratched black and white photographs

Cradle Head 2008
3 Photographs
Cradle Head 1
Cradle Head 2
Cradle Head 3
960 x 960 mm
Scratched black and white photographs

Casting 2008
5 Diptychs
Casting – Regents Street
Casting – Hot Falafel
Casting – Enchanted
Casting – Nike
Casting – Intimissimi
2000 x 660 mm
Photographs and pencil on paper

Shapeshifter 2008 (details)
690 drawings with accompanying video animation
Each drawing 37.5 x 50mm,
Whole vitrine of drawings 3206 x 709mm
Video on continuous loop
Pencil on paper and video

BIOGRAPHY

DRYDEN GOODWIN was born in 1971 in Bournemouth, England and lives and works in London. He graduated from The Slade School of Fine Art, London in 1996, where he currently teaches.

Selected Solo Exhibitions

Flight (Feldman Gallery, Portland, Oregon, USA, 2007), *Portrait Perspectives* (Stephen Friedman Gallery, London, 2006), *Sustained Endeavour: Portrait of Sir Steve Redgrave* (National Portrait Gallery, London, 2006), *Flight* (Chisenhale Gallery, London, 2006), *Stay and State* (Stephen Friedman Gallery, London, 2006), *Draw In/ Draw Out* (New Art Gallery, Walsall, 2004), *Dilate* (Manchester Art Gallery, 2003), *Closer* (Tate Britain, London, 2002), *Wait and Drawn to Know* (Stephen Friedman Gallery, London, 2000), *New Work* (Galerie Frahm, Copenhagen, Denmark, 1999), *Recent Video Work* (Mid-Pennine Arts, Lancashire, 1999) *Solo X 9: Artists in Clerkenwell* (Berry House, London, 1998).

Selected Group Exhibitions

Global Cities (Tate Modern, London, 2007), *Strangers with Angelic Faces* (Akbank, Istanbul, Turkey, 2006), *Animators* (Angel Row Gallery, Nottingham; Spacex Gallery, Exeter and Ferens Art Gallery, Hull, 2006), *Cross Town Traffic* (Apeejay New Media Gallery, New Delhi, India, 2005), *Clandestine* (50th Venice Biennale, Italy, 2003), *A Century of Artist's Film in Britain* (Tate Britain, London, 2003), *Sanctuary* (Gallery of Modern Art, Glasgow 2003), *Cathedral* (Baltic, Gateshead, 2003), *Reality Check* - British Council and Photographers' Gallery international touring show (Moderna Galerija, Ljubljana, Slovenia; House of Artists, Zagreb, Croatia; Rudolfinum, Prague, Czech Republic; Bunkier Sztuki, Cracow, Poland; Arsenals, Riga, Romania, 2002/03), *Fantastic Recurrence Of Certain Situations* (Canal de Isabel II, Madrid, Spain, curated by the Photographers' Gallery, London, 2001), *Video Positive - The Other Side of Zero* (Tate Liverpool, 2000), *Video Cult/ures* (ZKM, Zentrum für Kunst und Medientechnologie, Karlsruhe, Germany, 1999), *Traffic* (Site Gallery, Sheffield, 1999), *The Pandaemonium Festival* (Lux Gallery, London 1998), *Paved With Gold*, Kettle's Yard, Cambridge,1998), *The New Contemporaries '97* (Corner House, Manchester; Camden Arts Centre, London; CCA, Glasgow, 1997/98).

Selected Publications

Dryden Goodwin: Sophie Howarth and Sean Cubitt, Film and Video Umbrella, 2004 (ISBN: 1 90427 004 2)
Dryden Goodwin: TheEYE
Part of a series of interview-based video profiles of contemporary artists, Illuminations, 2006

Selected Fellowships

NESTA Fellow, 2000-03
Fabrica Research Fellow, Venice, Italy 1996-97

Public Collections

The Museum of Modern Art, New York; National Portrait Gallery, London; Arts Council England; The British Library, London.

www.drydengoodwin.com

For Jo, Fynn and Heath

Artist's Acknowledgements

David Chandler
Jo Cole
Camilla Brown
Brett Rogers
Steven Bode
Dean Pavitt
Richard Rowland
Michael Mack
Steidl
Stephen Friedman
David Hubbard
Jason Wellings
Tim Mitchell
Spectrum Photographics
Michael Dyer Associates
Michael and Fiona King
Eric Franck
Jeff and Christine Goodwin
Amit Lahav
Mike Jones
Laura Thomas
Photoworks
The Slade School of Fine Art

Published in 2008 by Photoworks and Steidl, in
association with The Photographers' Gallery, London,
to accompany the exhibition *Dryden Goodwin: Cast* at:
The Photographers' Gallery, London
26 September – 16 November 2008

© 2008 Photoworks/Steidl
All images © 2008 Dryden Goodwin
Essays © 2008 the authors

British Library Cataloguing-in-Publication Data
A catalogue record of this book is
available from the British Library

ISBN 978-3-86521-727-1

Editor: David Chandler
Design: Dean Pavitt at LOUP
Printing and production: Steidl, Göttingen
Printed in Germany

Photoworks
The Depot, 100 North Road, Brighton, BN1 1YE, England
T: +44 (0)1273 607500
F: +44 (0)1273 607555
E: info@photoworksuk.org
W: www.photoworksuk.org

Steidl
Düstere Str. 4
37073 Göttingen
Germany
E: mail@steidl.de
W: www.steidlville.com

Photoworks gratefully acknowledges the financial
support of The Esmée Fairbairn Foundation
and Arts Council England: South East in the
making and publication of this book.